THESE
PARTICULAR
WOMEN

KAT MEADS

Sagging
Meniscus

Earlier versions of some of these essays appeared in *The Decadent Review, Eclectica, Exacting Clam, Full Stop, Gargoyle* and *New England Review*. "Margaret Mitchell's Dump" and "Things Woolfian" are *Best American Essays'* Notables.

Additional thanks to Shirley Staples for seeing this project's forest as well as its trees.

Set in Adobe Garamond Pro with LATEX.

ISBN: 978-1-952386-54-1 (paperback)
ISBN: 978-1-952386-55-8 (ebook)
Library of Congress Control Number: 2022949950

Sagging Meniscus Press
Montclair, New Jersey
saggingmeniscus.com

Easy stories drive out hard ones.
—*Phyllis Rose*

Each of us is caught up in a machine that is both of our own making and out of our control.
—*Mary Ruefle*

What I've always wondered was WHY—why must the show go on? Why is there never any getting out of the SHOW?
—*Lucy Ellmann*

CONTENTS

THESE PARTICULAR WOMEN

THINGS WOOLFIAN

ATTICS OFTEN give shelter to what shouldn't be preserved. Rediscovered in a crinkly, yellowed state, my dreadful 1973 term paper written for Professor Frank Ryan's honors class on the "search for unity" in Virginia Woolf's novels, nephew Quentin Bell's then-new biography my only secondary source.

Throughout the thirty-two pages, Professor Ryan diligently circled my (numerous) typos:

```
"How did one judge people, think of them?...Standing now,
apparently transfixed by the pear tree, impressions poured
in upon her of those two men, and to follow her thought
was like following a voice which speaks too quickly to be
taken down by one's pencil...All of this danced up and
down, like a company of gants danced up and down in Lily's
mind, in and about the branches of the pear tree..." 17
```

—but gave up correcting the error of my block paragraph quotation marks early in the game, likely worn out by the task.

On the title page, in slanting blue script, he posed these questions:

> *Do you imply that V.W. found unity in death? Was she "ripe" and "ready for death" in a Nietzschean sense?*
>
> *Any relationship between V.W.'s art, her life and death, and Freud's Thanatos as dominant over Eros in 1930's?*
>
> *Did V.W. feel that England was dying in 1930's?*

I

Although I accumulated points for "handling the themes" of "male/female dichotomy," "art and its limitations," "love and its limitations," "madness," and "death," Professor Ryan signed off with another question: *Could more have been done with silence?*—a question time has plumped with irony.

Why can't we Woolfians stop gabbing about Virginia?

As early as 1974, in her essay collection *Seduction and Betrayal,* Elizabeth Hardwick already bemoaned Bloomsbury rehash: "The period, the letters, the houses, the love affairs, the blood lines: These are private anecdotes one is happy enough to meet once or twice but not again and again." Should the reading public need reminding in 1978, that banner year for Woolf studies and publications, John Hillaby announced in a *New Scientist*'s article that "the Woolf hunt" was "still under way." In a 2015 review of Viviane Forrester's *Virginia Woolf: A Portrait,* reviewer Suzanne Berne used up some of her own word count to re-ask: "To the hundreds of books that have been written about Virginia Woolf, *why* (Berne's italics) add another? More to the point, why aren't her own books enough?"

Worthy questions, both.

They are also questions that ignore the attractions of spectating a turf war composed of interpretive skirmishes, internecine bickerings, and revelations regarding who aligns with which side and why. As Jacqueline Rose reminded in her review of Hermione Lee's 1996 biography of Virginia Woolf, closest rival—in terms of influence—to Quentin Bell's 1972 account: "It is always worth asking of any biography, with whom in the story, if anyone, does the biographer identify?"

❁

Thus far no Virginia Woolf biographer has identified with Sir Leslie Stephen—writer, scholar, expert mountaineer, Shreckhorn first ascenter, *Dictionary of National Biography* editor. What's intriguing, from the

biographical standpoint, is the similarity of his portrayal in books, essays, and criticism devoted to his daughter. About Sir Leslie's personality there seems to be neither undue argument nor abundant sympathy. A prickly, whiny, sulky man, often overwrought and constantly overly demanding of his family's attentions and concern. A patriarch soaked in self-pity, the perpetually weeping widower. A stepfather who deeply resented Stella Duckworth's leaving his household for marriage and a household of her own. A breadwinner "with an irrational fear of ending his days in the poorhouse," his operational standard a "melodramatic tyranny" (Phyllis Rose, *Woman of Letters: A Life of Virginia Woolf*). A fellow who excelled at enacting a "Victorian widower's hysterical helplessness" (Janet Malcolm, "A House of One's Own"). In penning the *Mausoleum Book*—"purportedly a letter to his children to memorialize their dead mother," scoffed reviewer Virginia Hyman—Sir Leslie, once again, managed to make it all about Sir Leslie. After pledging "simply to write about your mother," the memoirist amends: "In order to speak intelligibly it will be best to begin by saying something about myself." During his lifetime, Sir Leslie was obeyed—but not without resentment. After his death, Vanessa "dreamt on more than one occasion that she had murdered him," reports Frances Spalding (*Vanessa Bell*). Short of murdering him, Vanessa appears not to have expressed undue sorrow when she, Thoby, Adrian, and Virginia were freed of his rule and presence.

Julia Jackson Duckworth Stephen's cohesive presentation derives from a different set of guidelines and judgments. Julia plays (patient) saint to Leslie's (peevish) child. Accordingly, any attempt to parse the individualities of the woman requires a jog through the heavy mists of hagiography. Complementing Julia's rectitude: superior good looks. Roger Poole, in his otherwise disputatious *The unknown* (lower case, his) *Virginia Woolf*, not only sticks to the party line regarding Julia's appearance but goes one better, insisting on a unanimous verdict. In the language of Poole, Julia was "by all accounts, immensely beautiful."

To the contemporary eye, in photographs, Julia Stephen comes across less beautiful than wan, worn, fragile, and weary. If the actual woman actually did look wan, worn, fragile, and weary, she had cause. She had lost through death a husband she adored, Herbert Duckworth. As the wife of Leslie, she gave birth to another four children, upping her brood total to seven. She oversaw the day-to-day enterprise of a large Victorian household. Inside the home, she nursed her children as needed and her second husband perpetually. The Leslie/Julia relationship as summarized by Thomas Caramagno in *The Flight of the Mind: Virginia Woolf's Art and Manic-Depressive Illness*: "Leslie was a willing patient, she was a willing nurse, and both were depressed." Julia also undertook nursing duties outside her home, experiences she drew upon to compose the caregiver guide *Notes from Sick Rooms,* published in 1883, a year after Virginia's birth. Julia's advice included:

> Don't talk while bathing patients. ("Useless remarks . . . take away all the refreshment the bath would have given.")
>
> Don't argue with patients. ("Invalids' fancies seem, and often are, absurd; but arguing will not dissipate them; it will only increase them.")
>
> Choose a "pleasant" disinfectant. (Burnt vinegar counts as "the most pleasant of scented disinfectants.")
>
> When a patient dies, follow the relatives' lead. (Unless the nurse "sees that the relations are unwilling to do so, she should make no attempt to close the eyes of the dead nor to tie up the chin.")

For her own late-night reading (as cautionary tale? fantasy cure?) Julia "always kept . . . beside her bed" a copy of Thomas De Quincy's *Confessions of an English Opium Eater* (Spalding). No feminist thoughts or yearnings roiled the mind and heart of Virginia Stephen's mother. Not only did Julia fail to actively support women's rights, she actively

disapproved of both the crusade and its objectives, a full-on "anti-feminist" in the estimation of Jane Marcus (*New Feminist Essays on Virginia Woolf*).

"Technically" Julia died, age 49, "of rheumatic fever but essentially of exhaustion," Jean Love posits in *Virginia Woolf: Sources of Madness and Art*. Virginia was thirteen at the time. She was twenty-two when Leslie died of cancer. For the previous six months, Virginia had "shouldered the weight" of "nursing" her terminally ill father (Poole). Following the death of her mother in 1895 and the death of her father in 1904, Virginia experienced severe mental and emotional turmoil, or—depending on the chronicler—went "mad."

<div align="center">❀</div>

On the subject of Virginia's madness, opinions divide and subdivide. At the most basic level of contention: when precisely her breakdowns/outbreaks of madness occurred. In the third volume of his autobiography, *Beginning Again* (1964), husband Leonard records that Virginia four times "passed across the border which divides what we call insanity from sanity," listing those occasions as follows: "She had a minor breakdown in her childhood; she had a major breakdown after her mother's death in 1895, another in 1914, and a fourth in 1940." Quentin Bell's biography of his aunt broadens the scope of Leonard's 1914 notation, describing the 1913 to 1915 span as "two years of intermittent lunacy" for Virginia, the term "lunacy" officially in play, Hermione Lee reminds, until the U.K.'s Mental Treatment Act of 1930 adjusted the wording, replacing "lunatic" with "person of unsound mind."

Word choice aside, not everyone accepted Leonard's and Quentin's timeline of events.

Biographer Phyllis Rose notes that Virginia's husband "omits the breakdown after her father's death and substitutes one in childhood which is not otherwise documented." Hermione Lee regards the break-

down in 1895, following Julia's death, as "the least fully chronicled" of the episodes, its evidence "somewhat ambiguous." Mincing fewer words, Viviane Forrester insists no proof whatsoever exists to support Quentin Bell's claim that Virginia went mad, age thirteen: "What evidence, what document, what testimony? None." Such fact-less invention, Forrester declares, "is how myths are born." In his short biography *Virginia Woolf,* Nigel Nicolson agrees that Virginia "acted very strangely" after Julia's death but considers her behavior at the time in no way comparable to the "more serious . . . attack in May-August 1904." Sisters Stephen biographer Jane Dunn (*A Very Close Conspiracy*) adds rather than subtracts from the standard list, including two other dates when Virginia "slipped from public view": the "summer of 1910" and the "summer of 1936," when Virginia "collapsed in suicidal despair," prompted by "worry and work on her novel *The Years.*"

The intra-family view? Poole believes Leonard "more or less swallowed Vanessa's view of Virginia's instability hook, line and sinker" (i.e., that "the Goat"—Virginia's nickname—had "always been mad"). Ever more measured in her wording, biographer Lee states: "Vanessa tends to speak about her sister as a sad case which has to be managed." Unsurprisingly, Lee reports, Vanessa's children adopted that same view:

> As they grew up, the children conspired with their parents to create a family image of Virginia Woolf as the batty, playful, malicious, untrustworthy, eccentric genius. The letters between the children about Virginia always strike this note; it lingers on into Quentin Bell's biography, and has greatly influenced the British reading of her life.

" 'Mad' was the word employed by Virginia's family and by herself, in faint derision of her condition," explains Nicolson. Poole refutes not only the term "mad," but also the term "ill": "Virginia's mental condition was not so much 'ill' as anguished. This is what psychiatry could not afford to recognize. Her condition was one of metaphysical or

existential despair." In *All that Summer She was Mad,* a title lifted from a line in Bell's biography, Stephen Trombley argues: "Those critics who have assumed her madness have not been able to say what they mean by madness, or to prove that Virginia suffered from it."

Virginia's symptoms of stress and distress are, on the other hand, plainly stated and plentifully documented by Virginia herself, Leonard, and others within their close circle: headaches, a racing pulse, insomnia, anxiety, restlessness, a disinclination to eat. During her most severe attacks, she experienced feelings of persecution (judged legitimate or imagined, depending on the interpreter), saw and interacted with hallucinations, verbally assaulted friends, family, and medical staff, and attempted suicide.

By the 1990s, evaluators of Virginia's condition, including Thomas Caramagno in *The Flight of the Mind,* had begun to favor the term manic depression. In her biography, Hermione Lee praises Leonard for "quite rightly" rejecting "the diagnosis of 'neurasthenia' in favor of 'manic depression.'" Yet Lee later reports that Leonard told the coroner his dead wife had all her life suffered from "acute neurasthenia"— perhaps because neurasthenia was the more widely employed and accepted term, perhaps because, having recently identified his wife's water-disfigured corpse, Leonard no longer cared about diagnostic vagaries.

As to the root cause of Virginia's difficulties, Louise DeSalvo's 1989 *Virginia Woolf: The Impact of Childhood Sexual Abuse on her Life and Work* points the finger squarely at half-brothers Gerald and George Duckworth and their serial sexual pawing.

Virginia's take on the matter? In letters, she very often trucked in that Nicolson-noted "derision," irony her sword. "A touch of my usual disease, in the head you know," she writes to Katherine (Ka) Cox in February 1912. From Twickenham nursing home, in March of that same year, she writes to Leonard: "I shall tell you wonderful stories of the lunatics. By the by, they've elected me King." In a January 1922

letter to E. M. Forster, after estimating she'd "wasted 5 whole years" in bed, she writes: "Not that I haven't picked up something from my insanities and all the rest. Indeed, I suspect they've done instead of religion." But all traces of that arch treatment disappear in her essay "Old Bloomsbury." The successive deaths of her mother, half-sister Stella, and father, Virginia writes, resulted in "the illness which was not unnaturally the result of all these emotions and complications."

Not unnaturally—as if in argument to the prevailing view.

In her essay "On Being Ill" (1926), she throws out another sharp rebuke of accepted bromides: "There is, let us confess it . . . a childish outspokenness in illness; things are said, truths are blurted out, which the cautious respectability of health conceals."

Truths blurted—as in restriction and restraint contravened.

A truth Virginia disclosed to Violet Dickinson: "My life is a constant fight against Doctors follies, it seems to me." A wrenching disclosure—more so because it is expressed in a letter dated November 26, 1904.

In November 1904, Virginia Stephen was twenty-two years old.

<center>❖</center>

During my college years, my female gang counted ourselves Leonard fans, impressed by any fellow who'd devote such care and attention to his (genius or otherwise) partner, charmed by what we perceived to be Leonard's sacrifices, his recognition that, of the two writers in the household, his was the lesser light. We were not *Commentary* readers in 1973, and so missed out on Cynthia Ozick's early shading of Leonard's "saintly socialist" and "saintly husband" reputation with an observation regarding Leonard's social striving: "He also knew, like any percipient young man in love with a certain segment of society, how to seize vantage ground." (Citing Ozick's essay in *Bloomsbury Pie: The Making of the Bloomsbury Boom*, Regina Marler reinterprets Ozick's in-

terpretation even more bluntly: "In his access to Bloomsbury and to his wife's creative genius, Leonard was more than compensated for all those breakfast trays he had carried to Virginia.")

In the BBC production "A Night's Darkness, a Day's Sail," Quentin Bell declares: "Leonard had to be the family dragon."

Did he?

If so, in his protective zeal, did husband Leonard overdo, behave too much the nursemaid, too much the watchdog, too much the disciplinarian? Already in January 1913, he had daily begun to record the state of and variations in Virginia's health, including when she had "slight headaches" or worse, V.n.v.w.b.n.—code for "Virginia not very well bad night" (Bell). Among the Woolfs' contemporaries, society hostess Lady Ottoline Morrell is on record as having "often lamented" Leonard's "control of Virginia," reports Lee. (In her Leonard bashing, Lady Ottoline didn't stop there. She also, recounts Lee, called Leonard "wicked" in her journal.) In Angelica Bell Garnett's accusatory-in-general *Deceived with Kindness*, Leonard gets off relatively lightly:

> Leonard never failed in vigilance and never fussed; neither did he hide his brief anxiety that Virginia might drink a glass of wine too much or commit some mild excess; he would say quite simply "Virginia, that's enough," and that was the end of it.

Dealing with work colleagues, Leonard trod less carefully. In Joan Russell Noble's *Reflections of Virginia Woolf by Her Contemporaries*, Leonard's onetime Hogarth Press partner John Lehmann recalls:

> Leonard, in spite of his charm, sense of humour and outstanding qualities of mind and sensibility, could be a very exacting taskmaster, nervy and obstinate in petty argument . . . Quite often a small mistake in production, or a failure to account for a penny stamp in the day's petty cash, would reduce him to an absurd depth of irritation.

Angus Davidson, who also worked briefly at Hogarth Press, describes his former boss as "a stickler for absolute punctuality" (Noble). On one occasion when Davidson arrived late to work (by Leonard's calculation), the two compared watches, found their "watches varied by two minutes," and to settle the argument "ran . . . up the basement steps together" to check the Russell Square clock. "Beneath his surface urbanity there lingered old angers and frustrations . . . he didn't suffer fools gladly," Leon Edel observed ("Some Memories of Octavia Wilberforce," *A Cézanne in the Hedge*). Biographers, who were not his intimates, contribute these descriptions: a "man of almost numbing common sense" (Phyllis Rose); "a man who found it virtually impossible to admit he was wrong, or to say he was sorry" (Jane Dunn); a man with a "rage for order" (Hermione Lee).

Sifting through Leonard's personal history, Viviane Forrester declares his Ceylon letters to Lytton Strachey "agonized," "shattering," the revelations of someone "mired in defeat, forever disappointed, and with suicidal tendencies." Yet an unadorned synopsis of Leonard's early career reads like an account of unqualified success. Employed by the Colonial Civil Service from 1904 to 1911, he was promoted to Assistant Government Agent in 1908 and put in charge of running the Hambantota Province in Southeast Ceylon, a territory comprised of more or less 1,000 square miles and 100,000 inhabitants. An imperialist endeavor to be sure, but one that occasionally required no small amount of personal courage. As recounted in Victoria Glendinning's *Leonard Woolf: A Biography*, Leonard once found himself in the very Orwellian situation of having to shoot two "unrestrained" cows as villagers with "hostile mutterings" looked on, an audience that would have "shot him in the back, if they dared."

During this period of his life, a photograph reproduced in *A Marriage of True Minds* (George Spater and Ian Parsons) captures Leonard in light suit and broad hat, a dog between his knees, looking remarkably like a young Bob Dylan, troubadour with canine. As did Virginia,

he stood five feet, ten inches. He had a lifelong hand tremor that became more pronounced when he became upset. He wanted to ditch Ceylon, return to England, live once again among the English, and marry Virginia Stephen. To pull off the feat of marriage to Virginia Stephen, he'd need all the perseverance and discipline his personality could muster. Before ultimately accepting the "penniless Jew," Virginia hemmed and hawed. In a May 1912 letter following his marriage proposal, she reminds him that she entertains "no physical attraction" for him, that his kiss left her feeling "no more than a rock." She frets about obligations: "Because you care so much . . . I feel I've got to care before I marry you. I feel I must give you everything; and that if I can't, well, marriage would only be second-best for you as well as me." Those cards—and others—laid squarely on the table, she further stipulates that if he will "still go on, as before, letting me find my own way," she will join him in taking the "risk." Announcing her pending marriage to Violet Dickinson in a June 4 letter, Virginia misspells her fiancé's last name: Wolf. In a subsequent letter to Violet, dated twenty days later, the misgivings continue. "But wont it be awful if . . . my character, which promised so well, finally rots in marriage?"

Virginia and Leonard married in August 1912. In December, Virginia was "unwell with headaches" (Bell). In January 1913, Leonard began consulting various physicians about whether or not Virginia should have children. Her own childhood doctor, George Savage, thought becoming a mother would do Virginia "a world of good"; others disagreed. Leonard abided by the dissenting opinion. Among the biographers who judge the "no children" edict ill-advised: Viviane Forrester. Forrester attributes Virginia's subsequent breakdown to the "shock" of having the decision made for rather than in consultation with her, a breakdown tellingly marked by Virginia's "screaming her hatred of Leonard for days on end, refusing to let him come near her for weeks."

There was also the little matter of Leonard's thinly veiled fiction, a novel featuring Leonard-like character Harry and Virginia-like Camilla,

begun by Leonard on their honeymoon and published in 1914. In her preface to the reissued 2003 edition of *The Wise Virgins*, Lyndall Gordon notes that when Virginia was "finally allowed to read" the novel, "three months after publication, in January 1915, she had to face an opinion contrary to Leonard's love letters." On display, in print, shades of the resentful fellow Leon Edel described as nursing "angers and frustrations." In Gordon's dating of events, two weeks after the permitted read-through, Virginia suffered the "worst of the four or five" lifetime breakdowns, "significantly, the only one during which she rejected Leonard."

In less alarming times, Virginia submitted to but chafed at the glass of milk regime prescribed by doctors and conscientiously carried out by Leonard. In an October 1930 letter to Ethel Smyth, recalling the thrill of discovering her mature voice and method, her irritation resurfaces:

> I shall never forget the day I wrote The Mark on the Wall—all in a flash, as if flying . . . The Unwritten Novel was the great discovery, however. That—again in one second—showed me how I could embody all my deposit of experience in a shape that fitted it . . . Jacobs Room, Miss Dalloway etc—How I trembled with excitement; and then Leonard came in, and I drank my milk, and concealed my excitement . . .

—Concealed it because excitement put her husband on alert.

For a time, Virginia shared her diary with Leonard, affording her "an opportunity to be kind and to be unkind," Glendinning observes. Later, they would squabble over Monk's House improvements and Leonard's obsession with greenhouses. Yet the marriage endured, and the majority—friends, family, and biographers in retrospect—consider the union an overall success, crediting Leonard with his role in keeping Virginia writing and alive for fifty-nine years. Psychoanalyst Alix Strachey, who knew both Woolfs, is adamant that Virginia was aware and deeply appreciative of the assistance and, consequently, "absolutely de-

voted to Leonard" (Noble). Naysayer Roger Poole puts a different spin on the relationship, calling out the couple's "tragic incompatibility," a hopeless clash between "the male-rationalist mind and the female-intuitive mind." In March 1930, five months shy of her eighteenth wedding anniversary and again in a letter to Ethel Smyth, Virginia offered her own assessment: "What about marriage? I married Leonard Woolf in 1912, I think, and almost immediately was ill for 3 years. Nevertheless we have nothing to complain of."

An extraordinary sequence of statements, a startling mix of the said and unsaid, a positive conclusion phrased entirely in negatives.

❁

Fiercely debated: the question of Virginia's sexual frigidity. That being sexually preyed upon by her half-brothers affected Virginia no biographer denies; what's argued is degree of effect. The Duckworth episodes, Quentin Bell concludes, "left Virginia with a deep aversion to lust." Phyllis Rose ascribes to the "frigid" nomenclature, but Hermione Lee balks at the label: " 'Frigid' seems a ridiculously simplistic description of this complicated, polymorphous self"—strong language for Lee. Forrester sputters with indignation at the very notion: "Thanks to Leonard, it was decided that (Virginia) was frigid toward men and the sexual act, under the pretext that her experience—if it could be called that—with her husband (on her honeymoon) had not delighted her."

Liberated from parental oversight and the doom and gloom of Hyde Park Gate, at their new Gordon Square digs the sisters Stephen reveled in calling semen, semen and buggers, buggers. Along with their Bloomsbury cronies they dispensed with the strict decorum of Victorian interchange, rebellion relished as rebellion and also, perhaps, a sly acknowledgment of the group's fluid sexualities. (Despite her risqué talk, the exception to that fluidity seems to have been Vanessa who, throughout her life, remained firmly in the heterosexual camp.) Less

impressed with his sisters' bravado than the sisters themselves: younger brother Adrian. In his 1907 diary, Adrian snipes that Vanessa—by then a married woman—"is always trying to sail as near to the wind as she could . . . always trying to bring out some bawdy remark and is as pleased when she has done it as a spoilt child." Four years later, in a letter to Duncan Grant, Adrian sums up Virginia's "method of wooing" Leonard as talking "about nothing but fucking . . . which she calls with a great leer copulation." That said, Adrian supposes "she will be successful, I hope so anyway."

Writing to Lytton Strachey on her European honeymoon, Virginia reverts to amused irony mode: "Several times the proper business of bed has been interrupted by mosquitoes." A few days later, she pens the often quoted letter to Ka Cox, wondering why "people make such a fuss about marriage and copulation," finding "the climax immensely exaggerated."

"Of the two" newlyweds, Leonard "is the one who finds sex repulsive," Forrester asserts. When a young Stephen Spender asked Leonard "how important he thought sex was in marriage," Leonard cheekily responded: "It depends how much importance you attach to cocks and cunts" (Glendinning). Reportedly, neither cock nor cunt figured in Leonard's later relationship with Trekkie Parsons, the woman he loved after Virginia's death and to whom he left his estate. With Trekkie, Leonard expressed his amorosity through "smaller physical intimacies such as kissing Trekkie's toe" (Glendinning).

About Virginia's enduring friendship and brief love affair with Vita Sackville-West, biographers have the testimony of Vita herself. She and Virginia, Vita writes in a 1926 letter to non-interfering husband Harold Nicolson, had "gone to bed . . . (twice)." The difficulty: Vita's alarm at where Virginia's passions might take her. "I am scared to death of arousing physical feelings in her, because of the madness," Vita admits. "That is a fire with which I have no wish to play."

Arousal and frigidity, fire and ice.

The debate continues.

❁

And what of the non-ill, day in/day out Virginia? She chain-smoked, a habit she took up after Leslie's death. She had bad teeth and endured serial tooth extractions. She hated to clothes shop, her style of dress less fashion forward than odd. She attended an art lecture by Roger Fry wearing what appeared to be an "upturned wastepaper basket on her head" in *Vogue* editor Madge Garland's memory (Noble). She liked to tease and taunt, her tactics, on occasion, "aggressively jocular" (Glendinning). Elizabeth Bowen splits the difference, admitting her friend and sister novelist could be "fleetingly malicious, rather than outright cruel" (Noble). Damning with faint praise, Alix Strachey recollects that "unlike other members of the Bloomsbury Group she was malicious not behind one's back but to one's face" (Noble). Suggesting otherwise are the gossipy letters and diary entries in which Virginia merrily maligns friend and foe. Three examples (from a wealth to choose from) feature T.S. Eliot, Katherine Mansfield, and David (Bunny) Garnett, one-time lover of Duncan Grant and eventual husband of Duncan's daughter and Virginia's niece, Angelica:

> "Mr. Eliot is an American of the highest culture, so that his writing is almost unintelligible" (May 1919 letter to Violet Dickinson).

> Katherine Mansfield "stinks like a . . . cat that had taken to street walking" (*Diary*, 11 October 1917).

> "Poor old Bunny! He is as if caked with earth, stiff as a clod; you can almost see the docks & nettles sprouting from his mind . . ." (*Diary*, 8 September 1918).

Marginally more kind is Virginia's treatment of friend and soon-to-be lover Vita Sackville-West. Although Virginia gives Vita props for

"maturity" and "full breastedness," an ability to "take the floor in any company" and "control silver, servants, chow dogs," in certain essentials Vita is found lacking. "In brain & insight," Virginia writes, "she is not as highly organised as I am" (*Diary*, 22 December 1925).

Like a pet snake, Virginia would strike eventually—but when and at whom?

Within her social circle, Virginia liked to show off and "could seldom resist exhibiting her cleverness" (*Deceived with Kindness*). Then again, being clever, showing oneself clever in conversation, was a Bloomsbury imperative, a pride of the tribe. In the literary arena, she was every inch the competitor. *Orlando*, which might well be the "longest and most charming love letter in literature," as Nicolson describes it in *Portrait of a Marriage*, was also written to one-up Lytton Strachey, according to Alexandra Harris in *Virginia Woolf*: "For twenty years they had been showing off, outwitting each other . . . a 500-year biography might challenge even such a controversial form of life-writing as Strachey had practiced in *Eminent Victorians*."

Modernist Virginia's own judgment about the work of her modernist contemporaries hits wide of the mark. D.H. Lawrence is "airless, confined" (*Diary*, 2 October 1932); Joyce's *Ulysses* is "diffuse," "brackish," "pretentious," and "underbred" (*Diary*, 6 September 1922). Rebecca West's opinion of Virginia's Joyce assessment: "She wrote about James Joyce in an astonishing, almost stupid way" (Noble). About Katherine Mansfield's work—which the Hogarth Press published—Virginia seesawed between jealous admiration and rivalrous pleasure if she thought a Mansfield story did not come up to scratch. In a March 1922 letter to Janet Case, Virginia dismisses Mansfield's story "Bliss" as "shallow & so sentimental." (Mansfield got her own digs in earlier. As reported by Lee, in a letter to husband John Middleton Murry, she critiqued Virginia's 1919 *Night and Day* as "a lie in the soul . . . so long and tahsome"). Writing to Vanessa in June 1926, the same year Hogarth Press published Gertrude Stein's *Composition as Explanation*, Vir-

ginia describes attending an Edith Sitwell-hosted party honoring Stein, "throned on a broken settee," as an occasion at which "a good deal of misery was endured." She goes on to mock Stein's claims on her own behalf (e.g., "the most popular of living writers") and winds up her word portrait: "Leonard, being a Jew himself, got on very well with her."

Virginia's anti-Semitism was ingrained, reflexive, unrepentant, utterly undisguised, and often aimed at her husband. In a July 1923 letter to painter Jacques Raverat, Virginia first praises Leonard's organizational "mastery" regarding travel arrangements, then swivels to: "Poor devil, I make him pay for his unfortunate mistake in being born a Jew by discharging the whole business of life." Even the staunchest of Virginia-defending biographers acknowledge the extremity of the prejudice. Announcing her engagement to friends, "she emphasized the Jewishness of her fiancé with excessive crudity," Poole condemns. Dangerous as it is to conflate character and author, Forrester believes we "hear" in the "voice" of Sara Pargiter (*The Years*) Virginia's "outbursts" and refers to a scene in the novel "that has no other reason to be there" other than to reveal an "instinctive, visceral disgust for a Jew about whom we know nothing, except that he is Jewish."

Virginia was a "formidable bowler," according to Bell, as well as an extremely competitive player during friends-and-family matchups at Monk's House. Leonard had played bowls at Cambridge; she had played since girlhood. (Virginia's game-face concentration survives in a photo taken at Monk's House. In wide-brimmed hat and splashily-flowered outer garment, she grips her own ball while tensely/intensely watching young Quentin take his turn.) To break out the bowls balls, the Woolfs didn't need the excuse of company. Most often they played each other, late afternoon, weather permitting, on a lawn with "dips and hollows," those elevation variations more likely known by someone "who had . . . run a mower over it," surmise Spater and Parsons in *A Marriage of True Minds*. Although Virginia, they write, "hated to lose to

Leonard . . . lose she did." To add salt to the wound, Leonard recorded the results of every game to derive an annual tally. According to his meticulous records, between 1935 and 1940, Virginia won 328 games, he won 1,052 games and four games went down as a draw.

Serious business, bowls.

The flip side of Virginia's competitive spirit was a rampant, pestering neediness, the existence of which she fully acknowledged. She signs off a June 1903 letter to Violet Dickinson: "Write to me, and tell me that you love me dearest. I wish no more. My food is affection!" In the opinion of Phyllis Rose, the "keynote" of the Virginia/Violet correspondence is Virginia's "pathetic need for affection." For many years, according to Angelica Garnett, Vanessa wrote daily to Virginia. As a result: "Virginia learnt to rely on a constant sense of sympathy" *(Deceived with Kindness)*. It is also via Angelica's memoir that we're treated to the indelible image of Virginia "crouching" alongside Angelica and Vanessa, "demanding . . . a kiss in the nape of the neck or on the eyelid, or a whole flutter of kisses from the inner wrist to the elbow." It was a performance Angelica viewed as "ingratiating, even abject, like some small animal trying to take what it knows is forbidden"; it was also a manipulative maneuver that visibly annoyed her mother. "After a long hesitation," Angelica writes, Vanessa would finally bestow upon Virginia "one kiss . . . to buy her off."

In her jealous attachments, Virginia could be vindictive. Very soon after Vanessa married Clive Bell and became a doting mother, feeling she'd been replaced in her sister's affections, Virginia embarked on what is usually interpreted as a payback flirtation with Clive Bell that deeply wounded Vanessa. Although Virginia famously "joked" to Vanessa in a June 1926 letter that the "fame by rights" belonged to her because Vanessa had "the children," motherhood for Virginia remained an extremely fraught and complicated issue. After admitting in her diary that having no child of her own "rakes me wretched in the early hours," she immediately remonstrates, blaming such regrets for "spoiling what I

have" and resolving "to exploit my own possessions to the full" (*Diary*, 5 September 1926). When the writing was going well, as with *The Waves,* she judged that achievement the greater prize: "Children are nothing to this" (*Diary*, 18 March 1930). Yet children still formed the comparison—the children she did not have.

Very often in letters, Virginia addressed Vanessa simply as "Beloved." In an August 1937 letter, she declares: "Lord knows I can't say what it means to me to come into the room and find you sitting there." In a letter two months later, she expresses her "complete adoration" of Vanessa. However sincere and long standing those feelings, their communication in late 1937 must partly have been offered to support Vanessa in her grief and loss, to remind Vanessa that she still had family who loved and valued her. Julian Bell had been killed in Spain in July. In the wake of her eldest child's death, Vanessa suffered "a complete physical breakdown" (Spalding). In this one instance, in a reversal of their usual dynamic, it was Vanessa who needed Virginia. "I am with Nessa as much as possible," she wrote on July 22, 1937 to Ethel Smyth. "We shall try to get her down to Charleston on Sunday if we can."

Not the best of car drivers (even after taking lessons), Virginia plowed into a hedge in one of her first outings behind the wheel; thereafter, Leonard did the steering. Her relations with the hired help were—to understate—notoriously difficult, the history of those employer/employee clashes detailed in Allison Light's *Mrs. Woolf and the Servants.* In Rodmell, she seemed to have forged a more congenial relationship with Louie Mayer, largely because Mayer did not live with the Woolfs but came and went daily. Despite Virginia's non-cook reputation, Mayer insists her employer "could make beautiful bread" (Noble). Virginia also liked to bottle fruit: "jade-green gooseberries" in Angelica Garnett's recollection (Noble).

Virginia's color of choice was green—not the pale "unripe apple" green Vanessa preferred (Dunn), but the deeper, bluer green that domi-

nates the décor at Monk's House. Green walls, green bookshelves. Even her bedroom space heater was a species of green. The writing table she inherited from half-sister Stella was "stained green and brown" (Rose). In France, Vita recalls the two of them purchasing "green corduroy coats"(Noble). To engage Louie Mayer as cook and housekeeper, Virginia sent Mayer a job offer on "bright green paper" (Noble). In January 1933, when the Woolfs upgraded cars, they bought a Lanchester "with a green enameled body and a silver convertible top." When Ottoline Morrell died in 1938, Virginia chose from Ottoline's effects only a "big green ring" as memento (Marder, *The Measure of Life: Virginia Woolf's Last Years*). On his home turf, mountaineer Sir Leslie was a great walker. "He would sometimes go for what he called 'a potter,' covering 30 miles or so," Quentin Bell tells us. An equally enthusiastic tramper, his daughter relished tramping the green, green Sussex Downs and regularly hoofed it the four (or six or seven, depending on the source) miles from Monk's House in Rodmell to Vanessa's Charleston farmhouse outside the village of Firle.

Also like father Leslie (who "could write an 8,000-word article at one sitting," Spalding reports), Virginia was a workhorse. She married a workhorse. In *The Journey Not the Arrival Matters,* record-keeping Leonard ballparks: "I should say that in an ordinary normal day of twenty-four hours we each of us slept for eight and worked ten or twelve hours." Other biographers (Alexandra Harris, Phyllis Rose, Mary Ann Caws) have further broken down Virginia's typical routine: three hours devoted to her own writing, lunch, revisions, a walk, the vetting of Hogarth Press manuscripts, solitary tea or tea with visitors, diary entries and letter writing, an evening of socializing or, if not, an evening of reading history and literature. And whatever the day-and-evening schedule: in bed, lights out, by eleven. During her workday, she also occasionally set type for the press. (Leonard's hand tremor made setting type a hardship.) One advantage to having their business housed in their house:

Virginia could set type in her nightclothes. From Ralph Partridge, as reported by Bell:

> Sometimes in the summer when I was working in the printing room, she'd wander in and set up type or distribute it with her quick, sensitive fingers, looking like a disheveled angel—her bare feet shuffling about in bedroom slippers, in a nightdress with a great tear down the side, and a dressing-gown vaguely thrown over it, but her mind far, far away from her mechanical task.

Both Virginia and Leonard were what university extension brochures now refer to as "lifelong learners." As an adult, Virginia took lessons in French and Italian. She and Leonard together attempted to master Russian with minimal success.

Was she a snob? She was, and called herself one in a 1936 essay she wrote on the topic ("Am I a Snob?") that she read to members of the Memoir Club, an audience of likeminded snobs. In his excoriating 1984 *London Review of Books* review of Woolf's diaries, John Bayley accused her of worse: a snob who operated with a "fatal lack of independence." (In Bayley's opinion the diaries also highlighted Virginia's "childishly unattractive" self.)

What Virginia was *not*, according to Clive Bell, Elizabeth Bowen, and others: a gloomy Gus. Protesting that "silly caricature" of Virginia, Clive Bell declared: "Let me say once and for all that she was about the gayest human being I have known" (Noble). In a sentiment first expressed on BBC TV and requoted in Bell's biography, Bowen admits to feeling "a curious shock when I see people regarding her entirely as a . . . tragic sort of person claimed by the darkness." The Virginia she knew often "hooted" with laughter and had done so while "mending a torn curtain" during Bowen's last visit to Monk's House. Angelica Garnett also recalls her aunt's "hoots of laughter." During their playtime together, after turning out a paper doll "the very image of Ottoline

Morrell," Virginia's hooting laughter commenced (*Deceived with Kindness*). However, Phyllis Rose reports: on those occasions when Virginia laughed so hard "tears came to her eyes, Leonard would begin to look concerned."

<p style="text-align:center">❁</p>

Against Sir Leslie and his domineering ways, Vanessa held her own. After his death, it was Vanessa's steely will that got the Stephen four out of the doom and gloom of Hyde Park Gate and into the breathable air of lighter, brighter (in every sense) Gordon Square, there supplementing the family core with a salon that included Maynard Keyes, Roger Fry, Lytton Strachey, Duncan Grant, and Clive Bell, careful to restrict the female component of those meet-ups to just two: herself and Virginia. In sharp contrast to the sibling whose "imagination was furnished with an accelerator and no brakes" (Bell), Vanessa is remembered as coming across "very calm and composed" (Angus Davidson, Noble). There was "an ease and largeness of gesture in Vanessa wholly lacking in her sister," Phyllis Rose reports. "People admired Virginia; they adored Vanessa."

In both reminiscences and the bulk of biographies, Francophile, postimpressionist painter, Omega Workshop designer, Charleston farmhouse and gardens doyenne Vanessa presides over her menagerie of trying servants, naked children, dogs and rabbits, current, past and future lovers in serene, earth mother fashion—a sensual, sexual woman who somehow managed to shake off the damage inflicted by her grabby half-brothers and come out the other side with an enjoyment of sex intact. George Duckworth's "embraces . . . apparently had no lasting effect" on Vanessa, Spalding reports. Following marriage to Clive Bell (considered "third-rate" by family friend Henry James) and a lengthy affair with Roger Fry, Vanessa fell deeply, passionately, and permanently in love with homosexual Duncan Grant, the strains in their

relationship unrelated to any lack of sexual interest or availability on Vanessa's part.

Scattered among the free-and-easy characterizations of Vanessa are comments about her "relentless need to control those around her" (Simon Watney, *Bloomsbury in Sussex*) and her "unconsciously possessive and restricting" attitude toward her children (Spalding). In *Deceived with Kindness,* alongside a host of other complaints, Angelica Garnett holds her mother responsible for her spotty education. "Convinced" that Angelica would become an artist, Vanessa decided her daughter "needed no more education than she had had herself." Angelica's best-known grudge is also her bitterest complaint: Vanessa's late reveal that Angelica's biological father was Duncan Grant, not Clive Bell. Beyond the personal hurt inflicted by that lie of collusion, in her memoir Angelica goes after its hypocrisy: "Given the freedom that Bloomsbury supposed it had won for itself, it is . . . the conventionality of the deception that is surprising."

Over the long haul, rejection compromised whatever satisfactions Vanessa derived from sharing a house with the man she loved, the father of her daughter, an artist whose work she revered above her own. "Eccentrically vague" Duncan Grant, previous lover of brother Adrian, had never made a secret of preferring men in his bed and in the midst of an affair with Bunny Garnett only occasionally "consented to sleep with Vanessa"—and only in Bunny's absence (Malcolm). After Angelica's birth, Grant refrained from sleeping with Vanessa altogether, thereby leaving Vanessa, age thirty-nine, with "no sexual ties with anyone" (Forrester). Both sisters, Simon Watney reminds, "spent their adult lives in sexless central relationships . . . both slept for most of their adult lives on chastely single beds."

Yes, but with a very conspicuous difference.

From her single bed, Virginia was spared overhearing Leonard's sexual romps; Vanessa, in loving and living with Duncan Grant, was not.

Vanessa was more cosmopolitan than her sister. Rendezvousing with Leonard and Virginia in Berlin in 1929, she is "struck" by the Woolfs' provincialism and "awkwardness" in situ, how "they walked miles to avoid the difficulty of taking a cab" and ate in the hotel restaurant to avoid mingling with strangers (Spalding). Although Virginia's cattiness gets far more ink, Vanessa, so inspired, is every bit her sister's equal in the withering thumbnail sketch. In 1935, following a chance encounter with Vita on the streets of Rome, Vanessa sent a letter to Roger Fry's partner, Helen Anrep, that described Vita "looking red as beetroot—with a thick moustache—rather fine in a manly way, with a small rather mousy looking creature in tow, her sister-in-law with whom she is desperately in love." Vanessa also liked her downtime; her sister's company could be draining. Recovering from the Woolfs' 1925 Christmas stay at Charleston, Vanessa complained in a December 27 letter to Duncan: "Virginia held forth in her usual style . . . It was brilliant of course . . . but one simply gets exhausted and longs for some quiet talk that will lead nowhere for a change."

The favored brother Thoby, dead at age twenty-six from typhoid contracted on a Grecian holiday, elegized and idealized in both *The Waves* and *Jacob's Room*, was, during his lifetime, closer to elder-by-a-year sister Vanessa than to Virginia (Lee). Neither sister was particularly close to the remaining Stephen brother. Niece Angelica calls Adrian an "unwanted child" who was nevertheless "spoiled" and "over-protected." If "unwanted" actually meant a late-life surprise baby for Julia Stephen, the surprise, once arrived, became "everything" to his mother (Forrester). The downside of that everything: a child who "found himself isolated, facing nothing, upon her death," in Forrester's opinion. Bell describes Adrian as "a thin, bony, almost stunted little boy known in the family as The Dwarf" until "he began to sprout," leveling off at six feet five inches. "At Cambridge," Bell adds, "he appeared no more than the evening shadow of his brother, less brilliant, less charming." When Vanessa married Clive, Virginia and Adrian (grudgingly) set up

house together in Fitzroy Square. "Their relationship would always be an uneasy one . . . they irritated and disappointed each other," writes Alexandra Harris. At meals, in exasperation, they sometimes resorted to throwing pats of butter across the table, aiming for each other's head (Bell). In the early going Adrian slept with men as well as women. He reportedly contracted tertiary syphilis from a prostitute, "either before or just after leaving Cambridge" (Jean MacGibbon, *There's the Lighthouse: A Biography of Adrian Stephen*). Often depressed, in 1914 he married depressive Karin (sometimes spelled with an "e") Costelloe, Bertrand Russell's niece by marriage. Following the First World War, both became psychoanalysts. Virginia "took a dim view of her brother's (late) conversion to psychoanalysis" (Forrester). In a May 1927 letter to Vanessa, Virginia paints the scene: "in full daylight . . . a woman in the last agony of despair, lying on a sofa, burying her face in a pillow, while Adrian broods over her like a vulture, analyzing her soul!" "Possibly" Adrian "made a suicide attempt when out sailing" but lived to die in his sleep in 1948 (Glendinning). When Vanessa wrote to him of Virginia's death in 1941, Adrian responded:

> The whole thing is very unreal to me . . . It is like a distant dream. For a good many years I had not heard . . . much of her and of course had never been nearly as close to her as you have always been . . . Since about 1914 in fact I have seen her rather seldom and have never been quite sure that she wanted to see me when we did meet.

His sisters kept letters; Adrian did not keep theirs. "How little we know ever about brothers and sisters," one of those sisters observed in "A Sketch of the Past."

✵

The Charleston farmhouse outside of Firle where Vanessa lived until her death in 1961, age eighty-one, where Duncan lived until his death in 1978, and where Angelica, mother of four, returned to live briefly after divorcing Bunny, was not owned by the Bells; Vanessa leased it from a local farmer who, in turn, leased it from the owner, Lord Gage (*Deceived with Kindness*). It is currently operated by the Charleston Trust, and visitors can gaze upon pond, refreshed gardens, and garden paths where once upon a time Maynard Keynes, sparked by a "love of weeding," penknife at the ready, inched "his way along a path . . . removing even the tiniest seedling" (Spalding). In groups of fewer than ten, those same visitors can shuffle through rooms that no longer smell of paint or food or cigarettes or wet dogs to gaze among Bell- and Grant-painted surfaces in the dining room, library, Clive Bell's study, Duncan Grant's studio, the bedrooms of Vanessa, Grant, Clive Bell, and Maynard Keynes, the "green bathroom," and the Garden Room, where Angelica learned of her true parentage, where Leonard told Vanessa that her sister's body had been recovered from the River Ouse (Spalding). In a 1999 travel piece published in *The Guardian*, Stephen Cook advised visitors unable to "face the sustained eccentricities" of the hour-long house tour to take refuge in the onsite café or bookshop.

The Woolfs alerted Vanessa to the farmhouse's existence when Vanessa began casting about for a means of legitimizing Duncan's and Bunny's conscientious objector status during the First World War. Working as laborers on local Sussex farms achieved that objective. In a May 1916 letter to Vanessa, Virginia shilled for Charleston, its "charming garden with a pond and fruit trees . . . now rather run wild, but you could make it lovely. The house is very nice with large rooms, and one room with big windows for a studio." Although "unimpressed by the house at first sight," Vanessa eventually came round (Dunn). Initially, Virginia hadn't been all that keen on her new Sussex homestead either,

but Monk's House grew on her "after the fashion of a mongrel who wins your heart" (*Diary*, 28 September 1919).

<center>۞</center>

To tramp Virginia's route in reverse, Charleston to Monk's House, is to encounter baleful sheep, stinging nettles, marvelous views of the chalk-and-green downland and, intermittently, to feel a whiff of sea breeze coming off the English Channel. Even in spitting rain, it's difficult to argue with Leonard's take on the landscape: "There are few more beautiful places in England than the valley of the Sussex Ouse between Lewes and Newhaven, the great sweep of water-meadows surrounded by the gentle, rounded downs" (*The Journey Not the Arrival Matters*).

Is it Monk's House or Monks House? "Monks House" is the spelling on the original deed (Watney). In "letters and diaries" Leonard and Virginia sometimes added the apostrophe, sometimes not (Caroline Zoob, *Virginia Woolf's Garden: The Story of the Garden at Monk's House*). Biographers mix and match, the majority adopting the possessive, but the wooden gate to the house remains apostrophe-free. The Woolfs would have preferred to continue to use Asheham House, outside Beddingham, as their Sussex retreat but couldn't after the landlord gave them six months' notice to vacate (Harris). In 1919, they bought Round House in Lewes, instantly regretted the decision, and switched out that purchase for Monk's House after Virginia bicycled over "in a cold wind to Rodmell" to inspect the interior of the "primitive cottage" (Lee). The Woolfs paid the Verrall family seven hundred pounds for the house, title and property (just shy of an acre) and, at auction, successfully bid on "30 or so lots" of Verrall possessions: curtains, blankets, table linen, a table and chairs, three paintings on wood, glassware, crockery, and cutlery, including "twelve bone-handled knives and six forks" (Spater and Parsons). When the Woolfs took possession of the "brick and flint dwelling" with its "low small rooms," there "was of course nei-

ther bath nor hot water nor w.c." (Bell). Instead, there was an "earth closet in the garden" and, indoors, "a chair with a cutaway cane seat over a bucket, up in the loft" (Glendinning). The occupants "bathed in a tin hip-bath on the kitchen floor" (Bell). The sitting room's "red brick floor . . . oozed moisture" (Spater and Parsons). When it rained, a "stream flowed down eight steps into the kitchen" (Glendinning). Book sales funded upgrades: an oil stove in 1925, lavatories in 1927, a 1930 two-story house addition that provided Virginia with a ground-floor bedroom and upstairs sitting room, a refrigerator and electric lights in 1931 (Watney). In 1932, the Woolfs had their first telephone installed, that number either LEWES 385 (Watney) or LEWES 382 (Glendinning). The summer-months' writing lodge, built in 1934 at the back of the property, where Virginia worked on *The Years*, the Roger Fry biography, her final novel *Between the Acts*, and perhaps composed at least one of her three farewell notes, afforded a view of Mount Caburn.

Nearly seven years after moving into Monk's House, Virginia was still soliciting interior decorating tips from her sister. In a June 1926 letter: "I shall want a great deal of advice, not to say help, from you— The drawing room, for example . . ." As at Charleston, at Monk's House Vanessa's art and designs are everywhere on display: walls, tables, chairs, carpets, screens, cushions, dishes. Nevertheless, Virginia stuck to her guns regarding her favorite palette, painting the banisters "blue-green" and the kitchen "vivid green" (Zoob). Vita "never ceased to despair about the lack of visual taste in either of the Woolves," her son Nigel Nicolson reports, his mother's censure extending to Leonard's garden configurations as well. "She once commented that Leonard was attempting to reproduce Versailles in a quarter acre of Sussex" ("Vita and Virginia and Vanessa," *A Cézanne in the Hedge*).

Altogether, the Woolfs "lived rather sluttily" (Olivia Laing, *To the River*). As at Charleston, the Monk's House tourist is hard pressed to recapture a sense of its previous mess and muddle in its current cleaned up, orderly state, no stacks of books or papers strewn about, no chairs

losing their stuffing, no pet bowls of half-eaten grub littering the floor or stairs. As Hermione Lee cautioned more than twenty years ago, Virginia's "Monk's House, 'her' Rodmell, exist and do not exist." Time will do its business: to homes, to Sussex villages. (The modest side-street house in Rodmell where I overnighted sold a month later for more than a million pounds.) During her Rodmell tenancy, Virginia groused about the "gentrification of rural England" (Lee), incensed in 1931 by a local politician's new hillside house and its village overlook, predicting "the whole district" would soon become a "suburban eyesore" (Marder). Regarding Monk's House transformations, however, time and gentrification got an assist from Trekkie Parsons, Leonard's post-Virginia girlfriend and ongoing wife of Ian Parsons, he of the *Marriage of True Minds* co-authorship. The writing lodge that survives isn't the writing lodge of Virginia's era. The current structure is twice the size of the original; Leonard enlarged it for Trekkie to use as an art studio (Zoob). In compliance with Trekkie's wishes, the exterior of Monk's House was, for a stretch, "color-washed in pink" (Glendinning). Trekkie, who slept in Virginia's bedroom, also had it "painted . . . a pale pink" (Zoob). (During my visit—and thankfully so—the only Trekkie tint still in evidence was a potted pink geranium by Virginia's bed.)

Although Virginia, and later Leonard and Virginia in tandem, paid homage at various literary sites (Haworth parsonage, Stratford-upon-Avon, Shelley's Lerici), Leonard did not want Monk's House to become what it has. In the 1960s, "an American" contacted Leonard, pitching the idea of purchasing Monk's House and managing it "as a literary shrine." In response, Leonard "robustly" replied "that there was 'no question'" of that happening because he intended to "leave it to someone else" (Light). The someone was Trekkie, who, upon Leonard's death in 1969, inherited Monk's House and grounds, two other Leonard-owned cottages, his London apartment, "all returns from Virginia's original . . . fortune, the Hogarth Press, Virginia's work,

Leonard's publications, and his compensation for directing the press" (Forrester). A contingent of Leonard's relatives contested the will; after two years of fractious litigation, Trekkie agreed to an out-of-court settlement. In 1972, Trekkie either donated or sold (accounts differ) Monk's House to the University of Sussex, which planned to operate it as something of an exclusive writers' retreat. Saul Bellow reportedly came and swiftly departed after becoming acquainted with the house's discomforts: "freezing" in temperature (Light), "spooky" in atmospherics (Glendinning). In 1980, the National Trust took charge, opening the doors of Monk's House, against the wishes of Virginia's widower, to any and all comers—the worshipful, the mildly curious and the holiday bored.

<div align="center">⚙</div>

"If I were asked to name the chief benefit of the house, I should say: the house shelters daydreaming, the house protects the dreamer, the house allows one to dream in peace," submits Gaston Bachelard in *The Poetics of Space*. In the restricted final months of her life, German bombers overhead, Nazi victory a very real threat and credible fear, Rodmell and Monk's House ceased to offer Virginia comfort or sanctuary. "The solitude is great. Rodmell life is very small beer. The house is damp. The house is untidy. But there is no alternative" (*Diary*, 26 January 1941).

Almost two months to the day after writing that fatalistic diary entry, Virginia succeeded in what she'd at least twice attempted (or once, depending on the reporter). While none contest the unambiguous Veronal overdose of 1913, fewer biographers accept that death was Virginia's ultimate objective when she jumped from an insufficiently high window at Violet Dickinson's house in Welwyn, Hertfordshire, in 1904.

In 1941, Virginia left behind three letters of intent. Two of the three—one to Leonard and one to Vanessa—were possibly or proba-

bly (depending on the source) written on Tuesday, March 18, and kept hidden. On March 28, Virginia left those two letters, tucked in blue envelopes, to be found in the upstairs sitting room of the house. A third and final note, addressed to Leonard and left on her desk in the writing lodge, was written on March 28, the day she died (Lee).

About that Leonard doubling, Phyllis Rose remarks: "A writer to the last, Virginia Woolf made a draft of and then revised her suicide note." In Virginia's first letter to Leonard, Roger Poole notes a "verbal assonance" in the phrase "I don't think two people could have been happier," comparing that wording to Hewet's response to Rachel's death in Virginia's novel *The Voyage Out*: "No two people have ever been so happy as we have been." Moreover, Poole considers Virginia's final letter to Leonard "the most generous fraud, the most magnificent deception, in modern literature." Because Virginia didn't accept the verdict of madness while alive, Poole contends, "it must be the suicide note which was untrue," the terms "madness" and "disease" summoned to "reassure" Leonard in "the terms he habitually used."

They had agreed, should Germany win the war, to die together by asphyxiating themselves in the garage or (as back-up) by overdosing on the morphine psychiatrist Adrian, when asked, had supplied for that purpose. They couldn't have known at the time that their names appeared on the kill list in the Nazis' "Black Book," but they were certainly aware of how the Nazis, given the opportunity, treated Jews and intellectuals. Although Virginia didn't wait for the war's conclusion, in choosing to end her life she went against none of her husband's principles. Asked how he felt about suicide in a televised interview when "he was very old," Leonard said: "I think it's a lamentable thing when it happens, but I think if life isn't worth living one ought to commit suicide" (Glendinning). In drawing that conclusion, Leonard had close-to-home examples other than Virginia's to draw upon: two of his brothers committed suicide. He and Virginia had visited Dora Carrington, wretched with grief over Lytton Strachey's death, mere hours before

Carrington shot herself. Karin Stephen, Adrian's wife, had killed herself in 1953. (As reported by *The Telegraph*, Angelica Garnett believed her eldest daughter, Amaryllis, who drowned in the Thames in 1973, "was a suicide," and that her second daughter, Henrietta, had attempted, but failed, to kill herself "by jumping out a window" at age 25. If true, Angelica's daughters chose methods of harm eerily similar to those chosen by their grandaunt.)

On Friday, March 28, Virginia's unexplained absence wasn't discovered until lunchtime, recounts Louie Mayer. "I had cooked a leg of mutton with mint sauce, which she liked very much" ("A Night's Darkness, A Day's Sail"). Wearing "an old fur coat, Wellington boots, and a hat held on by an elastic band" (Lee), walking stick in hand, Virginia exited the property by a back gate. Alongside the River Ouse, near Southease Bridge, she weighted her coat pocket or pockets with a stone or several stones (accounts differ) and either with or without her walking stick walked or jumped into the high-tide river whose currents that afternoon, Glendinning reports, were running fast. Despite her ability to swim "very well" (Nicolson), she "allowed herself to drown"— Hermione Lee's gentle summation of what must have been at the cellular level a tremendous struggle between instinct and desire, body and mind.

Leonard found the walking stick (which he'd bequeath to Louie Mayer and which would be sold at auction by Louie's widower and eventually end up in the New York Public Library's Berg Collection) either on the riverbank or floating in the water (again, accounts differ). Louie Mayer alerted the Woolfs' gardener, Percy Bartholomew, who in turn alerted the village policeman, Wilfred Collins. Collins "dived repeatedly into the water" in search of Virginia's body; blacksmith Frank Dean and son "brought ropes and tackle" and dragged the river (Glendinning, Laing). Vanessa heard the news from Leonard. Afterwards, Clive, Duncan, and Quentin anticipated Vanessa's "physical collapse, but she seemed less affected than they feared" (Spalding).

Angelica echoes that assessment: "At Charleston I found a fragile but not overwhelmed Vanessa: it must have been an event she had expected for most of her life, and now that it had happened it had lost its power to shatter" *(Deceived with Kindness)*. Some of Vanessa's letters, written decades earlier, do seem to reveal a resigned acceptance of Virginia's situation and fate. In a 1910 letter to Clive: "How utterly incapable the Goat is of taking any care of herself. I dont know whats to be done. Nothing seems to have any permanent effect." In a 1914 letter to Roger Fry: "Of course I think she isn't nearly well yet and it is rather worrying . . . but there seems to be nothing to be done but go on."

The very night of Virginia's disappearance, Leonard wrote to Vita: "I do not want you to see in the paper or hear possibly on the wireless the terrible thing that has happened to Virginia." Without a body, Virginia could not be declared legally dead, but the press knew of her disappearance. On April 3, the *New York Times* published what amounted to an obituary notice under the headline "Virginia Woolf Believed Dead," misspelling Rodmell, Rodwell. Not until April 18 was the body accidentally discovered by teenagers picnicking along the river. The corpse "had not travelled far," Lee writes, having gotten "wedged either under the piers of the bridge at Southease or in one of the holes dug under the fences on the river banks to prevent cattle getting into the river at low tide." Once dislodged from that entanglement, "it floated a little way downstream." If "the young people had not stopped by the river," Glendinning adds, "Virginia's body would indeed have been carried out to sea."

No critic (or biographer) disputes the prevalence of water imagery in Virginia's oeuvre or the many instances of characters being, or wishing to become, submerged. Sexual abuse victims commonly have an "obsession with images of drowning," De Salvo reminds.

From the short story "A Terrible Tragedy in a Duckpond," penned when Virginia was seventeen: "I sank and sank, the water creeping into

ears, mouth and nose, till I felt it close over my head. This, methinks, is drowning."

From the first novel, *The Voyage Out*: "While all her tormentors thought that she was dead, she was not dead, but curled at the bottom of the sea."

From the last novel, *Between the Acts:* "What wish should I drop into the well?...that the waters should cover me."

Glendinning describes Virginia's fiction as "saturated with underwater imagery." Scholar Marie-Paule Vigne counted those images. Vigne's findings: "Water . . . occupies almost one half of the cosmic vocabulary" ("Reflections on a Theme: Virginia Woolf and Water").

References to water, water as metaphor, also show up in Virginia's nonfiction. In "A Sketch of the Past," Virginia evokes the past tidally: "Let me then, like a child advancing with bare feet into a cold river, descend again into that stream."

During the war, an exploded bomb caused the River Ouse to spill across the water meadows behind Monk's House, the transformation "a source of great delight" to Virginia (Bell). "You *must* come here instantly," Virginia implores Vita in a letter dated 15 November 1940. "Not to see me. To see the flood . . . We are so lovely—all sea, up to the gate."

<p style="text-align:center">۞</p>

The River Ouse, a forty-two-mile river that "begins in a little clay ditch . . . at the foot of a hawthorn hedge," becomes tidal at Barcombe Mills, Olivia Laing informs. "There's nothing pastoral about the River Ouse; it runs through an industrial district. It's a setting out of Zola," writes Viviane Forrester. In the estimation of Hermione Lee: "a dangerous, ugly river" (*Virginia Woolf's Nose: Essays on Biography*). "An unlovely river between Rodmell and the bridge at Southease," Victoria Glendinning concurs.

So those of us mocked by Regina Marler in *Bloomsbury Pie* as the "devotees, mostly American" who "each summer . . . dot . . . the water meadows behind Monk's House . . . retracing Virginia Woolf's path across those meadows to the River Ouse," have been duly warned. And yet to stand alongside the Ouse at the Southease Bridge is to feel shocked not so much by its lack of beauty as by how un-treacherous the waterway appears: a narrow flow, no precipitous banks, a benignly flat approach to river's edge, clear and easy access, not even nettles to block the way. And swiftly following those realizations, another: it is a site, a landscape, unconducive to accident in the form of a trip, a fall, a down-hill tumble, land to sea. To stand alongside the River Ouse at Southease Bridge is to be made acutely aware that, before she reached water, Virginia Woolf received no help from the elements in slowing down or speeding up what she had decided to do. Her success depended entirely on her own follow-through. And she followed through.

Despite what Marler's account had led me to expect, no throngs of Americans crowded the Southease Bridge the day of my pilgrimage. I saw no one of any nationality until an Englishwoman with two dogs ran past. Leonard and Virginia owned many dogs over the years: Gurth and Hans and Pinka and Grizzle and Sally. According to nephew Quentin, Virginia "almost always had a dog, she took a dog with her when she went for a walk."

Alongside the flowing River Ouse, reminded of that biographical passage by a come-and-gone jogger with canines, I wondered: *Where was the dog?*

On March 28, 1941, *where was Virginia's dog?*

❀

Hours before her death, Virginia had been thinking about more than suicide, the evidence of other concerns contained in the final lines of her second letter to Leonard, written on the backside of the page: "Will

you destroy all my papers." It was a final request phrased, but not punctuated, as a question. Virginia's husband—but also her editor—did not, of course, honor the request. In Regina Marler's summation: "Days after (Virginia's) suicide, Leonard met with his partner, John Lehmann, in London and, in lieu of a funeral, drew up a publishing program for Virginia's work." For the rest of his twenty-eight years, Leonard oversaw the publication (and republication) of Virginia's works and the selling off of her manuscripts; her diaries went to the New York Public Library for its Berg Collection in 1958 (Glendinning). It was Leonard who published a "severely edited" collection of Virginia's diaries under the title *A Writer's Diary* in 1953; it was Leonard who decided Virginia's essays would be published "in selections without dates or annotations" (Lee). "Every few years through the 1950s and 1960s," adds Alexandra Harris, "Leonard made sure that there was a new book to refresh (Virginia's) image in readers' minds."

In the 1960s, Leon Edel approached Leonard for permission to write a biography of Virginia. Leonard turned him down. He wanted the first biography to be written by a family member, specifically Quentin Bell. (Among Bell's previously published books: *On Human Finery*, a "mock serious" account of "why people wear the clothes they do," according to *Kirkus Reviews*.) Leonard began pressing Quentin to take on a biography of Virginia in 1964. At the prospect, Quentin felt "uneasiness verging on horror. He was no literary critic" (Marler). He was also far less convinced than Leonard of the advantages of a familial biographer.

A complex undertaking, the writing of biography—for family member or stranger. Competing with the frustrations of external roadblocks and false leads, the challenge of assembling and interpreting wads of material, the difficulties of synthesis. Anne Sexton biographer Diane Middlebrook (who also entered the Plath jungles with her biography on Ted Hughes) declared: "With a biography there is no straight line; all is muddled." Even so, there's pressure, an unrelenting push,

to find "continuity in the inconvenient anarchy of an artist's life," according to biographer Thomas Caramagno. Add to those dissuasions and deterrents: the underlying pretense of the form itself. As the reluctant biographer of Roger Fry, Virginia herself observed: "Biographers pretend they know people" (*Diary*, 4 September 1927). In reviewing Lyndall Gordon's *Virginia Woolf: A Writer's Life*, Carolyn Heilbrun declared: "Biographies are fictions we contrive about lives we find meaningful." Inevitably, questions will arise regarding motivation and bias and how both factors affect result. Again, from Caramagno: "We hope to detect a pattern in the evidence of one subject's life, but what pattern we recognize depends in part on our preconceptions of what an artist is." Last but not least: the reputational risk. In Sigmund Freud's opinion, every biographer not only dealt in duplicity but signed up for that vulgarity by taking on the project. Batting away Arnold Zweig's 1936 request to write his biography, the still-alive and kicking Freud thundered: "Whoever undertakes to write a biography binds himself to lying, to concealment, to hypocrisy, to flummery and even to hiding his own lack of understanding."

Quentin Bell knew his aunt Virginia, but could he adequately render her many selves? To his credit, Bell initially passed on the assignment. Leonard, however, leaned hard: Could his nephew "bear the idea of someone else writing it? I must have said No because I found myself writing it," Quentin told the *Arts Guardian* in a June 1972 interview. (Leonard did not live to see/read the final, published text.) The Bell biography—lauded as "exceptional" by Janet Malcolm, as a "scene of carnage" by Rebecca West, as "condescending" by Viviane Forrester, as a book "about Virginia" that "has the smell of Vanessa's house" by Cynthia Ozick, and as "a monument of restraint, truthfulness and good writing" by half-sister Angelica, who apparently perceived no potential conflict in the terms "restraint" and "truthfulness"—represented for its author, for better or worse, the first step in a long career of publishing Bloomsbury–themed books and articles that would establish him,

particularly after Leonard's death, as the go-to authority on all matters Bloomsbury, gatekeeper to the Bloomsbury trove and keeper of the flame. The unasked-for-but-accepted role also carried with it requests to contribute to and critique the Bloomsbury accounts of others. In compliance, Bell often resorted to exceedingly careful or exceedingly tortured turns of phrase. About his half-sister's *Deceived with Kindness*: "To say that this is an honest narrative is not to say that it is accurate" *(Books and Bookmen)*. In what reads as a backhanded compliment at best, in his introduction to *A Marriage of True Minds*, he praises authors Spater and Parsons for telling the story of Leonard and Virginia "in a clear and lucid way without affectation or 'fine writing.'"

Whatever one's opinion of Bell the biographer, it is hard not to feel sympathy for Bell the besieged.

<center>❁</center>

Most of us come to the biographies of writers having first been smitten by their work. The same semester I turned in my Woolf paper, I also took Carolyn Kizer's poetry seminar. Prior to (justifiably) ripping into one of my productions, Ms. Kizer turned upon me a glittery eye. "Darling," said she. "What *have* you been reading?" I had gone the opposite of Virginia's misspelling in announcing her engagement to Leonard. In my poem, the animal wolf had acquired an extra "o." Carolyn Kizer rarely smiled upon anyone in my poetry class, but that day she smiled upon an obvious Woolf enthusiast.

In an early full-length assessment of Virginia's full-length fiction, *Virginia Woolf: Her Art as a Novelist* (1964), Joan Bennett writes: "After *Night and Day* the novels of Virginia Woolf cease to tell stories. The sequence of events no longer leads to a climax and in the final pages no knot is unraveled." Although many of Virginia's contemporaries (including her friend E.M. Forster) considered "And then?" to "be at the

back of all fiction," Virginia did not, Hermione Lee emphasizes in *The Novels of Virginia Woolf.*

"The few students who do like Virginia Woolf (they are usually girls)," pronounced Stephen Spender, "do so partly because they regard her as a feminist, partly because her novels offer them the prospect of enigmas, strange symbolic patterns, by which they can become mystified" (Noble).

Certainly we were students, my college coterie, and arguably still "girls." We were also females who had begun to weary of fictional renditions of experience that did not jibe with how we perceived and interpreted existence and sensorily took in the world. And although reading Virginia's novels my first go-around did nothing to improve my understanding of when and when not to use a semi-colon or apostrophe in the strictest grammatical sense, I and my "girl" group came away from her fiction nodding our heads, deeply appreciative of the narrative layering, the turn, turn, turning of the prose, the willingness of the author to stay with and within a moment and thereby explore that moment's proclivities to the fullest. In my recollection, we were not, as Spender suggests, confused or mystified by reading Virginia; on the contrary, we were exhilarated, vindicated, and radically reassured.

<div align="center">❁</div>

In "A Sketch of the Past," Virginia writes: "Scene making is my natural way of marking the past. Always a scene has arranged itself: representative; enduring." She was speaking, writing, in this instance as an autobiographer, not biographer. In the same paragraph she goes on to explain that she isn't, in this essay, using the term "scene" strictly as a "literary device" that delivers "one concrete picture" through summation. She's referencing visual impressions that linger.

As a reader of Virginia Woolf biographies, these, for me, are the "scenes" that linger:

Twenty-four-year-old, pregnant Julia Duckworth lying prostrate across Herbert Duckworth's grave, insensible to time, weather, physical discomfort or cemetery observers. Silent.

Sir Leslie Stephen at the dinner table, flailing, weeping, groaning at his widower fate, his children's meals interrupted, his need for sympathy insatiable.

Virginia, her favorite brother Thoby dead, taking up her pen to write cheerful updates to the ill Violet Dickinson, who "must at all costs" be kept ignorant of the news. "Thoby is going on splendidly," Virginia invents, three days after his funeral. "He is very cross with his nurses, because they won't give him mutton chops and beer, and he asks why he can't go for a ride with Bell and look for wild geese" (Bell).

Virginia taking tea with Henry James at Rye, wait-and-watch listening to The Master discourse: "My dear Virginia, they tell me—they tell me—they tell me—that you—as indeed being your fathers daughter nay your grandfathers grandchild—the descendant I may say of a century—of a century—of quill pens and ink—ink—ink pots, yes, yes, yes, they tell me—ahm m m—that you, that you, that you *write* in short" (25 August 1907 letter, Virginia to Violet Dickinson).

Virginia, "on form and brilliantly amusing" at Quentin's fifteenth birthday party at Charleston, rising suddenly from her chair, staggering toward the door, Vanessa and Leonard "with the efficiency of long training" springing up to catch her seconds before she collapses, her face the color of "a duck's egg" (Bell).

Vanessa, "in her vague but deliberate way," interrupting Leonard and Virginia's marriage ceremony at the St. Pancras Registry Office to ask how she should "set about" changing the "name of her younger son" (Bell).

August 16, 1940, Virginia and Leonard caught out in their Monk's House garden, falling to ground beneath a tree, assuming the position—face down, hands behind heads—Virginia obeying Leonard's tense, terse reminder not to clench her teeth, blast waves from a German bomb rattling the windows of her writing lodge.

CHARMING (TO SOME) ESTELLE

NAMED BY and in part for her mother, Lida Estelle Oldham Franklin Faulkner was assessed, early in the game, by mother Lida just so: "You're not beautiful, so you must be charming."

Despite that maternal critique, the Falkner boys down the street (author William added the "u" to the family name later) liked much of what they saw. John Falkner approved of Estelle's "dainty" form (five feet, four inches tall; weight fewer than 100 pounds) and compared her, favorably, to a "fairy." Jack Falkner compared Estelle to a partridge—also a compliment. Estelle's "dark red" or "reddish brown" hair drew its fair share of praise, and Falkner cousin Sallie Murry reportedly considered 'Stelle's figure *and* teeth mighty fine.

If Sallie Murry did indeed favorably regard Estelle Oldham's appearance, she was, and would remain, one of the few females to do so. In Oxonian Emily Whitehurst Stone's opinion, Estelle always "looked like skin and bones, a walking skeleton." Meta Carpenter, Faulkner's Hollywood lover, derided her rival as a "pale, wasted creature" who bore the "stamp of a small Mississippi town," her "dress lacking in distinction, hair stringy . . . the splotch of rouge and layering of powder on her face giving her a pasty look." Even Dean Faulkner Wells, who adored her aunt and had no competitive ax to grind, described Estelle as "very thin. Her legs looked barely strong enough to support her . . . her arms too weak to raise a cup of her beloved chicory coffee to her lips."

There is no clear evidence that Lida senior's eldest child dismissed, disbelieved or, heart of hearts, disagreed with the opinion that she lacked beauty capital in its fullest payload sense. As such, and if so, charming for Estelle Oldham Franklin Faulkner would have to do the trick.

<div align="center">⚙</div>

Taxing work, charming.

A goal/aspiration/attainment requiring continuous, unflagging effort. No skating on past accomplishments. No resting on laurels. Charming last week was charming last week. On each and every occasion, the charmer starts from scratch. Simply by appearing on the scene, beauty collects admirers. Charming is a campaign, demanding study, practice, coordination, nuance, precise calibration, minute observation, impeccable timing. Charming is all about receipt, response, reaction, effect. To succeed, charming depends on transaction. The *other* is its focus, its achievement dependent on audience. Charming's coin? Persuasion, flattery. Neither a core tenet nor central to its methods: accuracy. As necessary, charming shaves, inflates or grandiloquently ignores what passes for truth.

Not everyone who travelled early or later in Estelle's circles recognized or approved of those rules of exchange. She "lies all the time," first husband Cornell Franklin complained to his mother, Mamie Hairston Franklin. "If you could only tell when she's telling the truth." Second husband Faulkner, in 1952, warned his editor Saxe Commins: "In ten minutes, she can have you believing that black is white." After her mother's death, Jill Faulkner Summers floated this theory: "Sometimes, I guess, she came on too strong with the charm." Came on strong but failed to convert every mark, including Faulkner's literary-mentor-turned-frenemy Phil Stone, who pronounced Estelle "not worth a damn to anybody."

Insider perspectives and evaluations, those.

What an outsider gleans about the particulars of William Faulkner's childhood sweetheart and wife must be gleaned through the filters of published interviews with the good folk of Oxford, Bill's family and friends, Estelle's children and grandchildren, Bill's literary acquaintances, Bill's paramours, and Estelle the Widow; letters written by Estelle and Bill; memoirs written by kin (John Faulkner's *My Brother Bill*, Dean Faulkner Wells's *Every Day By the Sun*, Malcolm Franklin's *Bitterweeds*); memoirs by and/or about Bill's girlfriends (Meta Carpenter Wilde's *A Loving Gentleman*, Lisa Hickman's *William Faulkner and Joan Williams: The Romance of Two Writers*); documentaries such as *William Faulkner: A Life on Paper*; and a pile of biographies, authorized and unauthorized, first out of the hatch Joseph Blotner's 1974 two-volume version.

What those public sources of information in combination suggest about Estelle Oldham Franklin Faulkner to at least one outsider is this: despite Southern Belledom's near-useless training, the girl-and-woman in question did what she could with the resources at her disposal, maneuvered and performed, despite setbacks, with as much finesse and aplomb as she could muster, accepted her beauty deficit as an operational disadvantage but not, in the final analysis, an insurmountable obstacle to negotiations in Oxford, Mississippi, Honolulu, Shanghai, New York, and Charlottesville as a single miss, as the wife of Cornell Franklin, as a divorcée, as the wife of literary lion William Faulkner, and as William Faulkner's widow.

※

In Faulkner biographies, Estelle Oldham tends to show up early, the devil in the divergent details. Discrepancies abound, starting with her age. In Blotner's biography, Estelle clocks in "a year and a half" ahead of Faulkner, a spread that gets picked up and recorded in several sub-

sequent studies. In *William Faulkner and Southern History,* biographer Joel Williamson corrects his predecessors, reducing the gap to "actually only seven months," Estelle born in February and Faulkner in September of 1897. Why the confusion? Perhaps because Estelle "blossomed early," Williamson conjectures.

In Oxford, Estelle's house, described as "sumptuous" by Louis Daniel Brodsky (*William Faulkner: Life Glimpses*) and "commodious" by Stephen Oates (*William Faulkner: The Man and the Artist*), was a quick scoot from Buchanan Avenue-based Billy Falkner. The financial fortunes of both families waxed and waned over the years, but in 1903 Lida and Lem Oldham's fortunes were on the rise, Maud and Murry Falkner's on the decline. The Oldhams considered themselves superior to the Falkners and made no secret of their rating. Regardless, the Oldham and Falkner kids hung out together. From Sally Murry, as quoted by biographer Williamson: "Billy loved Estelle from the time he was old enough to have a girl"; Estelle was "boy crazy from the age of thirteen."

Also arty.

Estelle sang and played the piano, instructed musically by her mother. Teenagers 'Stelle and Billy read poetry together, collaborated on stories and drawings. Calorie-conscious Estelle's breakfast consisted of dry toast and black coffee. Until Maud Falkner put a stop to the nonsense, her son, in imitation, ate and drank the same. Estelle loved to dance; Billy did not. Sulking, he'd watch from the sidelines, Estelle's dance card filled, first slot to last. In high school Estelle dated Ole Miss college guys (chaperoned by mother Lida), collected fraternity pins and the occasional marriage proposal. At sixteen, she left home to attend not the finishing school of her choice (Stuart Hall in Staunton) but the Daddy-picked Mary Baldwin Seminary, where, according to Estelle's own account, she and her girlfriends had a "grand time" attending weekend frat parties at the University of Virginia. A truncated adventure, Estelle's first Virginia sojourn. After a single year at Mary

Baldwin, either in the fall of 1914 or 1915, she returned to Oxford and entered Ole Miss either as a "special student" or run-of-the-mill under-graduate (again, sources disagree).

In an interview conducted by Louis Daniel Brodsky, first published in *The Southern Review* and later collected in *Life Glimpses,* Victoria (Vicki) Fielden Johnson revealed that grandfather Cornell Franklin wanted to be a professional baseball player. Instead, the Ole Miss law grad became a hard-driving legal eagle, judge, and businessman, pros-pering in Columbus, Mississippi, Honolulu, and Shanghai. Five or seven years (sources disagree) older than Estelle, Cornell remained smit-ten, long distance. After professionally establishing himself in Hawaii, he wrote directly to Lida Oldham ("My dear Mrs. Oldham"), request-ing that she "give" Estelle "to him," a request not considered untoward by the recipient. Cornell's matrimonial project enjoyed enthusiastic backers in both families. His mother, Mamie, and Lida Oldham, long-time chums, agreed that a Cornell/Estelle merger would be just dandy. Mamie promptly provided the engagement jewelry, a "double dia-mond ring," that Estelle with comparable speed pretended to misplace (Blotner). A wedding date was set for April 1918. Invitations, printed by Tiffany & Co., were dispersed. Despite Estelle's decided reluctance and Billy Falkner's profound misery, plans for the Oldham/Franklin nuptials proceeded.

Did Estelle pass the night prior to her wedding in tears? Another area of dispute. Among the yea-sayers: biographers Williamson, Oates, and Blotner. In Blotner's rendering, a "sympathetic great-aunt . . . sat with" the weeping Estelle throughout the night and come morning announced her intention to intervene with Lem Oldham "and make him call this wedding off." In response, Estelle fatalistically declared: "It's too late," adding: "Daddy would be furious."

Roses and lilies from the Oldham's garden spruced up the Episco-palian church. The bridesmaids wore gowns of pink georgette crepe, the bride a dress of white satin brocade trimmed in rose point lace with a

court train. The groom's attire included a dangling saber. The Reverend W.E. Dakin, granddad of Tennessee Williams, conducted the wedding ceremony. Billy's brother John acted as chauffeur, driving Estelle and Cornell from the church to the reception at the Oldhams' house. En route to her new home in Hawaii, Estelle saw ocean for the first time. Her first child, Victoria (nicknamed Cho-Cho), was born ten months later in Honolulu, Cornell's base of operations until he divined greater prospects for success in China. In 1923, Estelle gave birth to her only son, Malcolm, in Shanghai. In whatever country or time zone, Estelle and Cornell liked their entertainments. Both husband and wife drank prodigiously. (Estelle curtailed her eating, not her drinking.) Both also gambled: Cornell at cards, Estelle at "high stakes" mahjong (Blotner). When such diversions ceased to divert, Estelle returned home for extended visits. In either 1926 or 1927, she arrived in Oxford with her two children and without her husband and stayed put. The end of the Franklin/Oldham marriage wasn't made official by divorce until 1929 (in February or April, depending on the source). In June of that same year, the divorced mother of two married again.

Among biographers' explanations/excuses/bewilderments regarding this development: "That Faulkner pined for Estelle is both puzzling and touching. She had treated him very badly, and there had never been much between them, sexually or intellectually" (Jay Parini, *One Matchless Time: A Life of William Faulkner*); "She had no one else to turn to. Her nerves were gone, her mind, too. He was her last hope" (Oates); Faulkner "must have seen that he was stepping into a doomed relationship . . . but couldn't stop himself" (Parini, again).

From daughter Jill Faulkner Summers: "I don't think of them as a happy couple, but they were happier with each other than they would have been with anybody else."

From Estelle's second groom, the much quoted quip: "They don't think we're gonna stick, but it is gonna stick."

Whether or not "it" should have stuck is a contested point.

❄

Compared to her first, Estelle's second wedding was a stripped down, low-key affair. No biographer describes the wedding party's apparel. Because no Episcopalian minister would officiate the wedding of a divorcée, the couple married at College Hill Presbyterian Church, Estelle's sister Dot the sole attendant. After the fact, Estelle wrote her parents a letter, quoted in its entirety in Judith Sensibar's pro-Estelle biography, *Faulkner and Love: The Women Who Shaped His Art*. Addressed to "My Darling Mama and Daddy," it reads in part: "I'm not asking for forgiveness, for I wouldn't do that, but I do pray you to try and realize that I honestly love Bill and believe that after all these years, I have at last found peace and understanding in marrying him."

Peace and understanding.

Such were her hopes.

In Pascagoula on her second honeymoon, during a night of heavy drinking, Estelle, dressed in what Dean Faulkner Wells describes as a "silk dinner gown," walked into the Gulf of Mexico and kept walking. Was or wasn't it a suicide attempt? As evidence that Estelle's self-harming tendencies were nothing new, Blotner quotes the unnamed "daughter of one of (Estelle's) friends." According to that source, while married to Cornell, Estelle showed up in Oxford "with bandages on both wrists." Dean Faulkner Wells's recreation of the Pascagoula event ends with a question:

> William watched from the gallery. "She's going to drown herself," he shouted. One of the dinner guests sprinted across the lawn into the shallow water, grabbed her just before she waded into the channel, and dragged her, struggling against him, onto the sand. Why didn't her husband try to rescue her?

Jill Faulkner Summers pooh-poohed the suicide interpretation and labeled the episode "pure fake," an example of her parents' dramatics.

If her mother had truly wanted to end her life, she'd have gone for a "quicker and cleaner" method, Jill told biographer Sensibar. In the late 1960s, in an interview that coincided with her Charlottesville art show, Estelle was asked why she painted "underwater scenes." Her response: "I am deathly afraid of the water; yet the sea fascinates me. I keep wondering what can be under the sea" (Williamson).

※

Back in Oxford, the newlyweds rented the first floor of Duvall House on University Avenue from Miss Elma Meek. Their accommodations included a drawing room, two bedrooms, dining room, kitchen, and bath. Estelle's piano, among other furnishings, arrived from Honolulu; help was hired to assist Estelle with the housework and childcare. Cornell sent monthly support checks for Malcolm's and Cho-Cho's upkeep not to Estelle but to Lem Oldham, who, depending on the cash flow situation in the Oldham household, did or didn't hand over those funds to the Faulkners (Sensibar). Bill visited his mother daily. Early in the marriage, Estelle occasionally accompanied him. Dean Faulkner Wells reports that whereas Maud "actively disliked" two of her daughters-in-law, she tolerated Estelle. Biographer Parini disagrees: "Miss Maud was downright hostile to Estelle and would remain so throughout her life." The reason for the antagonism, according to biographer Oates: "(Maud) couldn't bear the thought of sharing her brilliant and gifted son with another woman. She liked . . . thirty-one-year-old Billy living and working at home under her care."

While living in Duvall House, Faulkner published *The Sound and the Fury* and wrote *As I Lay Dying*. Did he share his writing with his wife? Sources disagree. "Certainly he could not rely on Estelle for advice about his novels or stories" (Parini). "Now (Faulkner) showed Estelle, not Phil Stone, what he was writing" (Williamson). If Williamson's

account is correct, Phil Stone's ferocious enmity toward Estelle gains a motive; it fed on grievance.

<center>❁</center>

Career going well, in 1930 Faulkner decided to buy the house he'd rename Rowan Oak. He paid in installments, total purchase price: $6,000. With the "old Bailey Place" came four or fourteen (depending on the source) acres of hardwood and cedar, terrain that had been part of Bill and Estelle's childhood playground (Blotner). Built by Robert Shegog in the 1840s, the house was a Greek Revival two-story structure, featuring a central, four-columned portico and constructed on a south-facing, elevated plot of land.

In the *Life on Paper* documentary, newspaperman Phil Mullen, editor of the *Oxford Eagle,* accuses Faulkner of acquiring the property because he "was a plantation man . . . He was trying to live like his great-grandfather did."

In grave disrepair when the Faulkners moved in, Bill's "plantation" lacked plumbing, electricity, central heating, and window screens—an essential in mosquito country. The foundation beams were rotten; the roof leaked. The house, according to *Faulkner's Rowan Oak* (University Press of Mississippi), "had not been painted in memory."

Move-in day, one female on the scene plopped down on the porch steps and wept at the shabbiness of their new domicile. That weeper was Cho-Cho, according to Cho-Cho's daughter (Brodsky). Biographers Williamson and Oates identify the culprit as Estelle. Reports across the board credit Faulkner with taking on many of the home improvement tasks himself, from jacking up the foundation to replacing wallpaper to restoring floorboards and replacing broken windows. Estelle's furniture, including her piano, once again moved house. Plumbing, electricity, and central heating were eventually installed, and over time, when solvent, the Faulkners added brick terraces, bedrooms, a sewing room,

an arbor for scuppernong vines, and other structural upgrades to the house and grounds. Even so, the final result didn't impress every visitor. Called in to counteract a prolonged drinking binge by his prize author, New Yorker Saxe Commins communicated his impression of Rowan Oak in a letter to wife Dorothy: "A rambling Southern mansion, deteriorated like its owner . . . The rooms are bare and what they do contain is rickety, tasteless, ordinary."

Between acquisition and Commins's scornful appraisal of the property in 1952, much drinking and much else had transpired at Rowan Oak.

<p style="text-align:center">✿</p>

For the premiere of the film based on Faulkner's *Intruder in the Dust*, Dean Faulkner Wells remembers Estelle, an accomplished seamstress, whipping up an "iridescent orange taffeta dress with wide sash" for granddaughter Vicki. Estelle also knew how to throw a party. On the occasion of niece Dean's first marital engagement, Estelle improved the standard white linen tablecloths by adding the embellishment of pink rosebud hems. According to Faulkner Wells, when aunt Estelle "chose to be"—telling tag—she "was a consummate hostess . . . master gardener and lady of the house," who set an "elegant table" with silver goblets and finger bowls, a "gourmet cook" whose specialties included quince preserves and "exotic curries and chutney dishes."

Did the creator of that bounty pick at her plate while the rest of her guests chowed down? One imagines so.

Their first winter in residence, Bill and Estelle began a tradition of hosting an elaborate Christmas dinner at Rowan Oak for a slew of Oldhams and Falkners/Faulkners. Overseeing production of that first feast: an exhausted Estelle, who continued to weigh in at fewer than one hundred pounds, six months pregnant.

Estelle's history of difficult deliveries and ongoing anemia concerned John Cully, her Oxford doctor and the man William Faulkner later claimed to have taken a shot at in retribution. Born prematurely, January 10, 1931, the Faulkners' first daughter, Alabama, lived only ten days. Estelle never saw her baby. She was not immediately told of Alabama's death or consulted about funeral arrangements. She did not attend the burial. Consigned to bed at Rowan Oak, she remained under heavy sedation. After Alabama's death, grief briefly reunited the Faulkners as a couple. Attending a University of Virginia-hosted Southern writers event that fall, geographically separated from his equally disconsolate wife, Faulkner wrote: "I don't think that I will need to tell you to give my love to the children, any more than to tell you that you already have about 1,000,000 tons of it yourself. But I do, nevertheless. Oh well, just darling, darling, darling."

That same year in November, still anemic and physically frail, Estelle joined her husband in New York. Neither she nor Bill had emotionally recovered from their loss. Bill was drinking tremendous amounts of alcohol; Estelle, after a shopping excursion, became "hysterical" in her Algonquin Hotel room, tore at her dress, and tried to jump out the window, according to Dorothy Parker. At Bennett Cerf's apartment overlooking Central Park, Estelle told her host: "When I see all the beauty, I feel just like throwing myself out the window." While taking the precaution of leading her elsewhere, Cerf made the mistake of assuring Estelle she didn't "mean" what she'd just said. "What do *you* mean?" she countered. "Of course I do" (Blotner).

❖

In June 1933, despite her own poor health, Estelle gave birth to a strapping baby girl, the instantly adored and cherished Jill. Jill's existence and only that, insisted Meta Carpenter, kept the doting dad from divorcing Estelle.

After Jill's birth (or the 1934 addition of a separate bedroom for Estelle at Rowan Oak—sources disagree), the Faulkners reportedly ceased to have sex. Granddaughter Vicki disputes the idea that the separate bedroom arrangement indicated Estelle's "frigidity," noting "contraceptives were largely unknown then" and that, at age thirty-six, Estelle was already "a tired, sick lady." Biographer Oates's two cents: "Not that he wanted her anymore." Meta Carpenter, in her memoir, assures us William Faulkner definitely and ardently wanted *her*. Prior to their bedding, Carpenter relates: "Womanwise, I sensed the tumult of his blood within him when we stood face to face, and the strain he felt at being close to a desirable young female."

In 1936, during their first stay in California as a family of three, the Faulkners eventually settled at 620 El Cerco, just north of Santa Monica. Jill acquired a white bulldog. After Bill returned from work at the studio, he and Estelle socialized with the Hollywood set. Clark Gable stopped by for drinks; the Ronald Colmans came to dine. To entertain guests, Estelle played the piano. Estelle met director Howard Hawks's secretary, Meta Carpenter, when her husband invited his young lover to supper as the "date" of Ben Wasson, a mutual acquaintance of the Faulkners. Throughout the evening in question Estelle seems to have stuck with the charm tactics. The following morning, however (according to Carpenter), Estelle telephoned Wasson in a fury and informed him she hadn't been fooled "for a second . . . I know that the person you brought to my house is Billy's girl out here and not your girl at all!"

In June 1944, Estelle and Jill again joined Faulkner in Hollywood. Their 1944 home base was a "pink adobe apartment house" off Sunset Boulevard. As a family, they played miniature golf and went to the beach (Blotner). Eleven-year-old Jill took riding lessons at the same riding school Elizabeth Taylor attended. Her father bought her a "mare," Lady Go-Lightly. At summer's end, to accommodate Jill's school schedule, mother and daughter set off by train for Oxford. They were two hours into the journey when Faulkner sent a telegram to be "delivered

en route" to Estelle, asking: "ARE YOU ALL RIGHT." If, when, or what Estelle replied, biographer Blotner does not specify.

As have other literary writers who took up screenwriting, Faulkner declared often and loudly a loathing for the job and Hollywood. (He also disapproved of California's "monotonous" weather.) What Faulkner didn't hate about California, Hollywood, and screenwriting was the paycheck—nor, while the income stream lasted, did his wife.

<div align="center">❁</div>

Faulkner met new gal pal Joan Williams in 1949, when she was twenty and he fifty-two. Getting Williams to bed proved to be a protracted, three-year struggle, according to Lisa Hickman in *William Faulkner and Joan Williams: The Romance of Two Writers*. Via her own testimony, Williams sought writing advice from Faulkner, not a romantic liaison. Dean Faulkner Wells judged the Williams affair—an open secret in Oxford and fodder for gossip humiliating to Estelle—"more destructive than any other" to Estelle and Bill's marriage. Biographer Parini tells of a "Mrs. Smallwood" who took it upon herself to inform Estelle at the beauty parlor that Faulkner and Williams "had been seen in a juke joint in Memphis," after which Estelle took direct action. In a face-to-face standoff with Williams at the Peabody Hotel in Memphis, Estelle demanded to know Williams's long-range agenda. Did she intend to marry Faulkner? Williams's swift negative seems to have brought Estelle's interrogation to an end; the dalliance, however, continued. In 1952, Faulkner gave Williams the handwritten manuscript of *The Sound and the Fury* but soon retrieved and transferred it to Saxe Commins for "safekeeping." Some years later, a married Williams wrote to Faulkner, asking that he return the gift; Faulkner elected not to reply (Hickman). After Faulkner's death in 1962, Williams filed a lawsuit against the University of Virginia to obtain the manuscript. "Finally a lawyer got me $25,000 for it," a bitter Williams told biographer Hickman, "which is

a pittance because it's worth millions now." Williams waited until after Faulkner's death to publish, as fiction, an account of their affair. She did not wait for the death of Faulkner's widow.

In a 1954 letter to Saxe Commins, a "hurt but not despairing" Estelle allows that "in all probability," had she "been an aspiring young writer," she would have "accepted" Faulkner's attentions as "avidly as Joan did" (*The Brodsky Collection, Volume II: Letters*). Open to interpretation, whether this summation represented a true perspective shift or subterfuge, a bid to convince Commins that she, the injured wife, was taking the high road.

Granddaughter Vicki maintains Estelle "never burdened anyone with the knowledge of Pappy's affairs, except in her letters to Saxe and Dorothy Commins . . . they were the only people she confided in. And she never, never told her children." Of Estelle's chosen confidantes, one of the pair, it would seem, didn't quite deserve her trust. According to Joan Williams, Dorothy Commins tattled to her about Estelle's age and appearance insecurities, detailing the contents of Estelle's Rowan Oak bathroom cache, a stockpile of "every known jar of cream . . . that had ever been invented . . . to make you look younger."

<p style="text-align:center">❀</p>

In facsimiles of her letters, Estelle's handwriting is spidery, spiky, jagged. In her letters in general, but specifically to the Comminses, Estelle labors to come off charming. Ever prompt with her thank-you notes ("Please let me thank you again and again for your marvelous hospitality"), she nevertheless invariably apologizes for not having written sooner ("Do forgive an erring mortal!"). She apologizes for not having sent Dorothy a promised pair of gloves sooner ("Forgive me for being so lazy!"). She apologizes for intruding on their time ("Please let me apologize for my 'phone call at such a busy hour for you—Am sure you were at dinner and maybe had guests!"). In her letters she is fond

of dashes, overly fond of exclamation marks (". . . how good it is to be Home once more!" "My stay with you was joyous!" "Such courage usually wins!" "A very Happy New Year to you—and of course it will be!" "Jill is ecstatic over the Books—so am I!").

Forced gaiety.

Desperate gaiety.

A dancing-fast-as-I-can sort of gaiety.

In 1956, an "anonymous caller" offered Estelle information about a "Miss Stein" for five hundred bucks (Oates). In his cups, Faulkner confirmed his affair with then twenty-two-year-old Jean Stein, Joan Williams's replacement. Again Estelle took up her pen, writing to Saxe Commins: "I know, as you must, that Bill feels some sort of compulsion to be attached to some young woman at all times—it's Bill—At long last I am sensible enough to concede him the right to do as he pleases." According to Dean Faulkner Wells, believing "her marriage had reached the breaking point," Estelle offered her second husband a divorce in 1957. He declined the offer.

✺

In *Faulkner and Love: The Women Who Shaped His Art*, Judith Sensibar rhetorically but pertinently asks of William and Estelle Faulkner: "What access does one have to the inner landscapes of two alcoholics, both children of alcoholic fathers and grandfathers? The disease itself is all about opacity and emotional unavailability."

In his biography, Stephen Oates serves up a scene of Bill and Estelle companionably hooking up, end of day, for a pre-dinner cocktail on the east veranda of Rowan Oak, both enjoying the twilight, neither immediately drinking to excess. A rare occurrence in Faulkner lore: that description of tempered imbibing. Together and apart, Bill and Estelle could and did drink to oblivion, falling off furniture, puking, taking to their beds where they fouled themselves with piss and shit and blacked

out entirely. Both went on an extended binge following Jill's 1954 wedding, leaving granddaughter Vicki to try "to keep at least the beds clean of vomit and excrement and everything else." When Estelle "woke up from bouts like that one," Vicki told biographer Brodsky, "she never knew anything that was going on or what had gone on. She would just take another drink and pass out again." Jill believed her mother drank "as an escape." And when she wanted to achieve that escape, Estelle started drinking "at daybreak" (Sensibar). Apologists for Bill tend to blame the creative life/real life quandary. Faulkner's "binges were, in a sense, a way of taking a forced vacation—from the pressures of life, from the urgencies of his imagination" (Parini). Even the pro-Estelle camp takes pains to distinguish between Estelle's brand of alcoholism and the alcoholism of her husband. In Dean Faulkner Wells's summary: "Pappy in his later years could drink socially; Aunt Estelle could not. One drink led to a bender."

Excessive drinking hospitalized both Faulkners, Bill holding the edge in those statistics. Over the years, Estelle was also hospitalized for hemorrhaging and kidney problems. Before having surgery to remove severe cataracts, her vision had become so blurred that she had difficulty reading what she'd written in letters. She remained dangerously thin and anemic. But to the surprise of many and surely herself, sometime during the mid-1950s (sources disagree as to the precise year), Estelle joined Alcoholics Anonymous, stopped drinking altogether, and never again took up the practice, remaining sober beside her still drinking husband and throughout the ten years she survived him. In granddaughter Vicki's blunt assessment of Faulkner's non-contribution to that lifestyle change: "I don't think he felt she ever would have the guts to do it, but she did quit, and without too damn much help from him, either" (Brodsky).

It was also during the 1950s that Estelle began to hit the road without her husband, travelling with Jill to Mexico in 1953 and alone to the Philippines, Switzerland, France, and Italy in 1955. Appealing to Saxe

Commins to provide hotel (not restaurant) recommendations for her time in Rome, she wrote with her customary complement of dashes: "Want some place easy to find my way to and from—Not being a linguist, will doubtless find it difficult to go to all the places I'd like—anyway—intend seeing and doing all I can."

This, too, was the decade in which the Faulkners' residence alternated between Oxford and Charlottesville, professionally because of Bill's gig at UVA, personally because Jill had settled in Charlottesville with her family. In 1959, to remain close to the favored daughter, Bill and Estelle opted to make the move permanent and purchased the house they'd been renting on Rugby Road. Jill was now an accomplished horsewoman; in his leisure hours her father tried to be an accomplished horseman. Estelle read, painted, and abjured alcohol. To observing others, during their final stretch together the Faulkners seemed to coexist more peaceably, giving the impression that some measure of the damage and distance between them had been repaired. That they might have grown too tired or uninterested to keep up the quarrel is a hypothesis nowhere pitched.

After Faulkner's death in 1962, in control of the narrative, Estelle pulled out all the charm stops for reporters and biographers who showed up at her door, pushing the "we were always sweethearts" fairy-tale version of the couple's turbulent history, resuscitating the anecdote of watching little Billy Falkner ride his pony down South Street and declaring on the spot, age seven, that she meant to marry the boy. Marry the boy she did, and married the William Faulkners stayed through the good, the bad, and the in-betweens.

※

From the exterior view, the second-story balcony of Rowan Oak appears narrow, a little cramped, but assumes significance in connection to the ghost story Faulkner fashioned to amuse and rattle the kids. In

outline: lovely Southern belle Judith Shegog falls for a Yankee soldier and longs to marry him; her father objects. Denied her true love, the bereft leaps from the balcony, breaks her neck, and lies buried beneath a Rowan Oak magnolia, her ghost a midnight rambler. In Charlottesville, Estelle painted Judith Shegog's ghost; she "believed in ghosts," affirmed granddaughter Vicki. If the New York stories are true, perhaps Estelle also believed that leaping to one's death cured misery.

Inside the house, Estelle's worse-for-wear Chickering piano, the ivory missing from several keys, dominates the first floor parlor. A staircase both drinkers of the house had tumbled down fills the foyer. Prior to Jill's wedding ceremony and before the serious drinking began, Estelle posed on these stairs for a formal, black and white photograph in mother-of-the-bride finery: veiled hat, evening gloves, her shimmery dress cinched tight around her tiny, tiny waist. (A 2006 color photograph catches Jill Faulkner Summers, in chic black sheath, climbing these same stairs, gazing upward, as if readying to encounter a few ghosts of her own.)

On a ledge in the hallway that joins dining room to the kitchen: the Faulkners' black telephone, the numbers of friends and kin scribbled in ink and pencil on the wall above. Because only Estelle answered the phone at Rowan Oak, it was here Faulkner "conspicuously" propped a snapshot of Joan Williams—an act of "intentional cruelty" that appalled Dean Faulkner Wells, who was living with her aunt and uncle at the time.

Estelle's response to that specific provocation?

Not disclosed.

Estelle's upstairs, back bedroom is spacious, multi-windowed, and bright. Although *A Visitor's Guild to the Literary South* describes her lair as more "ornate" than her husband's, this visitor is hard pressed to find a basis for that verdict. There's an easel set up beside the bed, but otherwise the furnishings are on par with those in Bill's quarters. An unremarkable vanity and chest of drawers, a hardback chair softened by

a worn seat cushion, a white chenille bedspread. Other than wallpaper, nothing decorates the walls. Framed and posted outside Estelle's bedroom, the air conditioner's origin story: "Due to her husband's dislike of air-conditioning, the window unit was added the day after Faulkner's funeral." Translation: extravagant appliance, insensitive widow. Or, in the vernacular: *The bitch waited a day, but just.*

Among the titles tucked into Estelle's bedroom bookcase: *Basic Documents in Medieval History*; Kenneth Stampp's *The Peculiar Institution: Slavery in the Ante-Bellum South*; Alphonse Daudet's *Lettres de Mon Moulin*; Bishop Fulton J. Sheen's *Way to Happy Living;* and Stephen Longstreet's *Senator Silverthorn*, marketed as "the giant new novel about a great Jewish politician, the women who loved him, and a choice that can destroy him." Missing from the bookcase and the world at large: Estelle's novel, titled either *White Beeches* or *White Beaches* (depending on the source)—a rather significant tree and sand swap. According to biographer Sensibar, Estelle started the novel in China during her marriage to Cornell and revised it, after they'd separated, in Oxford. In 1927, Faulkner typed up the manuscript and submitted it to either Liveright or Scribner's (again, sources disagree). It was rejected. After that single pass, Estelle destroyed the work, infuriating her recommender, and thereafter, so it would seem, left the novel writing to Bill.

Shoved against the far wall of Estelle's bedroom: white bathroom scales. Why such a placement? Could she not bear the suspense of travelling those extra few feet, bed to bathroom, to check on a pound gained or shed? Had Rowan Oak's current custodians decided to underscore the vanity of Estelle Faulkner, albatross around genius Bill's neck, with a bit of restaging?

Whichever the truth, those scales are a heartbreaking sight.

To charm, a woman need not be beautiful, but in Estelle Faulkner's universe, that woman must ever, ever, ever be thin.

THE HEADMISTRESS, INTERPRETED

O N MARCH 10, 1980, a fifty-six-year-old woman drove five hours north in rainy weather to the upscale hamlet of Purchase, New York, and there four times shot a sixty-nine-year-old man, most famous, prior to his infamous death, for authoring a bestselling diet book that he, a cardiologist, had expanded from a two-page handout compiled for his patients. The cardiologist/author had, and made no pretense not to have, a "wandering eye," often expressing a disdain for fidelity, a belief in the interchangeability of female companions in his bed, a man fond of the quip "women are like streetcars." With equal transparency, the woman, Smith College alumna, *magna cum laude* graduate in economics, divorced mother of two, then-current head of an exclusive boarding school for girls in Virginia, proclaimed (repeatedly) that the sole joy of her existence was the sporadic attentions bestowed upon her by the celebrity physician. On March 10, after reaching his house on Purchase Street, her destination, she entered the premises through the unlocked garage and made her way up an unwieldy spiral staircase to the doctor's bedroom, carrying a re-gift bouquet of daisies, a loaded .32 caliber revolver whose trigger required fourteen pounds of pull pressure, and extra bullets. The latecomer who stood over the single bed, doctor upon it, was experiencing Desoxyn (methamphetamine) withdrawal, was professionally under siege, and had recently been denied a seat next to the doctor at an upcoming tribute event. When she woke the sleeper, interrupting his high-priority slumber, he reacted with neither sympathy nor kindness. Seemingly,

even in close proximity to a strung-out woman holding a gun, Herman Tarnower believed he remained in control of the situation, the personal dynamics of the room, the messy lovers' triangle whose vengeful offshoots had already produced clothing smeared with excrement, slashed rugs, late-night anonymous phone calls, and serial face-to-face confrontations. His presumption proved wrong.

Ever after Jean Harris would claim that she intended to kill herself that night, not Herman Tarnower—suicide her intention, her operational plan. Developments that complicated and disrupted her mission: an unwelcoming reception, a gun that jammed, a rival's green negligee and pink hair curlers prominently displayed in the bathroom the headmistress considered her own. Later asked why, if she intended to kill herself rather than Tarnower, she hadn't put gun to head at her Madeira School residence in McLean after "test firing" her weapon of choice into the trees from her terrace, Jean Harris said she wanted to avoid "future generations of Madeira girls" pointing out the spot "where the crazy headmistress killed herself." Also, she wanted to say goodbye to "Hi." Since at this point in their relationship, Hi (or "Hy" as others spelled the nickname) couldn't be relied on to take her phone calls, she would say goodbye in person, then shoot herself by the pond at the back of Tarnower's property, site of many happy memories. That, Jean Harris insisted, was always her conscious intention, her conscious plan. No, she had not planned for Tarnower to kill her. No, she had not fantasized that, shocked into recovering his romantic attachment, the doctor would beg her to spare herself harm, re-pledge his love and devotion, and solemnly promise her the chair beside him at his tribute. The plan was to say adieu and die, alone, by the pond. If so, it was a plan that went spectacularly awry.

✧

The Harris trial, held in White Plains at the Westchester County Court-house, stretched over three months and ended with a second-degree murder conviction and a prison sentence of fifteen years to life for the defendant, a ruling that held upon appeal. Serving time in the Bedford Hills Correctional Center, inmate #81G98 suffered two, possibly three, heart attacks, worked in the prison's Parenting Center, taught sex education to former prostitutes, and advocated prison reform via service on the Inmate Liaison Committee. She also wrote several books, the proceeds earmarked for a foundation that benefitted the children of inmates. In a publicity shot for her memoir, *Stranger in Two Worlds* (1986), she leans against a prison wall topped with curling barbed wire wearing pearls and a filmy blue tunic, hair held back from her face by the expected hair band. In December 1992, after turning down three previous petitions for clemency, New York's then-Governor Mario Cuomo commuted Harris's sentence. At that date, she had served almost twelve years of jail time. Prerelease, Harris objected to the clemency campaigns waged on her behalf in this fashion: "I don't want to *ask* for clemency. I want to *give* clemency for what they did to me." As a freed woman, Harris resided first with friends, then in a cabin in New Hampshire, and finally in an assisted living facility in Connecticut where she died of natural causes, age eighty-nine, having outlived by more than thirty years the man she shot. The library of her alma mater, which houses, among other materials, drawings by Vanessa Bell and papers related to another famous graduate, Sylvia Plath, is home to the Jean Struven Harris papers. According to the Smith catalogue, the collection contains correspondence, "writings," memorabilia, news clippings, correctional systems research, legal documents, audio and video tapes, and Harris's "trial record."

More than one hundred writers and journalists showed up at Harris's trial, the majority covering the event for daily newspapers. Re-

porting on the reporters in a *New York Magazine* article, Anthony Haden-Guest described "media luminary" Shana Alexander in "black mink" taking up the "Shana Alexander position" directly behind the defendant, the same post Alexander had occupied during the Patty Hearst trial. Both Alexander and critic Diana Trilling had committed to writing full-scale treatments of the woman accused, whatever the trial's outcome. Those books, Trilling's *Mrs. Harris* (1981) and Alexander's *Very Much a Lady* (1983), published when the case remained relatively fresh in public memory, swiftly became bestsellers and forty years later retain their status as the definitive texts on Jean Harris. Comparing the two, Jonathan Yardley in *The Washington Post* kept it simple: Trilling's book was "bad," Alexander's "good." Another reviewer lamented that the books hadn't been published in reverse order, Alexander's researched account preceding Trilling's meditative assessment. No reviewer suggested the authors took similar approaches in interpreting a headmistress at odds with herself.

<p align="center">۞</p>

In *Mrs. Harris*, Trilling is as much a presence on the page as the woman she observed for sixty-four days in court. Despite that authorial front-and-center, Trilling's telling is cool, distanced. She admits that the Harris book is not her "usual line" of writing, but reminds readers "it had once been the high function of literature to deal with just such material, to acquaint us with our social variousness and our human complexity." She had gone into the trial a Harris supporter, her stance "one of unqualified sympathy for the headmistress," but along the way changed her mind. Critical to that shift in allegiance was evidence presented at the preliminary hearing but banned from the trial: Harris hadn't arrived in Purchase with only a gun and few extra bullets; she'd arrived with a back-up "box of ammunition" stashed in the glove compartment of her Chrysler, discovered by police in an illegal search. Before being privy

to the extra ammo disclosure, based solely on what she had read prior to the preliminary hearing and trial, Trilling had drafted a manuscript with the expectation of adding only a "summary" of the court proceedings. The draft, she soon realized, would require more than addition or revision; the whole of it had to be scrapped. "I could no longer think of Mrs. Harris as a symbol of our capacity for hurt and rage . . . I had to acknowledge the possibility that along with the rest of the public I had been misled . . . even perhaps in my fundamental perception of her character." The character of the woman seated at the defense table, once revealed, did not meet with Mrs. Trilling's regard.

Alexander started partisan and remained partisan. "As is apparent," she writes, "Jean Harris and I long ago became friends." Alexander visited Harris in prison; they corresponded, letters that in 1991 were published as *Marking Time: Letters from Jean Harris to Shana Alexander*. In her Author's Note, Alexander cops to an immediate identification with the accused: "She reminds me of me. Same hairdo, same shoes, even the same college class." Beyond the lure of personal affinity, Alexander took up the project determined to right the wrong of previous "atrocious" press coverage and to show "readers what the jury never got to see." Hers is a heated crusade for justice, a blistering indictment of the lover, defense lawyer, and legal system that failed her friend. The tone of *Very Much a Lady* is frequently fierce, the chapter titles scathing. The chapter backgrounding Tarnower's successful diet book is titled "Leibarzt Into Literary Lion." Other chapters devoted to the doctor kick off: "Big Fish," "The Greening of Dr. Lunch Hour." A chapter on the Madeira school and Harris's "punishing" schedule as headmistress bears the heading "Tender Little Ladies." In contrast, Trilling dispenses with chapter divisions altogether, opting for the decorous break of white space.

In addition to interviewing Jean Harris formally and informally, Alexander, like the trained journalist she was, talked to "hundreds of people" who knew Harris and Tarnower: "old friends, new friends,

professional colleagues, relatives, neighbors, servants, students, teach-
ers, parents, doctors, lawyers, judges, police officers, and members
of the District Attorney's office." Trilling's position: "There's a great
deal that eludes one in Jean Harris's early life . . . or perhaps because
hers is a Middle Western story . . . it's more elusive to my under-
standing." Alexander, sharing neither Trilling's misgivings nor sense of
limitation, conducted an extensive investigation of Harris's early life
and delivered a thorough account of Harris's triumphs and setbacks,
"good girl" behavior, scholastic achievements, and life with father,
"tyrant" and "bigot." Trilling attempted to interview Alfred Knopf,
Tarnower's neighbor, and was "courteously" refused. Trying to nego-
tiate her way into Tarnower's home, she briefly exchanged words with
gardener/chauffeur Henri van der Vreken before Henri's wife, Suzanne,
the household's housekeeper/cook, appeared and cut the conversation
short. Eventually Trilling spoke to a few students at the Madeira School,
but she never interviewed Harris. Hunting down sources and double-
checking data were not activities central to Trilling's method of closing
in on an interpretation. "The former Jean Struven was said to have been
born in Cleveland," she writes early on in *Mrs. Harris*, passing along
secondhand information whose veracity, despite the archness of the
phrasing, she apparently had no quarrel with.

More defining of Trilling's style is a reliance on literary compar-
isons, literary asides. Among the many authors referenced: Agee, Eliot,
Chekov, Flaubert, Fitzgerald, Tolstoy, Wharton. In describing the tes-
timony of Tarnower's gardener/chauffeur, Trilling expresses "doubts"
that Henri van der Vreken was a man who'd read *Hamlet*. Freud makes
several appearances. Presiding judge Russell Leggett "is no Freud or
Trotsky but he has his own small gift of homely reference." A witness
for the defense has "a curiously Dickensian look," though Trilling is
unable to "place the book or character." Alexander, so moved, also
calls up a literary analog. Describing Jean Harris's two sons, she writes:
"David Harris has Byronic chestnut hair"; "Jimmie Harris looks like

Tom Sawyer in the Marine Corps." Alexander's other nod to high art versus no-nonsense reporting is an occasional foray into atmospherics: "You could hear the horses snuffling down in the barns, and far away a groundskeeper clattered his mowing machine over billows of blue-grass lawn." Neither Alexander nor Trilling references Dame Daphne du Maurier, but a *Rebecca*-ish take on the story is there for the snatch-ing. A household ruled by possessive Suzanne and Henri, determined by means devious or foul to keep their employer a bachelor, fending off all encroaching females in order to retain their own power and prestige within the hierarchy, Herman Tarnower, unlike Max de Winter, their eager accomplice because, as Jean Harris explained to Barbara Walters in an ABC televised interview: "It's easier to get a woman than it is to get a cook, Barbara, let's face it."

<p style="text-align:center">✺</p>

"Moral" is a key word in Trilling's lexicon. In an earlier collection of nonfiction, *Claremont Essays*, she puts the term to liberal use. In "*The House of Mirth* Revisited," Trilling writes of Henry James's "moral pas-sion" and Edith Wharton's "moral truth." In "A Memorandum on the Hiss Case," she defines "conscience" as "formulated moral inten-tion." In "The Oppenheimer Case: A Reading of the Testimony," she writes: "Style is its own form of morality." She devotes an entire essay to "The Moral Radicalism of Norman Mailer." In *Mrs. Harris*, Trilling observes that Jean Harris, "in her connection with Tarnower," had "let herself be led off her own moral path." When Trilling appeared on William F. Buckley's "Firing Line" to promote *Mrs. Harris,* her host cross-examined the author about what, precisely, she meant by "some-one's 'moral style.'" "When I talk about moral style in my book, I'm not talking about transgressions," Trilling replied. "I'm talking about choices in conduct. Everyone has a moral style." Buckley pressed: "And

your sympathy eroded in part because of the moral styles of the principals?" "Quite," replied Trilling, "quite."

In her book about Jean Harris, Alexander's word of words appears in the title: lady. (The entire title repurposes a comment Harris's lawyer, Joel Aurnou, shouted at inquiring reporters: "Listen, fellas, you gotta understand my client! She's very much a lady!") Alexander homes in on both the behavioral dictates of the brand as well as its disastrous use as a defense strategy. Lizzie Borden's lawyer, A.J. Jennings, used much the same defense to free his client from the charge of hacking to death first her stepmother and then her father in Fall River on a steamy day in August 1892. But stereotypes helpful to the cause in 19th-century Massachusetts faced a tougher sell in 20th-century Westchester County. Alexander situates Harris among the "well-bred little girls" of her generation "taught to become 'ladies' of a particular northeastern upper-class WASP variety." (Harris grew up and attended high school in Ohio.) Being a lady required "ignoring or denying feelings that might ruffle the serene surface of life" and striving always to be "modestly understated, infinitely considerate of others . . . superbly controlled." Professionally, Alexander admits, the "gracious, ladylike image" served Harris well when Madeira trustees went looking for a new headmistress: "Jean Harris looked the part." The image served Harris less well as an accused murderess. "None of Jean Harris's lawyers understood her," Alexander contends. "They knew she *was* a lady, but they had little awareness of what that entails." For example, Alexander explains: "Jean's seeming lack of remorse"—which many onlookers, including Trilling, noted—"reflected her early training. A lady does not show emotion in public." On "Firing Line," when Buckley, playing devil's advocate, argued the merits of "self-control" on the witness stand, Trilling responded: "If you're arguing for self-command, it has to go across the board, doesn't it?" Jean Harris "cried a lot in the courtroom, but she cried only for herself." As summarized by Alexander, Jean Harris's lady code also contained a competition plank that required Jean Harris to "go to

prison for murder" rather than "admit she was jealous of the office girl." The "office girl" in question: Lynne Tryforus, Tarnower's employee and younger lover.

<center>❁</center>

Trilling's assessment of Harris is primarily based on the woman she observed in court; Alexander's relationship with Harris carried over from the courtroom to the prison cell. Both report on Harris's regrettable (in terms of acquittal) hauteur in court and arrogance on the witness stand, the defendant "queenly in her scorn" in Trilling's phrase. Both authors also report on Harris's flashes of temper, constantly jiggling foot, on and off dark glasses, and "assistance" at the defense table, handing papers and photographs to her attorney as she deemed those materials pertinent. Of Harris's appearance, Trilling writes: "As a well-bred victim, she's from Central Casting." Alexander goes in for wardrobe specifics, recording the head to toe components of Harris's preliminary hearing ensemble: "tortoiseshell hair band, creamy tweeds, pale silk blouse, horn-rimmed half-glasses, sling pumps." When Alexander studies Harris "in profile," what she sees is a "lovely face," someone who "looks no more than thirty. Her complexion is fine and transparent; a blue vein beats in her cheek." Trilling's "side face" view of Harris prompts a different conclusion: "To me her expression is that of the classic *belle indifférence* of morbid hysteria, the corners of the mouth turned up in the fixed beginning of a smile." Whereas Alexander laments Harris's lack of "street smarts," Trilling finds the defendant "naïve without innocence." (For context: Trilling considered Marilyn Monroe the opposite: innocent, but not naïve.) Trilling is put off by Harris's "very great . . . narcissism," her abundant self-pity, her self-centeredness ("Shouldn't her lawyer tell her that she ought at least to *act* as though she's sorry Tarnower's dead?"). Harris's in-court composure as she traced "with her fingers the extent and distribution of the doctor's blood" on the bed

sheets appalled Trilling. "There's not a glimmer of pain in her expression, no reluctance or distaste in her examination of the evidence. The bloodied sheets are but another datum in her self-defense." Alexander maintains the headmistress is "fragile and high-minded"; Trilling dismisses the fragile and disputes the high-minded: "Mrs. Harris strikes me as a woman of assertions far more than of courageous principle. In the clinches she opts for safety." Regarding Harris's mental health, Trilling concedes: "it appeared obvious enough" that the defendant was "emotionally ill." During a radio interview with Studs Terkel, Alexander offered a more specific diagnosis: Jean Harris, "classic depressive," was a "woman in a state of psychosis" the day she wrote what came to be known as the Scarsdale Letter.

Written in red ink and delivered to the addressee's home the day after he died, Harris's letter to Tarnower, read in open court, did severe damage to her defense and went far in guaranteeing a guilty verdict. The ranting, pleading, accusing, self-justifying document bubbles with bile and rage and in its language and lash out does not square with the "lady" claim. The letter writer, operating in what Alexander labels a psychotic state, labels Lynne Tryforus a "psychotic whore." It's not a one-off attack. Tarnower's "sick playmate" is "ignorant," "tasteless," a "lying slut" possessed of a "vomitous" voice, a jewelry thief and excrement spreader who "decided to sell her kids to the highest bidder." Under the impression Tarnower had cut her and her sons out of his will in favor of Lynne and her children, Harris reminds Tarnower that while he has grown "rich" over the course of their relationship, she has, at times, been "almost destitute," and twice had to borrow change from chauffeur/gardener Henri to pay the Garden State Parkway tolls. She beseeches the doctor to give her rival "all the money she wants . . . but give me time with you and the privilege of sharing with you April 19th"—the date of the tribute dinner. Both Trilling and Alexander reproduce the letter in full. In the defendant's estimation, the main flaw of that outpouring was its "whiney" nature. On the witness stand,

Harris clarified that her "role with Hi was . . . to be good company and not be a whiner." Cross-examined by the prosecution, she testified that calling someone a "whore" was "very out of character," then added the tone deaf afterthought: "But it's not like me to rub up against people like Lynne Tryforus." Updated on the art of trash talk in prison, the headmistress was advised by another someone she had not previously rubbed up against to "go fuck a dead doctor."

The doctor who reportedly charmed scores of women during his lifetime did not charm two who wrote about him after his demise. In conveying their dislike of and distaste for the man, Diana Trilling and Shana Alexander pull no punches. "From the start of my interest in Mrs. Harris case, I didn't like the Scarsdale diet doctor," Trilling writes. "I didn't like his face, his house, his book; and . . . as I learned about the musical chairs he played with women, I didn't like his games." His "was a meager soul, a spirit without generosity," a man with "an insatiable appetite for small power." Alexander's bashing of the "aging, balding" man, his pretensions and sadism, gets more ink. "Autocratic," a fellow interested in "dominion" and "control," "arrogant," "saturnine," "bad-tempered," "penurious," a "snob," a man who "twisted the ears" of his hunting dogs, who affected the accent of his Century Country Club cronies, who fancied himself a gourmet but always served, according to Alexander's "food authority" source, "mush . . . swimming in gravy" in a dining room hung with big game trophies, an "unsophisticated lover" who "showed little refinement with women," a doctor who, in a glaring case of professional malfeasance, prescribed extremely potent medications for Jean Harris not in the headmistress's name. Tarnower's residence—a pool house expanded and redesigned by the owner—Trilling describes as "a small monument to cultural inflatedness . . . a low two-storied house, not large but large enough to make a sizable bad impression . . . a sort of domestic pagoda, the façade incoherent with terraces." And those are just Trilling's objections to the outside of the building. After Tarnower's sister sells the property

and Trilling is allowed an interior poke-about by the new owners, her opinion does not improve. "The inside is worse than I'd imagined," she writes. The rooms are small, cramped, "deficient," the whole house "claustral." As for the site of the crime, "the doctor's bedroom is a high-priced cell screaming for its walls to come down. I try to think what it would be like for a woman to be brought to this bedroom by a pros-perous lover: if this is all the space he can buy with his money, what generosities of feeling should she count on?" Alexander, equally unim-pressed with Tarnower's home, pegs it "a curious glass-and-brick house in *faux* Frank Lloyd Wright style," a "house that presented itself to the world in the grand manner but once inside the proportions were oddly foreshortened, like a stage set." Alexander compares the constrictive kitchen to a "railroad dining car," inventories the "slightly worn fur-nishings" of the downstairs rooms, the "mulch of giftwares" on display, many of them "monogrammed, embroidered, stitched" by girlfriends and grateful patients. The "so-called cathedral ceiling" in Tarnower's bedroom Alexander judges to be low, stunted. As for bedroom furnish-ings, Alexander zeroes in on the "elaborately fretted and ugly work of massive cabinetry" that included "built-in headboards for two narrow, single beds," the beds between which Harris insisted she and the doctor wrestled over her gun. Aesthetics aside, the spiral staircase that accessed the bedroom was impractical and, on the night of the shooting, a hin-drance. Paramedics transporting the alive but dying doctor down its narrow twists and turns had a harder job than was strictly necessary. Herman Tarnower's chosen staircase design wasted time the selector, in his final moments, did not have to spare.

Alexander devotes a chapter to the "travesties" of the case, dis-cussing at length the errors of Harris's legal team, including the "fail-ure" to mount "a believable defense" and the go-for-broke strategy that preempted the "mercy" option of first-degree manslaughter. Harris's lawyers, Alexander contends, should have argued extreme emotional disturbance because Harris's was a "textbook example of an EED case."

(Alexander was not alone in this belief; others, including the presiding judge, concluded the same.) To argue "innocence"—or accident—in the face of four spent bullets is a problematic undertaking. Jean Harris considered herself innocent of the crime with which she had been charged. She did not want to be tried for manslaughter because she believed it amounted to a plea bargain and only the guilty plea bargained. She forbade her lawyers to criticize Herman Tarnower or Madeira. She did not want any psychiatric testimony introduced. Harris's lawyers should have overruled their client's wishes, Alexander insists. But they didn't; they obeyed the headmistress. James Harris, speaking to Barbara Walters, described Aurnou as "underpowered," lacking the "strength . . . to tell mother what to do." During the trial, Harris herself seemed pleased enough with her counsel, telling reporters that Aurnou was a "genius," optimistically predicting "he may get me off." As an inmate, she would revise that good opinion and complain to NBC's Jane Pauley (and others) that she'd been given "bad legal advice."

Trilling's quarrel with the verdict focuses on the prosecution. Although she "sees no travesty of justice in the jury's decision," she believes the prosecution failed to prove beyond reasonable doubt its case for murder in the second degree—the *conscious* intent to kill. Despite "questioning the verdict," Trilling harbors "no doubt at all that deep in her mind and heart (Harris) wanted to kill Dr. Tarnower. I think her fury at him was murderous and that this was plainly and repeatedly revealed." However: "If there'd ever been a time when the wish (to kill) was conscious, this was no longer so. It had departed her conscious mind, gone . . . where consciousness doesn't follow."

※

In 1981, the same year Trilling published *Mrs. Harris*, NBC broadcast the TV movie *The People vs. Jean Harris,* starring Ellen Burstyn, a Harris supporter and contributor to the Jean Harris Defense Committee.

The TV movie's scope is the trial and trial only, the drab, minimalist set a paean to the color tan. It's an earnest effort all around. No character in the cast comes off tightly coiled. Burstyn's muted, flattened performance gives no quarter to fury or prickliness and transmits little of Harris's widely reported snootiness. The actress plays the accused as a woman weighted with grief (as opposed to guilt), soft-spoken, hesitant, occasionally confused, and largely compliant. Because the principals—prosecutor George Bolen (Peter Coyote), defense attorney Joel Aurnou (Martin Balsam), judge Russell Leggett (Richard Dysart), witness Suzanne van der Vreken (Sarah Marshall)—along with scattered members of the jury—wear oversized eyewear, Burstyn/Harris's oversized sunglasses seem little more than prop, and a common one at that.

HBO's 2005 production is an altogether brighter, splashier, campier enterprise, filmed in multiple locations. Borrowing its title from Trilling but citing Alexander's book as its inspiration, *Mrs. Harris,* the movie, stars Annette Bening and Ben Kingsley, covers the Harris/Tarnower affair start to finish, and isn't afraid of humor. Bening gives her Harris a knowing, worldly, sarcastic edge. A single anonymous quote in Alexander's book on the topic of what women "saw" in Tarnower ("You never got into the locker room at Century, or you would know what they see") gets its own scene, a towel-less Kingsley strutting and strutting and strutting his equipment down the locker room aisle, basking in the admiring stares of his fellow country clubbers. Even the gun wrestling sequence between a zombie-ish Bening and irked Kingsley verges on the comedic: an awkward, clumsy tangle of limbs in the too-small space between beds; a loopy Bening on her hands and knees searching for the dropped weapon; the actress's slightly ironic delivery of the "phone's dead" line. Rather than a Harris desperate to achieve one last chat with her lover, Bening's rendition conveys a quizzical befuddlement at finding herself in the Purchase bedroom, now and again gazing upon Kingsley's Tarnower as if upon a puzzling illusion, a man in pajamas who *should* be her beloved but

whose impersonation in the moment doesn't quite convince. Nowhere to be seen during the trial, Lynne Tryforus lacks cinematic representation in the first film but in the second puts in a leggy appearance via Chloë Sevigny. It's a small role—too small for Chloë Sevigny fans. Given the screen time, Sevigny might have succeeded in bringing the most mysterious member of the romantic triangle into better focus.

<p style="text-align:center">⚙</p>

In Alexander's opinion, the Jean Harris story "rises to the level of tragedy" because Jean Harris's "character—her mix of unsparing honesty, idealism, integrity, and 'lady-like' values—became caught up in forces beyond her control." Trilling grants that the shooting was a "tragic happening in the headmistress's life," but stops short of granting the overall saga the tragedy stamp of approval. Very likely that withholding stemmed in part from what Trilling perceives as a "suggestion of sordidness" in Tarnower's household—people "informing" on each other, stealing money, slashing and befouling garments and furnishings—and Jean Harris's active participation in the ongoing intrigue. Trilling viewed the Harris/Tarnower imbroglio through the lens of class: "The only thing that distinguished the Harris-Tarnower story from usual crimes of passion was its social location and the repute of its leading characters."

Tucked into the pages of each book, Trilling's and Alexander's, is a showstopper sentence. From Trilling: "I still saw (Harris) as a woman who thought she loved a man whom she deeply hated—it's not an unfamiliar phenomenon." From Alexander, disputing the claim that Harris, in putting up with Tarnower's treatment for fourteen years, qualified as a "terrible masochist": "Every woman in love tolerates pain she would not otherwise tolerate. That is the nature of love."

Held by interpreters of the Harris/Tarnower misalliance, those sentiments are not without significance. Two clear-eyed skeptics of love,

the fairytale, took as their subject self-deceiving Jean Harris, fool for love. Of the two, only one remained her subject's champion.

CAT AND MOUSE

Christie, Tynan, Redgrave, and that Infamous Eleven-Day Gap

YOUTUBE PRESERVES a two-minute clip of Agatha Christie, who rarely consented to interviews, undergoing the ordeal in Lisbon in 1960. Wedged between the Queen of Crime and interviewer: Christie's silent second husband, Max Mallowan, hands folded upon his belly, benignly smiling. Christie wears a suit, pearls, a lapel brooch, a wide-brimmed dark hat, and what appears to be, from the side view, cat-eye glasses. Given her thoroughly documented dislike of the press, the author's cooperation during the give and take is an interesting performance. No viewer could mistake her for someone at ease with the process or delighted to be in the situation. Nevertheless, she affably nods and marginally titters while responding to questions she can't have welcomed, answering two of the three un-ironically.

> Q: I'd like to know what is the best story to you about Poirot?
>
> A: Very difficult to say. Oh, I should think, I should think, I should think . . . perhaps . . . *The Murder on the Orient Express.*
>
> Q: Do you prefer Poirot or Miss Marple?
>
> A: Oh . . . it's a very close thing between them . . . but I think I'm beginning to prefer Miss Marple.

Q: And will you write something about Poirot or Miss Marple in Lisbon after this week?

A: Perhaps, yes. We've had a nice holiday here so we must think of something.

Also posted on YouTube, a nine-and-a-half minute clip of a 1979 interview with Vanessa Redgrave—also not a fan of interviews or the press—on Thames Television's "Afternoon Plus." Redgrave is having a sit-down with the show's host to promote the movie *Agatha*, in which she stars, a film based on Kathleen Tynan's novel of the same name and inspired by Christie's eleven-day disappearance in December 1926. (Redgrave's previous Christie-related film was the 1974 version of *Murder on the Orient Express*. In that production, Redgrave plays minor character Mary Debenham and spends most of her screen time listening intently as Albert Finney's Poirot tells her what's what.)

In the "Afternoon Plus" interview, Redgrave wears slacks, a pale pink mohair sweater, and dark head band. In the YouTube comments section, P. Folliard remarks on Redgrave's "amazing . . . patience." Whether patient or resigned, the actress/activist gives the distinct impression she'd rather be swimming with electric eels than stuck in the "Afternoon Plus" studio. Quizzed about playing the famous novelist, the famous actress explains she doesn't "pretend to be the real Agatha Christie"; she's playing the *character* Agatha in Tynan's *novel*.

"It's rather like when a writer chooses to write about Richard the Third," Redgrave further attempts to clarify. "Richard the Third did live, but a writer's entitled to make certain assumptions . . . it's an imaginary story, an imaginary Agatha Christie."

Unappeased by that explanation, the interviewer persists. Surely, in preparing for the role, the actress researched the *real* Christie? In reluctant response, Redgrave admits she "read some of the novels (Christie) wrote under another name—that interested me."

Interested Redgrave how/why?

The authorial disguise?

The anonymity?

The genre switch, mystery to romance?

Regrettably, the interviewer declines to follow-up on that disclosure. It's on to topics Palestinian as Redgrave's tight smile grows tighter.

❁

Although Redgrave doesn't specify which of Christie's six Mary Westmacott romances interested her, chances are better than average that she gave *Unfinished Portrait* a browse. The incentive: in the character of Celia, "we have more nearly than anywhere else a portrait of Agatha," according to second husband Max's book jacket endorsement.

In the novel, a despondent Celia, having fled England for a sunnier isle, is discovered staring out to sea by portrait painter Larraby. Intuiting her suicidal intentions, Larraby prevents the deed by returning Celia to the hotel and spending the night listening to her saga of heartbreak, which he recounts. "After a while . . . I had ceased to exist for her save as a kind of human recording machine that was there to be talked to."

An unwieldy narrative set-up.

Adding to the unwieldiness: a hefty number of sentences that end in breathless, trail-off, three-dot fashion. The word "exciting" and its variants appear so frequently ("It was all very exciting." "The journey was very exciting." "Presently there was the excitement of going to bed." "The meals were exciting." "I've had the most exciting dream." "The excitement of it!" "Evening dresses were very exciting." "Something really exciting happened."), the reader begins to suspect her leg is being yanked.

By the time the film *Agatha* came out, Christie's Westmacott nom de plume had been public knowledge for thirty years. A *Sunday Times* columnist spilled the beans in 1949. Thereafter, *Unfinished Portrait* was marketed as "semi-autobiographical." Since the parallels between

Christie's life and character Celia's story are extensive and often exact, the "semi" qualifier under-promotes the product. Celia has lost her mother and husband to death and betrayal (as had Christie). As does her creator, Celia writes novels. Celia adores and perpetually mourns her mother (as did Christie). Celia enjoys a brief career as a singer, one of Christie's early creative outlets. In the novel, Celia's daughter prefers daddy (as was the case in the Christie household). In the novel, Celia's estranged husband Dermot is a cheater, a fellow prone to belittling his wife (as in the Christie household). Dermot golfs. Colonel Archibald Christie was a golf fanatic.

The list goes on.

Worth noting: when Dermot enters the narrative (page 213), the novel's languid dreamy tone gets tossed for sharper exposition, a vastly accelerated pace, and dialogue aplenty. Among the fiction's other close-to-the-bone details: Dermot expects Celia to remain as "lovely as ever" after giving birth. Disliking baby Judy's "curves" and "dimples," he wants Celia's assurance that their daughter "will be thin someday" because he "couldn't bear it if she grew up fat." Dermot also doesn't care for "silly women" or "people who are ill." Celia's mother dubs Dermot "ruthless." After eleven years of marriage, Dermot says, "one needs a change." When Celia initially refuses to divorce him so that he can marry his mistress, Marjorie Connell, Dermot calls Celia a "vulgar, clutching woman." In the novel, once Celia and Dermot divorce, he marries Marjorie Connell "a few days after the decree was made absolute." Free of Agatha, Archibald Christie waited slightly longer—just shy of three weeks—to marry Nancy Neele.

After piling on the details of Dermot's caddish behavior, Christie, in one of her odder *Unfinished Portrait* decisions, has narrator Larraby offer up a slew of justifications for that conduct. Dermot "was fond of Celia, but he wanted Marjorie. I can almost sympathize . . ." (The punctuation is Christie's.) "He'd loved Celia, I think for her beauty and her beauty only." "Also, she clung. And Dermot was the type of man

who cannot endure being clung to." "Celia had very little devil in her, and a woman with very little devil in her has a poor chance with men." "She (Celia) loved him enduringly and for life"—Agatha's plight with regard to Archie, according to Judith Gardner, the daughter of Agatha's lifelong pal Nan Watts. Gardner's take is unequivocal: "Agatha never got over Archie" (Jared Cade, *Agatha Christie and the Eleven Missing Days*).

For those schooled in Christie's crisper, brisker, crime fiction, the gush and purge and prolonged lament of *Unfinished Portrait* startle. Gone missing is the "Who? Why? When? How? Where? Which?" plot strategy outlined in her planning notebooks, which *Agatha Christie's Secret Notebooks* editor John Curran considers "the essence of detective fiction distilled into six words." Also not in evidence: the kind of tightly worked narrative that led critic Julian Symons to crown Christie the "supreme mistress in the construction of puzzles" (*Bloody Murder: From the Detective Story to the Crime Novel*).

Christie, as Westmacott, published *Unfinished Portrait* in 1934. Eight years earlier, writing as Christie, she published the crime fiction that made her reputation, *The Murder of Roger Ackroyd*.

Not every critic applauded ("Who Cares Who Killed Roger Ackroyd?" Edmund Wilson jeered), but the majority of reviewers, in step with the majority of readers, praised the novel for its originality and clever the-narrator-did-it twist. Still analyzing the ins and outs of the text in 2000, French psychoanalyst Pierre Bayard writes: "Few writers have mined the eminently Freudian question of psychic blindness as systematically as Agatha Christie. *Why don't we see?*" (Bayard's italics). Bayard's theory: "It was Caroline Sheppard—not narrator Jim Sheppard—who killed Roger Ackroyd" (*Who Killed Roger Ackroyd? The Mystery Behind the Agatha Christie Mystery*). Edging farther out on a critical limb, in a 2018 *Studies in Crime* article, the University of Newcastle's Alistair Rolls proclaimed Jim and Caroline Sheppard an incestuous pair.

�

An eventful year for Agatha Christie, 1926.

The Murder of Roger Ackroyd came out in June. On the evening of December 3, the author left her home in Sunningdale. On December 4, her Morris Cowley (two-seater or four-seater, depending on the source) was discovered approximately fifteen miles away, abandoned at the edge of a chalk pit near Newlands Corner in Guilford. Left in the car: a fur coat, a suitcase of clothes, and a driver's license (an "expired" driver's license, as reported by Matthew Bunson in *The Complete Christie: An Agatha Christie Encyclopedia*)—but no handbag. While police, bloodhounds, and volunteers scoured the countryside for clues (or the body of a clues expert), Christie settled in at the Hydro Hotel, Harrogate, registered as Theresa or Teresa (depending on the source) Neele, the surname of Archibald Christie's mistress. The mistress herself, Nancy Neele, relocated to her parents' house to wait out the publicity storm (Cade). Archibald Christie contributed to that storm by giving the *Daily Mail* an interview in which he revealed that "the possibility of engineering a disappearance had been running through (his wife's) mind," and that he "personally" felt that is what Agatha had done. He also stated that Agatha "was very clever at getting anything she wanted" but vehemently denied that "there was anything in the nature of a row or tiff" between husband and wife.

Reporters at the time didn't hide their skepticism about Archie's truthfulness or the reasons behind the vanishing. *Roger Ackroyd* sold well before Christie's disappearance; afterward, it sold even better. Some sniffed a publicity stunt. Subsequent biographers, for the most part, have stuck with the amnesia excuse, concocted by Archie as he collected his found spouse at the Hydro Hotel. (A member of the Hydro's house band blew Agatha's cover. After noticing Mrs. Neele of South Africa bore a striking resemblance to Agatha Christie of Sunningdale, he tipped off police.)

A Christie biographer who didn't buy into the amnesia explanation is Jared Cade. (Originally published in 1998, his *Agatha Christie and the Eleven Missing Days* was reissued in an expanded, "updated" edition in 2011.) Cade agrees with husband Archie's first theory: Agatha "engineered" her disappearance and did so, in Cade's opinion, to punish foot-out-the-door Archie and provoke speculation that the colonel had done his wife harm. In pulling off the scheme, Cade believes Agatha had the assistance of friend Nan Watts.

Cade's is an appealing interpretation because 1) it better suits our notion of "how a crime writer would act"; 2) rather than cast Agatha as a victim/doormat who passively accepted Archie's philandering, it reveals her to be a tit-for-tat avenger. What seems less open to speculation and disagreement: the author's severe underestimation of how famous she'd already become by 1926 and how feverishly interested the public would become in her private affairs.

It was friend Nan Watts, Cade reports, who urged Agatha, in the author's only public comment on the subject, to agree to a February 1928 *Daily Mail* interview and defend herself against the lingering assumption that she'd "deliberately disappeared." A misguided suggestion by Watts, if true. The interview didn't come close to putting the matter to rest and achieved much the opposite. After resuscitating the dubious amnesia excuse, Christie elaborates on the joys of a second identity. "As Mrs. Neele I was very happy and contented. I had become, as it were, a new woman." Despite being "greatly struck by (her) resemblance" to the newspapers' photos of Mrs. Christie, "it never occurred to me that I might be her, as I was quite satisfied in my mind as to who I was," Christie pronounced—apparently with a straight face.

Altogether, a plot with many holes.

Small wonder the fictioneers rushed in with plugs.

꩜

To the *Washington Post*, Kathleen Tynan ID-ed her novel as "not a who-dun-it" but a "why-do-it . . . an imaginary solution" to the "authentic mystery" of Christie's disappearance and activities between Christie's official dates of lost and found. In Tynan's novel, to get character Agatha to the Harrogate Hydro and subject to the pursuit of reporter Wally Stanton, Tynan gives short shrift to the Archie/Agatha prequel. In Tynan's novel, page 4, the Christies' miserable marriage and life together get disposed of thus:

> They set up house and had a daughter and lived happily till twelve years later, when the marriage lay ruptured and bleeding. During the previous summer, soon after the death of Agatha's mother, Archie had told her that he had fallen in love with another woman.

As for what motivates character Archie's unsporting behavior (in the novel): "I've really had enough of all this. These people. Your writing. Your damned garden. I'm simply not my own person anymore" (page 20).

In its uncomplimentary review of Tynan's novel, *Kirkus* tosses in criticism of the "upcoming film," objecting to the casting of "much-too-beautiful V. Redgrave as AC." In a nifty bit of casting, however, Redgrave's partner at the time, Timothy Dalton, plays Archie. Staying true to its source, the film downplays Dalton's role—a shame. Dalton's self-involved colonel is far more watchable than Dustin Hoffman's self-involved newshound. To shore up his criticisms of the film, Roger Ebert references George Orwell's essay "The Decline of the English Murder." Ebert's review also discloses that he's "never been able to work up much enthusiasm" for Christie novels because he prefers "books with some juice in them"—likely eliminating him as the ideal audience for any

movie inspired by Christie's life. Although the *New York Times* applauded the "resourcefulness" of Redgrave and Hoffman, the film as a whole proved to be a "handsome, rudderless sort of movie." Time hasn't improved the movie's reputation. Almost thirty years after its release, Robert Fulford in the *National Post* describes *Agatha* as "deadly" (in the uninteresting-to-the-max sense of the word) and revives accusations that the fault of the deadliness lay with Hoffman's endless rewrite demands and Redgrave's "ennui-projecting performance."

During the filming, squabbling broke out between and among writers, producers, and actors, actor Hoffman participating in several of those quarrels. In her essay "Autobiography in *Agatha*," Sarah Street describes the film production as "tortuous." Whereas Wally Stanton's role was significantly expanded in the film version, the role of Agatha's Hydro friend, Evelyn, was severely curtailed—an adjustment that displeased Tynan, Street reports. Frustrated by Hoffman's insistence on reshooting (and re-reshooting) scenes, co-producer David Puttman pulled out of the enterprise. Acting on behalf of the Christie Estate, Christie's daughter, Rosalind Hicks, attempted to block the filming from the get-go. Despite the failure of Hicks's lawsuit, its filing rattled Tynan, who worried the Christie Estate might next decide to sue her personally for penning the novel that started the ball rolling. And Tynan wasn't the only one made nervous by the Christie Estate's saber rattling. In the novel, night of the disappearance, Rosalind gets a goodbye kiss from her mother. The nursery scene—on the advice of attorneys—was cut from the film (Street).

In her "Afternoon Plus" interview, Redgrave expresses solidarity with the Rosalinds of the world. "You can understand," she says, why relatives would not want "things" they considered "private and personal . . . made public." Redgrave's membership in an acting clan exhaustively covered by the press probably accounts for her sympathy. In 2011, Vanessa led the charge in suing Tim Adler over *The House of Redgrave*, a biography the Redgrave family considered libelous.

❁

Christie might not have wanted to (again) discuss her eleven elsewhere days, but she was keen to leave her version of her life story for posterity. At seventy-five, she published her autobiography, the content dictated, according to grandson Mathew Prichard's introduction, over a fifteen-year period. "The disadvantage of a dictaphone or tape recorder . . . is that it encourages you to be much too verbose," Christie allows on page 341 of the 532-page text. As if to quash (far) in advance the possibility of readers agreeing with his grandmother's assessment, in the second paragraph of Prichard's introduction he insists: "A lot of people I know have found the autobiography so fascinating they couldn't put it down." In Christie's foreword, spoken/written in 1950, the author puts forth another stringent opinion: "I do not know the whole Agatha. The whole Agatha, so I believe, is known only to God"—quashing, in advance, any reader's hope of full disclosure.

Rather than divulge Hydro-at-Harrogate specifics, Christie sticks with vaguer summations of misery during that stressful period of existence. "The next year of my life is one I hate recalling. As so often in life, when one thing goes wrong, everything goes wrong." Her beloved mother died, and she was left to "clear up" her mother's house and estate. She turned down Archie's suggestion to accompany him to Spain.

> I wanted to be with my sorrow . . . I see now that I was wrong. My life with Archie lay ahead of me. We were happy together, assured of each other, and neither of us would have dreamed that we could ever part. But he hated the feeling of sorrow in the house, and it left him open to other influences.

In her run-down "nervous state," she "hardly knew" what she "was doing." She "began to get confused and muddled over things." Required to "sign a cheque," she couldn't recall what name to sign—a

detail disputed by biographer Cade, who contends Christie includes it merely to echo the amnesia alibi.

In a chapter of fewer than four pages, Christie shares Archie's confession of feeling "desperately sorry that this thing" (falling in love with Nancy Neele) "has happened." Nonetheless, he'd "like" Christie to give him a "divorce as soon as it can be arranged." "With those words, that part of my life—my happy successful confident life—ended," Christie declares, then qualifies: "I thought it was something that would pass . . . He had never been the type who looked much at other women. It was triggered off, perhaps, by the fact that he had missed his usual cheerful companion in the last few months." Christie goes on to supply Archie with other (convoluted) excuses for bolting. "He was unhappy because he was, I think, deep down fond of me, and he did really hate to hurt me—so he *had* (Christie's italics) to assure himself that this was *not* hurting me, that it would be much better for me in the end"—and more along those lines. The brief chapter winds toward its finish with: "So, after illness, came sorrow, despair and heartbreak. There is no need to dwell on it."

And dwell the author does not. There is only a fleeting allusion to her disappearance and its aftermath: "There could be no peace for me in England now after all I had gone through . . . life in England was unbearable"—and that to set up a swipe at the press.

> From that time . . . dates my revulsion against the Press, my dislike of journalists and of crowds . . . I had felt like a fox, hunted, my earths dug up and yelping hounds following me everywhere. I had always hated notoriety of any kind, and now I had had such a dose of it that at some moments I felt I could hardly bear to go on living.

She manages to do so, regardless. In 1930, still carrying a torch for Archie (or not), "scared of marriage" because "the only person who can really hurt you in life is a husband" (*An Autobiography*), and against sis-

ter Madge's stiff opposition, Christie married husband number two, archaeologist Max Mallowan, a gentleman thirteen or fourteen or fifteen years (depending on the source) her junior. In the autobiography, explaining why she married Mallowan on the QT, Christie returns to her grievances against the press. "I had had so much publicity, and been caused so much misery by it, that I wanted things kept as quiet as possible." In Christie's chronicle, her second marriage is portrayed as a companionable, non-tumultuous sort of union, involving archeological expeditions to the Middle East and assorted travel adventures. There is no mention of her second husband's flirtations. There are no confessions of anger or upset or depression caused by Mallowan's liaison with his former student and archeological assistant Barbara Parker. Neither Christie nor her biographers describe the author again driving off into the night to hole up elsewhere, supremely distressed, thoroughly amnesic, or ferociously vengeful. This go-around Christie stayed put, as did Mallowan, uninterested in divorce, supported personally and professionally in deluxe style by Christie's earnings. Dame Agatha Christie died in January 1976. Showing not quite the haste Archibald Christie had shown, Max Mallowan waited a year and eight months to wed Parker.

Whatever might be said of Agatha Christie's husbands, marriage to her put neither off the institution.

<div align="center">❖</div>

Christie's royalties, in addition to supporting her own household, supported the household of her daughter (who died in 2004) and continue to support the household of her grandson, who has owned the rights to his grandmother's play *The Mousetrap* since age nine or ten (sources disagree). Vested interest on display, in 2010, to *The Independent*, Prichard expressed "dismay" that, in its entry about the play, Wikipedia named the murderer. "My grandmother always got upset if the plots of her

books or plays were revealed in reviews," he said, "and I don't think this is any different." Fans dutifully took up the cause, swelling the complaint pool. Although Wikipedia kept the spoiler, going with a "just don't read it" rebuttal, there was an adjustment: the identity of the killer now appears under the bolded subhead **Identity of the murderer.** In Christie's lifetime, surprised by *The Mousetrap's* popularity and experiencing tax difficulties, the lifelong Tory is said to have regretted her precipitous royalties transfer to her grandson (Cade). But who, including its creator, could have predicted the play's phenomenal success, smashing records then and now and still running in London's West End?

If harboring financial regrets of her own, the actress who played an imaginary Christie seems to have kept those regrets closer to her chest. Redgrave is nowhere reported as wishing she hadn't given away bundles of money to the Workers Revolutionary Party and other leftist causes over the years. The fretters seem to have been her daughters. According to an article penned by Joely Richardson and published in *The Telegraph* in 2011: "My sister and I have always worried about Vanessa's total selflessness, hence Tasha's very poignant present to mum shortly before (Natasha) died—a little purse embroidered with 'save for a rainy day.'" Thus far: no published update as to whether Vanessa has acted on that monetary advice.

Another YouTube preservation: a late-middle-aged woman with late-middle-age spread in a less-than-flattering swimsuit and bathing cap, happily paddling in the surf, assuming she waved at intimates, not posterity.

Which of Dame Agatha's relatives or friends released that home video and for what reason?

A mystery.

THE AFTERLIFE OF KITTY OPPENHEIMER

F KITTY OPPENHEIMER were immortalized as a paper doll in the manner of Mary Todd Lincoln, Pin-up Girls of World War II, or Ladies of the Titanic, her costumes and props might include:

– Boots, jodhpurs, a handsome horse
 By age fourteen, German-born Kitty Puening, resident of Aspinwall, Pennsylvania, had already distinguished herself as an accomplished—and fearless—equestrian.
– *Daily Worker*
 Emblem of her one-time Communist Party affiliation and hawking-copies duties as a Party member in Youngstown, Ohio.
– Cigarettes (pack or carton)
 A nicotine assist for trying days, first to last.
– Jeans and Brooks Brothers shirt
 Everyday wear during her two-year, four-month stint on a New Mexico mesa.
– Blue Cadillac
 Notice-me wheels shared with husband Oppie in Los Alamos.
– Martini glass
 —And a spare, to cover breakage.
– Plaster cast, crutches
 To treat the results of multiple trips and falls.
– Black suit, black hat, white gloves
 For somber occasions, such as the 1963 White House cere-

mony in which her politically persecuted husband, as a token of amends, received the Fermi Award for his service to science.
– Potted orchid
A product of her Princeton greenhouse and grievance token of the professional botanist she never became.
– Sailing togs, sunglasses
For those joyful occasions when the Oppenheimers escaped physics and politics and took to the sea from their second home on St. John, U.S. Virgin Islands; to represent the Widow Oppenheimer's unvarying outfit as she sailed her fifty-two-foot ketch *Moonraker* in the company of her late husband's best pal, Robert Serber.

Rounding off the paper doll effects, there might also be a neck placard bearing the words "Wife of," because had Katherine Puening Ramseyer Dallet Harrison Oppenheimer not in her fourth marital adventure become the spouse of the theoretical physicist considered the "father of the atomic bomb," few would recognize her name or have the opportunity as readers to presume they understood the dips and swerves of her particular personality as posterity records it.

In kinder treatments, Kitty Oppenheimer is judged an unhappy, unfulfilled woman. The kindly do not carry the day. By and large those who revered Robert Oppenheimer thought much less of Kitty. For the contingent who considered Oppie a tortured saint, Kitty failed to measure up. In their view, more harm-mate than helpmate, Kitty's behavior and demands further taxed Oppie's already overtaxed organism, brilliant mind, and sensitive nature. Rather than comfort on the home front, she offered chaos. Other strikes against her: volatility, snootiness, selfishness, insobriety. She was a bad mother, a bad daughter. She had a scathing tongue. She abused friendships. She could never be without a man. She *had been a Communist*, thereby imperiling, throughout the Oppenheimers' relationship, the career and effectiveness of her philosopher/scientist/statesman mate. All in all: *not* the life partner

their Robert deserved. On the other hand, Kitty's few defenders describe her as vivacious, quick-witted, bracingly intelligent—a fun gal to be around. Matters on which both sides agree: Kitty's supreme devotion to Oppie, the ferocity of her loyalty and support during the Atomic Energy Commission's battering of her husband and revocation of his security clearance, and her deep, abiding hatred for all who contributed to Oppie's takedown, physicist Edward Teller prime among that batch. And because in any compilation there is always a minority-minority opinion, representing those who disliked the Oppenheimers equally, mathematician Mildred Goldberger, who labeled Oppie "a self-hating Jew who had to marry an anti-Semite to prove to himself that he was right" ("Manhattan Project Voices").

<p style="text-align:center">۞</p>

But before there existed a Robert and Kitty alliance to defend or disparage, there was Kitty the only child, Kitty the school girl, Kitty in marriages one, two, and three. With engineer father Franz and mother Kaethe Vissering Puening, Kitty crossed the Atlantic by ship as a toddler in 1912 or 1913 (accounts differ). Left behind were such relatives as Kaethe's sister Hilde, who would work on Nazi propaganda films, and first cousin once removed Wilhelm Keitel, who would lead the German Armed Forces High Command, a fanatical Hitlerite to the end. Kitty's immediate family of three immigrated to America for reasons of opportunity. The inventor of a new model of blast furnace, Franz believed he would prosper financially in the United States and did so, first at Koppers, a chemical and material company in Pittsburgh. In the Pittsburgh suburb of Aspinwall, young Kitty mastered a second language with ease, competed in horse shows, met with both social and academic success, and returned to Europe regularly with her parents, a cosmopolitan child. Commentators disagree about which parent fed Kitty tales of her royal heritage; those commentators also disagree about the legiti-

macy of the claim. In any event, Kitty Puening came of age believing in her blue blood lineage and all-around specialness. In 1928, she entered the University of Pittsburgh but continued to live at home. Bored or restless or both, she convinced her parents to fund a solo trip to Europe in 1930, where she may or may not have continued her studies (accounts differ) and met the man who would become her first groom: Frank Ramseyer, Harvard grad, jazz enthusiast, musician. Their whirlwind Parisian romance ended in a whirlwind divorce. After reading her new husband's diary, Kitty concluded she'd married a drug-addicted homosexual and made haste to extract herself from the union. Back in Pittsburgh, she met husband number two: Dartmouth dropout, committed Communist Joe Dallet, a handsome, poetry-quoting union organizer for whom she felt immediate "awe" and "instantly . . . turned on whatever it is that makes some women irresistible to men," according to biographers Shirley Streshinsky and Patricia Klaus. If, at the start of their relationship, Dallet felt similarly enthralled, he hid the sentiment well. His clinical rundown of Kitty's attributes in a 1934 letter to his mother (after his mother inquired): "Pretty good head. Plays good bridge. Rather slight of build, tho well-proportioned. Weight about 112" (Streshinsky and Klaus, *An Atomic Love Story*). As Dallet's legal, or, in the FBI's classification, common-law wife, Kitty lived with Dallet for two years in an Ohio rooming house, adopted her mate's politics, joined the Communist Party, distributed agitprop at factory gates and on the streets, taught English to workers, and served as Dallet's gofer. Then she tired of the setup, announcing to Dallet and their comrade Steve Nelson that she could "no longer live under such conditions." Her parents had relocated to England, and she joined them there. Although she'd taken a break from the relationship, she wasn't done with it. Nor was Dallet. He sent numerous letters that, for a time, Kaethe successfully intercepted. (As reported by Jennet Conant in *109 East Palace*, Anne Wilson, one of Oppie's secretaries and no great fan of Kitty's, had worse to say of Kaethe: "She was a real dragon, a very hard, repressive

woman.") Having discovered her mother's meddling—and infuriated by it—Kitty opted to return to Joe. After a brief reunion in Paris, he left to fight the fascists in Spain. Absence made his heart grow fonder. "Each time up in the lines that I see a fascist, I am sure that I'll be more effective if I say to myself: 'That bastard is trying to keep you away from Kitty.' So I'll say it and do my job right" (*Letters from Spain,* May 18, 1937). It was Kitty's intention to join him, the plan in play, when Dallet was killed. Streshinsky and Klaus report that Kitty told unnamed "friends . . . she would never stop loving Joe." Biographer Conant offers up a specific source, Kitty's Los Alamos drinking buddy Shirley Barnett. Dallet, Barnett believed, "was the great love of her life," his death a shock Kitty "never really got over." A case might be made that Joe Dallet was for Kitty what Jean Tatlock, physician, psychiatrist, and Communist Party member, was for Oppie: the love that got, or was taken, away: Dallet by war, Tatlock by suicidal depression.

Following Dallet's death, the worse for wear, Kitty returned to the U.S. Finally on track to finish her undergraduate degree—this go-around as a student at the University of Pennsylvania—she reconnected with Stewart Harrison, Oxford grad, radiologist, and Caltech researcher, when he blew through town. Harrison proposed; twenty-eight-year-old Kitty negotiated. She'd agree to another name change if he agreed to her remaining in Pennsylvania for the duration of her undergraduate work and thereafter to her pursuing a doctorate at UCLA. Harrison accepted Kitty's terms, and for the first six months of the ill-starred match lived apart from his wife. Once in California, per the agreed-upon agenda, Kitty entered graduate school. Harrison's friends and colleagues, eager to meet the new missus at last, hosted an August garden party. And there, in the bright Pasadena sun, Kitty encountered her fourth and final husband, the very tall, very slim, wunderkind physicist who held a dual professorship at Caltech and UC Berkeley, a man of such personal charm and magnetism that "male, female, almost everybody," in the words of his Berkeley colleague Harold Cherniss, "fell

in love with him" (Streshinsky and Klaus). Mrs. Harrison followed suit, her PhD goal put on permanent hold.

<div align="center">❁</div>

Accounts of Kitty and Oppie's fast-paced affair, Kitty's pregnancy, her Reno divorce from Harrison and same day exchange of I do's with Oppie, range from judicious ("The involvement was apparently immediate and intense."—biographer Richard Rhodes) to exasperated ("It was such a bad, stupid marriage . . . I don't think he had terribly good taste in women."—another of Oppie's secretaries, Priscilla Greene) to sexist (i.e., the successful manipulations of a conniving woman). "People," writes biographer Conant, "were moved to judge [Kitty] more harshly . . . because of the way she threw herself across [Oppie's] path and forced his hand in marriage" (*109 East Palace*). In the Oppenheimer biography *American Prometheus,* Kai Bird and Martin Sherwin describe the object of Kitty's pursuit—also known for getting his way—dialing up Stewart Harrison to announce Kitty's pregnancy and, at the end of that chat, securing Harrison's pledge "to divorce Kitty" so that Oppie "could marry her. It was all very civilized." Civilized, perhaps, but without protest? Conant in *109 East Palace* reports that Harrison feared "a divorce might ruin a rising doctor," suggesting that his professional, if not personal, preference might have been to drag his heels. However smooth or bumpy the process, Kitty scored another divorce. A single lass for mere hours, she then wed the man she'd stick by for better (American hero) and worse (American scapegoat) in the Virginia City, Nevada, courthouse, their marriage vows witnessed by a court janitor and local clerk, Kitty's baby bump on proud display (Streshinsky and Klaus).

In their first joint home at 1 Eagle Hill in the Berkeley Hills, Kitty settled into the role of wife of an academic star, thrilled by her husband's status and success, less thrilled with motherhood. Peter Oppen-

heimer, born in 1941, would not be the focus of either of his parents' lives. The new couple entertained often and well, pre-dinner drinks a round of Robert's potent and legendary martinis. Several biographers enthuse about both Kitty's and Robert's culinary talents, but not everyone left the table happy. In *Something Incredibly Wonderful Happens: Frank Oppenheimer and His Astonishing Exploratorium*, K.C. Cole records Frank's wife's complaint that "there was never enough to eat" at her brother-in-law's dinners. The Oppenheimer wives did not bond. Like her husband, Jackie Oppenheimer was a Communist Party member; Kitty's "aristocratic pretensions" pissed her off (Streshinsky and Klaus). In *J. Robert Oppenheimer, the Cold War and the Atomic West*, Jon Hunner replays a lengthier Jackie rant: "Kitty was a schemer . . . She was a phony. All her political convictions were phony, all her ideas borrowed." For the still un-persuaded, Kitty's sister-in-law kicked her criticism up another notch: "She's one of the few really evil people I've known in my life."

At Eagle Hill, the Oppenheimers welcomed such guests as Steve Nelson—Joe Dallet's comrade, Kitty's friend, and soon Oppie's friend. They contributed to various "leftwing" causes, including aid to California's migrant workers. They were put under surveillance by the U.S. government, and Robert continued to visit Jean Tatlock—with Kitty's knowledge, if not enthusiastic consent, according to Robert Serber ("Manhattan Project Voices"). Oppie also maintained what Streshinsky and Klaus label a "close emotional bond"—other biographers have labeled it an affair—with clinical psychologist Ruth Tolman, wife of friend and Caltech colleague Richard Tolman. Despite having to share her husband's affections, Kitty, for once, seemed relatively content. And when General Leslie Groves came calling, convinced, despite Oppie's Communist associations, that Oppie was the man to direct the Los Alamos Laboratory in its race to build an atomic bomb, Kitty shared her husband's enthusiasm and ambition, delighted at the bounce in prestige and Oppie's ascendancy to the world stage. As far as Army

base accommodations, hadn't they always enjoyed roughing it at Oppie's primitive cabin in the Pecos Mountains, not far, as the crow flew, from the mesa they'd now be calling home? How bad could it be, living in Los Alamos?

※

Already occupying the soon to be top-secret site: the Los Alamos Ranch School, founded in 1917 to toughen up rich, frail boys not unlike the rich, frail boy Robert Oppenheimer had been. Twelve years before the U.S. government commandeered the school and its property, fifteen-year-old William Burroughs counted as one of the students required to wear shorts year round, hike, camp, build trails, clean his room, and make his bed at a tuition cost of $2,400 per year. Burroughs's dis of the institution appears in his essay collection *The Adding Machine:*

> Far away and high on the mesa's crest I was forced to become a Boy Scout, eat everything on my plate, exercise before breakfast, sleep on a porch in zero weather, stay outside all afternoon, ride a sullen, spiteful, recalcitrant horse twice a week and all day on Saturday . . . I was always cold and hated my horse.

Subsequent targets of Burroughs's hatred: Robert Oppenheimer and the man, from Burroughs's home state, who gave the executive order to deploy what the Los Alamos Laboratory produced.

In April 1943, the director's family moved into what would be their home until October 1945: a log and stone cottage previously assigned to Ranch School faculty, Master's Cottage #2, renamed T-III by the Army. To "facilitate the social role of the director," the Army Corps of Engineers slightly enlarged the original 1,200-square-foot house, adding a new kitchen and converting the old kitchen into a dining room ("Historic Structure Report for the J. Robert Oppenheimer House"). The

Oppenheimers whitewashed the walls and, as they had in Berkeley and would again in Princeton, took a less-is-more approach to décor. To the eye of Louis Hempelmann, the Oppenheimers' close friend and physician, "all of their places were always very stark. They both had marvelous taste and they had marvelous things, but (their homes) were just as stark as they could be" ("Manhattan Project Voices"). At T-III cocktail parties, as elsewhere on the mesa, drinkers got drunk faster due to the mesa's 7,500-foot altitude.

Restricted and restrictive, Los Alamos forms the backdrop of much of Kitty's negative press. Kitty "would pick a pet, one of the wives, and be extraordinarily friendly with her, and then drop her for no reason," recalled Emily Morrison, wife of physicist Philip Morrison. "She could be a very bewitching person, but she was someone to be wary of" (Conant). Kitty did not thrive in what biographer Conant describes as the "small-town clubbiness that characterized life on an isolated army post." Kitty and Oppie had brought their horses with them, and Kitty rode often but less than she would have liked with her preoccupied and over-worked husband. She had time on her hands—too much time. Bored or lonely or antsy—or a combination of the three—Kitty ignored gas-rationing edicts and fled gated Los Alamos in a pickup truck, driving full-throttle down the switchback mountain road and on to Santa Fe, a thirty-five-mile, one-way journey. Destination: La Fonda Hotel bar.

What might have seemed in theory a grand adventure, day in and out proved challenging. Water was scarce on the mesa, electrical power uncertain. The commissary stocked less-than-fresh fruits and veggies. The secrecy of the project meant husbands couldn't talk about their work with wives, wives couldn't reveal to relatives where they lived. No outsiders were allowed to visit "The Hill." All mail was censored. Kitty was far from the only wife feeling besieged and struggling to adjust. In her essay from the book she co-edited, *Standing By and Making Do: Women of Wartime Los Alamos,* Jane Wilson lays bare the situation:

In the mountains of New Mexico the women aged. We aged from day to day . . . We had few of the conveniences which most of us had taken for granted in the past. No mailman, no milkman, no laundryman, no paper boy knocked at our doors . . . Everything had to be reported to the Security Officer. Living at Los Alamos was something like living in jail.

When Kitty got sloshed, she would "divulge extremely personal details about her sex life" to other women, including how she had to "teach" her husband the art of foreplay and encourage him to treat sex as "fun" (Streshinsky and Klaus). Having fun while having sex or just having sex, the Oppenheimers, like many couples cooped up on The Hill, conceived a wartime child. Katherine, known as Toni, was born in the Los Alamos hospital in December 1944. After the births of both her children, Kitty exhibited symptoms that suggest postpartum depression. In Berkeley, Kitty had experienced "a bad pregnancy and delivery" with Peter that left her "exhausted," according to Haakon Chevalier ("Manhattan Project Voices"). Chevalier gives further details in his book *Story of a Friendship*: Oppie "felt that Kitty badly needed a thorough rest" at Perro Caliente, Robert's New Mexico ranch. Assisted by a nurse hired by the Oppenheimers, the Chevaliers stepped in and took care of infant Peter in his parents' absence. Following Toni's birth in Los Alamos, Kitty also struggled to regain equilibrium. "The pediatrician's wife came to visit and was alarmed by Kitty's languour. The house seemed morose," reports Streshinsky and Klaus. "Kitty spent her days with drapes drawn, stretched out on the sofa." Eventually Kitty, with Peter in tow, went to stay with her parents in Bethlehem, Pennsylvania. During Kitty's three-month absence, Toni lived with and was cared for by Pat Sherr, another Los Alamos wife and mother. Visiting his daughter, Robert asked whether Sherr might like to adopt Toni; appalled, Sherr refused. In the opinion of Robert Strunsky, a later acquaintance

of the Oppenheimers: "I think to be a child of Robert and Kitty Oppenheimer is to have one of the greatest handicaps in the world" (Hunner).

At the end of the war, disinclined to return to teaching, Robert accepted the directorship of Princeton's Institute for Advanced Study, and the family, horses, and dog moved to a three-story colonial house with gardens known as Olden Manor, a short stroll from Robert's new office. Simultaneously serving as chair of the General Advisory Committee of the Atomic Energy Commission, Oppenheimer would run increasingly afoul of those who believed the more bombs the better as he argued against building a hydrogen bomb and in favor of international arms control. However beloved by a certain set of scientists, academics, and government officials, another set (J. Edgar Hoover, Lewis Strauss et al.), incensed by Robert Oppenheimer's beliefs and offended by his personal arrogance, formed an enemy bloc that ultimately resulted in the revocation of security clearance for the former director of top-secret Los Alamos Laboratory.

With her husband and his lawyer, Kitty attended the first morning session of the security hearings on crutches, her "face splotched from a recent outbreak of measles" (Streshinsky and Klaus). Thereafter she would be allowed in only as testifying witness. Asked by panel chair Gordon Gray: "Mrs. Oppenheimer, how did you leave the Communist Party?", Kitty answered: "By walking away." Pressed to explain, why then, she continued to be seen in the company of Communists, Kitty answered: "I left the Communist Party. I did not leave my past, the friendships, just like that." It was a friendship tutorial that failed to persuade the panel but won her points outside those chambers. In a break from the usual pattern, during this extended patch of stressful reality, Kitty drew praise from Oppie's circle. Princeton mathematician Freeman Dyson described her as "a tower of strength to us as she was to Robert" (Hunner). Physicist Rudolf Peierls described her as "a person of great courage," particularly when "facing enemies" (Streshinsky and Klaus).

That was the public face. Behind closed doors, Kitty was in bad shape and getting worse. She drank copiously, injured herself often. In almost constant pain from pancreatitis, she took massive quantities of pills—for pain relief and to sleep. Nodding off holding lit cigarettes, she burned holes in the sheets and her nightclothes and on at least one occasion, according to Oppie's Princeton secretary Verna Hobson, set fire to the house. And yet, "if there was some reason" to do so, Hobson continued, "I have seen her pull herself together when you did not believe she possibly could" ("Manhattan Project Voices"). What Kitty could not do, drunk or sober, was overturn the security panel's decision or buck up the spirits of her disheartened spouse. The hearings left both Oppenheimers angry and deeply bitter. In those reactions, they were not alone.

Their respite was the island of St. John, where in 1957 they built a simple beach house on two acres off Hawksnest Bay, property purchased from Robert and Nancy Gibney. There the Oppenheimer family swam, fished, sailed, went barefoot, and tried to forget the recent past. On St. John, Kitty had great success cultivating orchids, less success in charming her Gibney neighbors. Like many a woman before her, initially Nancy Gibney was drawn to Robert but not to his wife. Time and proximity reversed the preference. "I came to have a sneaking fondness and respect for Kitty," Gibney confessed. "At her worst, she was absolutely without guile, brave as a little lion, and fiercely loyal to her own team." Robert Oppenheimer, Gibney ultimately decided, was the "devious one" (Bird and Sherwin).

To judge by an account published by evolutionary biologist Lynn Margulis, during this phase of his life, Oppenheimer could also be tauntingly cruel to his wife while playing up to a worshipful student. During her spring break from college in 1955, on an Oppenheimer pilgrimage, Margulis showed up unannounced at Olden Manor. Despite Kitty's obvious displeasure, Robert insisted Margulis accompany the family of four on a trip to town and afterwards return to the house,

where he showed off his art collection and chided his "tight-lipped" wife for "not being very entertaining." Oppie's entertaining ways, described at length by Margulis, included pressing his guest's hand and gazing upon her "affectionately . . . with his melancholy gleaming blue eyes"—special attentions that caused Margulis to "tingle with pleasure" and feel "drunk with Dr. O and scents of spring." Although Margulis's "Sunday Morning with Robert Oppenheimer" was published as nonfiction, the encounter has the trappings of a one-act play: possessive wife, passive aggressive husband, the arrival of an unexpected guest.

<div style="text-align:center">۞</div>

Still alive when the first of his stage incarnations came into being, Oppenheimer threatened to sue playwright Heinar Kipphardt for the 1964 drama *In the Matter of J. Robert Oppenheimer*. Despite stellar reviews and audiences "mesmerized by Kipphardt's portrayal of Oppenheimer standing frail and lean before his accusers, like a modern Galileo," Oppie intensely disliked the play (Bird and Sherwin). The hearings, he fumed, were not the stuff of tragedy as presented by Kipphardt; they were the stuff of farce.

Characterizations of Kitty on stage and screen are, to date, the characterizations of a lowly supporting player. In none does she come close to co-star billing. In Carson Kreitzer's play *The Love Song of J. Robert Oppenheimer*, both Kitty and Jean Tatlock are overshadowed by "pre-Biblical demon/first woman" Lilith, a character only Oppenheimer can see. In Tom Morton-Smith's drama *Oppenheimer*, Kitty drinks (Kitty characters always drink), makes her play for Oppie at the Pasadena garden party by offering him a Scotch and soda, and as a first-time unmotherly mother whines: "I smell of sick, off-milk and baby-shit." As to why composer John Adams and librettist Peter Sellars had Kitty sing Muriel Rukeyser's poems in the opera *Doctor Atomic*, the reason

was dearth. They were no Kitty "quotes" to draw on, Adams explained ("Manhattan Project Voices").

In *Oppenheimer*, the BBC's seven-episode series starring Sam Waterston as Oppie, Kitty, portrayed by Jana Sheldon, has a feistier presence. As in other portrayals, few are the scenes in which Kitty is not clutching a drink—usually a drink and a cigarette—and during those exceptions her hands are on a steering wheel. The script soft pedals Oppie's well-documented impatience and displays of superiority; Kitty fills in the slack, calling General Groves a "fat idiot" and Edward Teller "a creep." When Lt. Col. John Lansdale, head of security for the Manhattan Project, quizzes Kitty about her Communist past, she cuts him off with a well-timed: "We know you've been spooking us." But those are the highlights. Otherwise the Kitty character berates the help, argues with Oppie's lawyers, drinks more while enjoying it less, and gets summed up by sister-in-law Jackie as "the same unhappy bitch" she'd always been.

❖

Although Kitty's parents lived within an hour's drive of the Oppenheimers in Princeton, Kitty saw little of them. There had been a further rift between parents and daughter. Franz died in 1955. In 1956, Kaethe decided to return to Germany to live with sister Hilde and booked passage on the Norwegian freighter *Concordia Fjord*. During the crossing, she stripped naked, placed a chair beneath the porthole, and crawled out. Her body was never found. Despite evidence reported in the ship's log and the U.S. State Department's conclusion of suicide, Hilde convinced herself her sister's death had been an accident, and Kitty, in a telegram to her aunt, reprinted in *An Atomic Love Story*, pretended to agree.

> I believe you are correct that it was an accident. You've done everything you could do and you shouldn't let it tor-

ment you. Mutti gives you everything that is left, about
$9,000 and her clothes. I had hoped in the end that you
would get everything and now it's true.

Closer to home, Kitty must have assumed, given the state of her
own health, that Oppie would outlast her. A malignant growth in his
throat was discovered in January 1966. Despite surgery and a course of
radiation treatments, the cancer returned a year later, this time inop-
erable. In keeping with Robert's wishes, Kitty distributed his ashes in
Hawksnest Bay within sight of their beach house. "Within a year or two
of Oppie's death," biographers Bird and Sherwin write, seemingly unin-
terested in nailing down the timeframe specifics, the focus of their book
departed, "Kitty began living with Bob Serber, Robert's close friend
and former student." Biographers Streshinsky and Klaus introduce the
Kitty/Serber relationship with this judgment: "Kitty did what she had
always done when she found herself without a man. She looked around
and saw that another was available, this time Robert Serber." Though
the couple intended to sail around the world, Kitty became ill off the
coast of Colombia and died of an embolism on October 27, 1972, in a
Panama City hospital. Her ashes were also scattered in Hawksnest Bay.
Robert Serber moved on with Toni Oppenheimer's friend and contem-
porary, the significantly younger Fiona St. Clair, whom he married in
1979. Of note: no source accuses Robert Serber of an inability to be
without a woman; no source accuses Robert Serber of attaching him-
self to the female nearest at hand.

At the current moment, to believe history has treated Kitty Oppen-
heimer well is to believe the adage that there is no such thing as bad
publicity. Peter Oppenheimer's daughter Dorothy Vanderford chooses
to take the longer view. In a "Manhattan Project Voices" interview,
Vanderford says of the grandmother she never knew: "She was a color-
ful, outspoken person . . . when women weren't necessarily outspoken
and colorful. We read things differently over time."

MARGARET MITCHELL'S DUMP

THERE COMES a point when one must venture beyond the hotel bar at a writers' conference. Days and nights of knocking elbows with contemporaries competing for jobs and book contracts is an exhausting, nerve-fraying business—so there's the self-preservation angle to consider. There's also the very practical matter of service. Jammed hotel bars tend to deliver the goods *slowly*.

In Atlanta, my conference roomie and I made it through a day and a half's worth of nonstop programming before broadening perimeters seemed not only a wise choice but a pressing necessity. Nonetheless (admirably? foolishly?) we stayed on theme in our offsite wandering. Leaving behind a Hilton filled with writers alive and well and professionally grasping, we set off to visit the lair of the dead and certifiably famous Margaret Mitchell.

According to the map, in terms of distance, we could have walked from the hotel to the Margaret Mitchell House and Museum on the corner of Peachtree Street and Peachtree Place, but a steady drizzle put us off the idea. Many are the Peachtrees in the city; even so, we'd assumed any Atlanta cabby would know how to reach the Mitchell shrine without backseat assistance. When that turned out not to be the case, my heart took a little hit for the departed. As famous as Margaret Mitchell had been and remained among a certain set, not every cabby currently driving the streets of her native city recognized her name.

To keep from endless circling, my pal took charge, telling the driver where to turn and when. After several more loops, we reached our des-

tination. Inside the museum, there was no line at the ticket counter—explaining, perhaps, the lack of cabby familiarity with the Margaret Mitchell House and Museum. A Southern gal deficient in Southern cordiality snatched our money and advised us to "look around" while waiting for the tour guide to show. The empty lecture hall contained blown-up photos of Mitchell primarily culled from her girl reporter era and featured a pert, tiny, perfectly made-up femme surrounded by beefier sorts. On an undersized screen, we watched a video of reminiscences about "Peggy" by those who'd known her when. The building seemed to have a tin roof. Rain clattered; thunder rumbled. My pal and I craned forward, hoping to improve our hearing. Very likely we would have had trouble understanding portions of that commentary on a cloudless day. A few of the interviewees reminded me of my male relatives and their antics when forced to communicate aloud. They permit sound to escape their mouths, their lips just refuse to take part in the process. Since I'm Southern born, bred and inculcated, I can say it: there's aggression in that verbal thwart and plenty of it.

I don't know about you, but when I do the touring thing, I expect my guide to at least pretend to care about the tour's subject—be it architecture, former illustrious inhabitants or expansive landscaping. As our group of seven gathered round, our Mitchell Museum rep kept her back to us, exchanging complaints with the cashier. Turning, she didn't adjust her frown. She looked, and continued to look, sorely put out. She showed no sign of—how to phrase this?—a fan's fervency and her "follow me" wasn't the least bit inviting.

Yet follow we did, into the drizzle, across the lawn and into the apartment building Mitchell christened "The Dump." The author had lived on the first floor, but we started higher, trudging through freshly painted, vacant, upper story rooms while our tour guide talked arson. Two onsite cases: the first in 1994, another in 1996, just prior to the opening of the Olympics.

"We have a pretty good idea who did it, both times," our guide said. Pressed for specifics, she said again: "We have a pretty good idea." And that was that.

Then we descended to Apartment 1—or very nearly. In the ground-floor hallway, our guide paused to pat the banister's decorative lion's head, as "Peggy" had "always" done in passing "for luck." Anyone fantasizing that our guide patted the *original* lion's head was fast disabused. Squatter thieves had made off with that treasure long before.

At last we entered the exalted chamber where the "majority" of *Gone with the Wind* had been composed. (Warning to future visitors: ask for a more specific definition of "majority" at your peril.) The living room slash study, the first of three rooms, each opening into the next, turned out to be a grim, ill-lit, claustrophobic cavity with furnishings bunched one in front of the other—a necessary arrangement, given the lack of spread-about space, but in effect not pleasing to the eye. Near the curtained window and window seat, cattycorner to the wall, stood the tiniest of desks and on it the tiniest of typewriters, a Remington manual. To bend closer to that doll-like workspace required pulling in the elbows an additional several inches. At this juncture, our guide repeated the oft-told anecdote of editor Harold Latham purchasing an extra suitcase to haul Mitchell's lengthy manuscript back with him to NYC. To summon up a sense of that bulk (I'm guessing), our guide pointed toward stand-in manila envelopes, stuffed and strewn about on the window seat.

All recreation.

The phonograph we saw hadn't belonged to Peggy, nor had the sofa, nor had the armchair doilies. One piano stool remade as a hardback chair had been in Peggy's mother's house, but otherwise what surrounded us had no family connection. Nonetheless, according to the guide, a distant cousin of the writer had once breezed through and pronounced the goods and their arrangement "exactly right." Then, as if

someone had contradicted, our guide repeated more sharply: "*Exactly right.*"

Immediately after the shock of the teensy desk: the startle of a radically undersized bed. The mattress occupying center stage of the middle room didn't appear wide enough to sleep two, no matter how petite the one. Inconceivable that John Marsh or any fellow of average or better height could have stretched his legs without smacking the bed frame.

Perhaps the original bed had been somewhat larger?

No. The dimensions of both original and replacement were *exactly* the same.

According to Margaret Mitchell House and Museum sources, Peggy's serious beaus were three: the fiancé who died in France during World War I while Peggy studied in the northland (Smith College); first husband "Red" Upshaw; and the man who quickly replaced him, Marsh. Since the Marsh/Mitchell wedding reception took place in Apartment 1 of The Dump, one can only hope petite Peggy had petite friends. Otherwise how would guests have managed a celebratory toast? How would they have found the elbowroom to raise a glass?

Exiting through the miniscule kitchen (the size of a large closet) onto a porch, we were soon again in drizzle. As our guide searched the pockets of her raincoat for the Movie Museum key, a thoroughly soaked fellow ambled by on the sidewalk, a fence between us and him, and asked for spare change.

"I don't have a dime on me. NOT A DIME," our guide replied. To us, she said: "And THAT'S why we keep EVERYTHING LOCKED."

I was still appreciating the psychological soundness of someone who worked at a toy desk and slept in a close-to-toy bed cavorting, imaginatively, in the broad fields of Tara when we single-filed our way into the cavern-like Movie Museum and were informed we'd be "on our own" for the next fifteen minutes.

Among the highlights: the movie-set front door to Tara; framed costume sketches of Katie Scarlett's ball gowns; and *Gone with the Wind*,

the film version, continuously playing in an alcove. When my pal and I passed by, Vivien Leigh was flouncing around the lumber mill, fuming at milksop husband number two.

Last stop: gift shop. There I'd hoped to purchase a Tara snow globe to bookend my Graceland snow globe. The shelves held figurines, collectible plates, postcards of petite Peggy hovering over her petite typewriter, but no snow globes. Also not in stock, even in the interest of making a buck for the Margaret Mitchell trust, Alice Randall's 210-page parody or empowerment text or uneven debut novel (depending on which critical opinion you favor): *The Wind Done Gone.*

Outside again and taking the long way back to our original departure point, our guide waved in the general direction of an intersection, three blocks distant, where Mitchell had been run over by an off-duty (perhaps lost and confused?) cabby. Mitchell and Marsh had been crossing the street together, but whereas Marsh continued safely to the other side, Peggy, our guide reported, skittered back and was hit.

Not *exactly* the version of the accident I'd read, but a version that suggested a lamentable lack of arm-lending chivalry by one Southern male, circa 1949.

"Wanted to be hit," my pal concluded.

Our return-trip cabby had no trouble whatsoever finding his way to conventioneers' central. We parted company, my pal and I, in the hotel lobby. She headed downstairs to the book fair; I beelined it to the bar and there found my editor, a Southern gentlemen of letters, comfortably settled in. After a few catch-up rounds, I confessed my earlier whereabouts.

"Margaret Mitchell. She a writer?" he asked, eyebrow cocked.

He'd been at the bar for a while. Even though I had every faith, *every faith*, that he'd be perfectly capable of holding his own should a brawl break out over Mitchell's ranking on the MOST INFLUENTIAL OF ALL TIMES author list, I prepared for an attack by eavesdroppers sin-

cerely offended by the mockery or happy to pretend offense in order to scream, slug or both.

But apparently no Peggy apologists/avengers were boozing at the bar just then.

We drank on, my editor and I, fighting only to capture the bartender's attention in a bar lousy with writers in Peggy Mitchell's hometown.

MARY MCCARTHY PERFORMS MARY MCCARTHY

*You know, I think she's never felt very real, and that's been her
trouble. She's always pretending to be something-or-other and
never quite convincing herself or other people.*

*—Elizabeth Bishop on the subject of Mary McCarthy in a
letter to Pearl Kazin, February 22, 1954*

FACT: Mary McCarthy was born in Seattle in 1912.
Fact: A lifelong smoker, she died of lung cancer in New York, age
seventy-seven.

Fact: At age six, she lost her parents, both victims of the 1918 flu
epidemic.

Raised thereafter by relatives, the first set of substitute guardians
making short work of destroying what previously had been an idyllic
childhood, Mary McCarthy quick-learned to take care of Mary. In the
process, she became a determined, ambitious, acerbic, scrappy combat-
ant who relished attention and prided herself on rising to a challenge;
a woman who, refreshingly, neither disguised nor distrusted her own
formidable intellect and tough-nut will; an eviscerating, provocative
critic, reporter, bestselling novelist, and three-time memoirist, two of
those memoirs composed in the last decade of her life.

"A noted autobiographer whose autobiographical work is riddled
with fiction, and a fiction writer who leans heavily . . . upon autobi-
ography," summarized Doris Grumbach in *The Company She Kept –
A Revealing Portrait of Mary McCarthy* (1967), a biographical project
originally supported by its subject—then not.

Not fact, but odds-on conjecture: Mary McCarthy preferred to tell her story herself.

ॐ

In the early stages of her career, McCarthy distinguished herself from the pack with slash and gut theatre reviews, "debunking anything that others applauded," in journalist Midge Decter's description. Among the playwrights and plays on McCarthy's takedown list: Tennessee Williams and *A Streetcar Named Desire*. A card-carrying member of the *Partisan Review* crowd, McCarthy speedily expanded her critical coverage to include prose and politics. Although she disliked being described by *Time* magazine as "quite possibly the cleverest writer the U.S. has ever produced," her writing—critical and creative—*is* clever. Also bracing and snidely funny.

From the essay "Naming Names: The Arthur Miller Case":

> When Arthur Miller . . . was indicted for contempt of Congress this February, the American liberal public was not aroused . . . This may be attributed to apathy . . . or, in this particular instance, to a sense that nothing bad can really happen to the husband of Marilyn Monroe.

From the unfinished novella, *Lost Week*: "The salient feature of this community of writers and artists was that most of the writers did not write and most of the painters did not paint."

McCarthy's essay "The Fact in Fiction" (1960) offers a crash course in her critical writing M.O., a network of sweeping pronouncements delivered forcefully, stylishly, and with unshakable confidence in the accuracy of a superior judgment. A novel is/must contain a "heavy dosage" of "fact." A novel must be "touched" by "the breath of scandal." A novel that contains talking beasts, the supernatural, occurs in

the future or contains miracles is *not* a novel. Those so-called "histor-ical novels"? Merely "romances." The "last great creator of character in the English novel"? James Joyce. The author "who may have killed the novel"? Henry James. The problem with Virginia Woolf's fiction? It does "not stoop to gossip."

Critics of McCarthy's own novels object to abrupt endings and an absence of plot. The author who argued that "the chapters on the whale and on whiteness" in Melville's *Moby Dick* could not be "taken away . . . without damaging the novel," herself came under fire for in-cluding "boring expository pages" on the "structure and function of a 'progressive college' " in *The Groves of Academe* (Helen Vendler) and for dwelling on the "varieties of helicopter landing gear" in *Cannibals and Missionaries* (Pearl Bell). Even McCarthy's pal Nicola Chiaromonte be-moaned McCarthy's inability to "to stick to some line of consistent development, instead of showing off in all directions." Outgunning naysayers of her fiction in a 1961 *Paris Review* interview, McCarthy questioned her engagement with the genre altogether, not "sure," she said, that any of her "books are novels. Maybe none of them are."

In the "Fact and Fiction" essay, elaborating on the point that an "air of veracity is very important to the novel," McCarthy contends: "The presence of a narrator, writing in the first person, is another guar-antee of veracity." Unreliable narrators are not discussed. In her own writing, McCarthy saved the first-person approach for her memoirs. That she, herself, could be unreliable in the narrating she revealed in *Memories of a Catholic Girlhood* (1957), a collection of eight autobio-graphical essays published individually in *The New Yorker* and *Harper's Bazaar*. McCarthy's ingenious and, for the era, arresting method of exposing textual inaccuracies was to cross-examine herself, copping to the "highly fictionalized" nature of "The Blackguard" in the essay's af-ternote and addressing other fabrications in other afternotes. If Mary McCarthy needed calling out, she'd handle the job herself, thank you very much.

McCarthy prided herself on truth telling—first time out, or second—a stance that led her to "imagine and deceive herself into a kind of exemplary figure of virtue" in the view of cultural critic Lee Siegel. As McCarthy's idol, mentor, and beloved friend Hannah Arendt wrote: "No factual statement can ever be beyond doubt—as secure and shielded against attack as, for instance, the statement that two and two make four." Did no friend to Mary, sharing a smoke break or preprandial martini, suggest the obvious? "Humans lie, Mary. Get over it." Judging by McCarthy's last two memoirs, no such intervention (successfully) took place.

<div style="text-align:center">⚙</div>

In the PBS series "The Brain," host David Eagleman discusses the limited shelf life, scientifically speaking, of memories: "Our memories fade because our brain has only a finite number of neurons, which then get used for other memories." In essence, the past is rolling invention. Make of it what you will. Pair that physiology-based license to invent with the impossibility of any insider "I" having full access to the external view and the question becomes: why read memoirs? One draw: to peek at how the author perceives herself and how that self-awareness will be revealed and constructed on the page. To the memoirs of successful, famous folk, we readers bring an extra layer of expectation in the form of preconceptions. Will our preconceptions be ratified or dispelled?

In Frances Kiernan's biography/oral history, *Seeing Mary Plain*, we learn that McCarthy's editor, William Jovanovich, had long been agitating for a follow-up to *Memories of a Catholic Girlhood* and was willing to pay handsomely for its delivery. *How I Grew* (1987) kicks off with an announcement of McCarthy's 1925 birth "as a mind," age thirteen, and finales with her having *"done the wrong thing"* (her italics) in marrying Harold Johnsrud "exactly one week" after her graduation from Vassar.

Intellectual Memoirs, a slimmer, posthumous volume containing the chapters McCarthy completed before her death in 1989, covers the beginnings of her career in New York and also finales with a marriage that "was a mistake," the second to Edmund Wilson.

Assessing McCarthy's canon in the author's *New York Times* obituary, Michiko Kakutani differentiated between the "beautifully observed" *Memories of a Catholic Girlhood* and the "more workmanlike" *How I Grew.* The second and third volumes of McCarthy's memoirs resemble each other more than either resembles the first. Chunks of both *How I Grew* and *Intellectual Memoirs* come off dictated, as opposed to written, "talked" rather than composed. "But wait! Now that I think of it . . ." "All of a sudden it strikes me . . ." "Hold on!" "Have I written this?" Both are chatty books that rely on the charm of a chatty performance. (McCarthy once aspired to the stage.) *How I Grew* also details the books McCarthy read (lists provided), drinks she's downed, and persons named and unnamed who fell for her charms. Seattle bohemian Czerna Wilson, she of the "slow, lazy movements" ("Could she have been an octoroon?"), took a fancy to the young McCarthy—an attraction unreciprocated, we're told, because "having been groped more than once by hairy girls who had asked (her) to spend the night," McCarthy "was not interested in being a lesbian." Among those McCarthy was interested in bedding: a "little Communist actor who wore lifts in his shoes" and once "three different men" in "twenty-four hours. It was getting rather alarming."

Sex, the comedy, was trademark McCarthy. From her first semifictional outing, *The Company She Keeps,* McCarthy refused to present screwing through the soft focus lens of romanticism. One of the funnier lines in *How I Grew* is McCarthy's description of penetration the "first" time she lost her virginity as "perhaps a slight sense of being stuffed." And yet, in the closing pages of *Intellectual Memoirs,* we are asked to accept that she, who had by then taken up and discarded scores of lovers, married Edmund Wilson in part to "punish" herself for having "gone

to bed with him." A more plausible explanation lurks in memoir number two: "Although a rebel, I did not care to picture authority as weak, putty in my hands . . . For self-realization, a rebel demands a strong authority, a worthy opponent." In Edmund Wilson, Mary McCarthy found a worthy opponent.

Another wobble in McCarthy's otherwise cavalier-about-sex attitude occurs when she references "some of the things" she, as a high school senior, did "in bed" with older fellow Kenneth Callahan. Those unspecified "things" made her "cringe with shame" and taught her "how to deal with shame and guilt. When you have committed an action that you cannot bear to think about . . . make yourself relive it, confront it repeatedly . . . thorough sheer repetition it loses its power to pain you." A rare admission of vulnerability and upset, a brief break in pattern. And then the pattern resumes. "I learned the trick of it. Nobody told me; I found out the recipe for myself."

A whiz at scathing characterizations in any genre, among the dozens McCarthy lets loose on in her last two memoirs: "soap and water Christian" Hope Slade; Kay Dana, the "yellow-eyed lynxlike blonde given to stretching herself like the cats she fancied"; George Guttormsen, that "freak case of a football star who was Phi Beta Kappa"; and Edmund Wilson's mother: a "stumpy downright old lady with an ear trumpet and a loud, deaf voice." Edmund Wilson himself, first eyeballed by McCarthy when he guest-lectured at Vassar, gets this flash portrait: "heavy, puffy, nervous . . . a terrible speaker, the worst" McCarthy "ever heard." Keen to establish in *How I Grew* that "sticking labels on things" was "not a Vassar habit," McCarthy declared that such a practice had "never been one of my own faults, congenital or acquired." "Monster" Edmund Wilson in *Intellectual Memoirs* might agree to disagree.

With the exception of select Vassar professors, McCarthy isn't overly kind to her gender. Dumpiness, in particular, offends her sensibilities. The "only time" she "saw Dorothy Parker close up," McCarthy

tells us in *Intellectual Memoirs*, she was quite "disappointed" by Parker's "dumpy appearance." Writer and editor Margaret Marshall compounds the dumpy offense by, to McCarthy's "horror," still managing to consider herself a "seductive" woman. (Marshall also gets black marks for never "cooking a meal" and failing to display "much energy." Laziness in any human, male or female, disgusted McCarthy.)

Repaying the compliment of McCarthy's snootiness about physical beauty, biographer Kiernan jumpstarts her 845-page *Seeing Mary Plain* describing a chance encounter with her subject in *The New Yorker's* "ladies room" in the 1970s, at which time the "glamorous dark lady of letters" Kiernan recalled "from photographs" appears in the flesh as a woman with "enough gray strands to make her seem pale and washed out and even a bit dowdy." Other less than flattering evaluations of McCarthy's looks, from other observers, follow. Author Mary Gordon reports "shock" at "how provincial" McCarthy appeared: "like a banker's wife." Vassar classmate Eleanor Gray Cheney supposes McCarthy, as a college gal, "might have been pretty," if only she "had stood up straight and washed her face." McCarthy's successor to the title of New York's leading female intellectual, the beautiful Susan Sontag judges McCarthy "attention grabbing" rather than "beautiful." *Partisan Review* co-founder William Phillips was of two minds: "Her legs weren't good, but the upper part was."

Interviewed by CBS's Faith Daniels in 1985, McCarthy assured both interviewer and the viewing public that in her heyday she had been "really quite good-looking." Near the end of *How I Grew*, describing herself on the cusp of her first marriage, McCarthy writes: "I was and always would be a flat-chested, wide-hipped girl"—a frank and forthright assessment, it would seem. Then comes the McCarthy shuffle: "It was a matter of bone structure, everyone said." Irony or excuse?

❖

Comparatively speaking, in the truth-amended *Memories of a Catholic Girlhood* McCarthy builds the case for her specialness with a fairly light touch, going about her task in cheeky, entertaining fashion, acknowledging when she began "to play, deliberately, to the gallery," wittily offering a run-on, overload list of early accomplishments in the manner of: "I stood at the head of my class and I was also the best runner and the best performer on the turning poles in the schoolyard, I was the best actress and elocutionist and the second most devout."

As a memoirist twenty-five-plus years later, McCarthy is cattier, more imperious, harder on others, and more lenient with herself. Regarding deceptions, the candor devotee indulges in some hair splitting. "Through fear of a monstrous guardian, I had become a terrible liar . . . yet lying to parents and teachers is a quite different thing from lying to oneself." "Induced to sneak out" of school with a "delinquent boy" who "had been sent to the reformatory after losing a leg in a hunting accident—perhaps he had got the drug habit," McCarthy demands credit for transparency in the retelling, reminding readers that she has "described how I lied—or at any rate practiced *suppressio veri*" about the "induced" sneak-outs. One of McCarthy's more absolutist claims in *How I Grew:* "In all honesty, I don't recall lying to myself, ever." "Self-deception always chilled me," she insists in *Intellectual Memoirs.* Deceiving lovers apparently didn't arouse the same chill. In a relationship with Philip Rahv when she began the affair with Wilson, McCarthy admits in passing that she "did not confess to Philip" that "a relationship with Wilson was beginning." Skipping on, she restates the situation thus: "The two of us" (she and Wilson) "had a secret between us, and Philip became the outsider."

❁

Over the course of her career, McCarthy appeared to have great fun answering questions about which of her fictional creatures were straight fictions and which were not, treating those queries with the amusement they deserved. Of course there were similarities between Macdougal Macdermott and Dwight Macdonald, Will Taub and Philip Rahv in *The Oasis*, she told Doris Grumbach. The characters in that work (published as a novel, though McCarthy preferred to call it a *conte philosophique*) were "all, more or less, straight portraits, not even composites." On the subject of fictional/nonfictional mergers, she commented and contradicted herself as the mood struck. To Grumbach, she claimed to perceive "no resemblance whatever" between herself and character Martha Sinnott in *A Charmed Life*, adding that Martha "was modeled after a girl she knew in her youth." In *Intellectual Memoirs*, she takes another line. "Martha, I admit, is a bit like me—I tried to change her and failed."

In basing a character on herself, McCarthy was spared the apologies. Explaining—or denying—other "impersonations" in her fiction required outreach. Although Vassar classmate Elizabeth Bishop didn't initially link herself with McCarthy's Elinor Eastlake in *The Group*—nor did she consider her lover, Lota de Macedo Soares, the model for the baroness—friends of Bishop thought differently. Eventually, so did Bishop. In *How I Grew*, McCarthy offers this convoluted account of the rift:

> Years later, I learned, she believed that I had put one of her own Boston marriages into *The Group*. I had not, but since she never told me of that unshakable conviction of hers, I could not deny it . . . I only learned of it—from Robert Lowell—not long before her death. I did not try to disabuse her mind in a letter and waited till I would see her, which never happened . . . The day she died I had just

mailed a letter to her, but on a purely literary subject—no reference, no hint of the "bone" lying between us.

The contents of the letter, dated October 28, 1979, and reprinted in Kiernan's biography, do not match McCarthy's recollection. To Bishop, McCarthy writes:

> Lying is not one of my faults, and I promise you that no thought of you, or of Lotta [*sic*], even grazed my mind when I was writing *The Group* . . . I can see how someone could imagine that you, as a Vassar contemporary, might be expected to figure in *The Group*. It's perhaps even strange that you didn't, but that is the fact.

Fact, truth, the collision of. Did McCarthy honestly misremember? Or did McCarthy convince herself a denial unread amounted to a denial unexpressed?

Once *The Group* accelerated her fame and celebrity, and long before the 1979 "Dick Cavett Show" appearance that sparked Lillian Hellman's lawsuit, McCarthy became a talk show regular, gamely sparring with William F. Buckley on "Firing Line," showing up for the "Jack Paar Show" in 1963 in chic attire, carrying, Queen of England style, a small dark purse with her to her on-set seat. In addition to sticking to her guns that sex was, indeed, comic—not to those "participating" but to "others"—she smilingly contradicted Paar's assumption that the point of *The Group* was to show that women were an untapped "resource." Then McCarthy hit her stride, proclaiming men "were more sensitive than women" and sharing that, unlike their American counterparts, "professional women" in Poland and Yugoslavia "didn't talk all the time"; rather, they let "the men talk"—behavior, McCarthy said, that "impressed her quite favorably."

Outspoken Mary McCarthy perched next to a talk show host known for on-air weeping, advocating that men do all the talking.

Quite the performance.

CAROLINE OF CLANDEBOYE

WHICH OF A WRITER'S BOOKS one picks up first matters. Any further reading will be heavily influenced—if not totally skewed—by that introduction. Expectations and suppositions sprout regarding the writer's methods and motifs that will be proved or disproved by the next title grab. In the meantime: freshness and discovery.

Who/what have we here?

I entered the world of author/reporter/character Caroline Blackwood via the last book she published (though not the last book she wrote) before her 1996 death from cancer. I had hunted down *The Last of the Duchess* not for its author but for its subject because at the time I'd been kicking around the (doomed) idea of writing a novel about young Bessie Wallis of Baltimore, fiction that would focus exclusively on the Southern portion of the Wallis Windsor saga, pre-Prince of Wales romance, pre-Edward VIII abdication, and pre-worldwide fame/infamy for depriving England of its monarch. Despite the narrowness of my intended focus, I had flung wide my research net (e.g., *Some Favorite Southern Recipes of the Duchess of Windsor*) on the working theory that any middle or end contained seeds of the beginning and vice versa.

To say that Blackwood's go at the Wallis Windsor story differs from other accounts on my Wallis shelf is to wildly understate. It is another species. On page one of the preface, Blackwood refers to Maître Suzanne Blum, the Duchess's attorney and Blackwood's adversary in terms of gaining access to the Duchess of Windsor, as Wallis's "necrophiliac lawyer"—someone who had "seized the right to act as

(the Duchess's) spokesperson" and whose penchant for lawsuits had delayed, until 1995, the publication of a book Blackwood had written in 1980, Blum's death finally eliminating the litigation threat. The intervening fifteen years had done nothing to diminish Blackwood's animosity toward Blum. Midway through Blackwood's lead paragraph I already suspected this would be a writer disinclined to tread lightly, who'd get down and dirty not only without apology but with obvious relish; a writer unconvinced by—and possibly contemptuous of—the pose and affectation of writerly restraint. Having since read my way through Blackwood's catalogue of nonfiction and fiction, I stand by my original impressions. There are no tepid Blackwood texts. Seasoned with rage and spiced with acidic humor, they boil.

The Last of the Duchess grew out of a British *Sunday Times* assignment. Blackwood had been enlisted to supply the copy—a brief profile of the Duke of Windsor's widow—that would accompany Lord Snowden's photograph of the Duchess, then eighty-four, in her Paris home in the Bois de Boulogne. That particular puff piece did not appear, but its failure gave Blackwood the material and opportunity to fashion a more lively and contentious account that pitted tenacious reporter Caroline Blackwood against wily lawyer Maître Blum. Structured as a quest narrative, Blackwood three times interviews Blum, attempting with flattery, deflection, obfuscation, and bribery (what if Lord Snowden photographed Blum as well?) to get past the ogre at the gate to the isolated Duchess, cut off from friends and confined (as Blum eventually admits) to bed in an upper story of an increasingly dilapidated mansion. Blackwood describes the décor of Blum's own Parisian digs as a "mixture of equally ugly modern furniture and fake antiques" that suggested "a woman devoid of visual sense." When—regally tardy—the woman herself deigns to join Blackwood for their first conversation, she exhibits a "cruel" mouth, "waxy" skin and, owing to an "overexcessive . . . use of cosmetic surgery," a difficulty in blinking. After Blum "feeds" Blackwood "a steady diet of untruths" about bedridden Wallis's indomitable

health, unblemished beauty, and financial impoverishment, her "ag-grieved and therefore vengeful" interviewer takes off the second glove, describing Blum as a "malignant old spider sitting in her cavern of an apartment spinning out her web of fantasies about the Duchess of Windsor." In support of her anti-Blum sentiments, Blackwood marshals the ill opinion of others. Biographer David Pryce-Jones, for one, characterizes the lawyer as "the purest horror and nightmare." Rumors are rife that Blum is stealing from the Duchess, selling off her jewels. There is speculation that the paralyzed, comatose Duchess, sustained only by feeding tubes, is being kept alive, her existence inhumanely prolonged, solely for the benefit of her keeper. Stonewalled by Blum, Blackwood chats with a number of Wallis's one-time pals and acquaintances about the Duchess's past and fate. Clever additions, those Lady Mosley, Lady Tompkins, Lady Monckton, and Lady Cooper set pieces, for they add another layer of wit and repartee to the tale. Old women themselves by then, Wallis's compadres are confined to wheelchairs, going deaf, denied their evening cocktails by well-meaning (or sadistic) doctors, stripped of choice and agency, at the mercy of someone else's whim, and suffering the indignities and infirmities of age that await us all—even women who enchant kings. Nonetheless, the crew Blackwood consults still thrives on gossip. "The Duchess was certainly never in love with the Duke," Lady Monckton assures Blackwood. "The Queen Mother is really nearly perfect," Lady Cooper confides. "But her one weakness is the Duchess. She still feels very unforgiving towards her." At the close of the book, Caroline Blackwood still has not set eyes on Wallis Windsor, a victory for Maître Blum—but a temporary one. Blackwood's excoriating portrait of Wallis's lawyer remains in print. To paraphrase Harry Crews: *Don't screw with writers. They'll get you in the end.*

✿

That Lady Caroline Maureen Hamilton-Temple-Blackwood would be-
come a writer seemed, at the onset, unlikely. Born into the Anglo-Irish
aristocracy in 1931, Blackwood was the eldest child of Basil Sheridan
Hamilton-Temple-Blackwood, 4th Marquess of Dufferin and Ava, and
brewery heiress Maureen Guinness. (In a wink-wink passage in Black-
wood's autobiographical novel *Great Granny Webster,* the character
Aunt Lavinia drinks "Guinness . . . mixed with vintage champagne.")
Blackwood spent her childhood at Clandeboye, the crumbling ances-
tral estate near Ulster, viewable on the BBC's "The Country House
Revisited" series and currently doubling as a wedding venue. Black-
wood's father was killed while on a covert Army mission in Burma when
Caroline was thirteen. Vain, anti-Semitic, society-mad, fart-machine-
between-her-legs practical joker Maureen lived on. And on. Flamboy-
ant, indifferent mothers do not fare well in Blackwood's fiction. In
"Taft's Wife," flashy, overdressed Mrs. Ripstone, who ignores the son
she abandoned at birth to flirt with the social worker who has orches-
trated their three-way meeting, is presented as a maximally insensi-
tive, preening fool. In the mother/daughter story "How You Love Our
Lady," although daughter Theresa anguishes over her own "drabness,"
all too aware that her mother "longed to get away from (her), as if (her)
dullness was like a disease that might contaminate," it is the mother
Blackwood kills off; Theresa survives.

Descriptions of Blackwood's simultaneously entitled and bleak
childhood tend to foreground absent parents (through death, by
choice), Ireland's endless rain, and the homestead's leaky roofs and
bitterly frigid interiors. At Dunmartin Hall, Clandeboye's stand-in in
the novel *Great Granny Webster,* the staff wear Wellingtons indoors to
"wade through the puddles" because "the roof was incurable," a sieve
for rain. Valuable books in the library have become "glued together and
blue with mildew"; the cold is so intense that the prescient "put on an

overcoat to walk the halls." Outside, "hostile native forces" have invaded the grounds, "fierce armies of stinging nettles . . . seizing . . . the driveway." For reasons obscure, food for Blackwood and her two siblings was less than plentiful. Ruling the nursery: a series of questionable nannies, one of whom dangled Blackwood's brother, Sheridan, out the window to stop him from humming himself to sleep. Blackwood portrays a different kind of danger in "Never Breathe a Word," nonfiction originally collected in the Ulster section of her first book, *For All That I Found There*. McAfee, ex-jockey and riding instructor for Blackwood and her sister, Perdita, is introduced as unsightly (toothless, deformed shoulder, stunted legs, "manure-clotted" fingernails) and annoying—but harmless. When McAfee sees—or pretends to see—potential in the elder Blackwood sister to become "the best wee rider in the whole of Ireland" and suggests a nighttime meeting in the woods to hand over the pills that will ensure that attainment, as readers we tense. Although uneasy and skeptical of a brilliant equestrian future, Blackwood bikes to the agreed upon assignation through darkness that "seemed like an evil, inky soup, floating with every ghastly kind of supernatural spook and spectre." The real threat, McAfee, creepily "wearing his best shiny bowler" and "false teeth," emerges from the shadows and urges Blackwood to take capsules from a bottle whose label has been scrubbed. Frightened and disgusted, Blackwood makes her escape, her adolescent self assuming McAfee meant to poison her, the adult writing the story knowing, and conveying, he intended something quite different. It is a piece in tune with the characterizations and atmospherics of fairytale—the dark woods, the young and vulnerable female, the sinister designs of a misshapen male. "Please . . . please . . . never breathe a word!" McAfee shouts as Blackwood flees, the plea of many an abuser. It is a chilling piece of work from the author who would later pen the novel-length tale of horror, *The Fate of Mary Rose*.

Sent to boarding schools in Switzerland and England, Blackwood completed her formal education at Miss Cuffey's finishing school in

Oxford. At eighteen, born who she was and to the mother she had, Blackwood made her societal debut and here the fun begins. At one debutante bash, guest Princess Margaret sang Cole Porter (off-key). While others beamed and applauded, the painter Francis Bacon hissed and booed. At Bacon's elbow was Lucian Freud, grandson of Sigmund, who in those early stages of his career liked to ponce about in his dead grandfather's overcoat. The married Freud had already made a string of sexual conquests and left behind a string of bruised and bitter lovers. (As reported by Phoebe Hoban in *Lucian Freud: Eyes Wide Open*, former paramour Joan Wyndham described going to bed with Freud akin to "going to bed with a snake.") Bohemian, handsome in a feral sort of way, and on the make in every respect, Lucian Freud was catnip to Caroline Blackwood. Bonus attraction: running off with a married, impoverished, Jewish painter would infuriate Maureen. Freud equally disliked Maureen, calling her "corrupt" and "monstrous" and accusing her of paying "some people to have (him) killed" once he and her daughter became a couple (Geordie Greig, *Breakfast with Lucian*). In Paris, Blackwood and Freud lodged at the Hotel La Louisiane, where Freud began painting the now famous, eye-centric portraits of Blackwood, the first three, including *Girl in Bed,* making his sitter look like a waif of twelve. (The last, *Hotel Bedroom,* painted some time later, transformed Blackwood into a wizened, worried, considerably older creature.) An anecdote both Blackwood and Freud loved to repeat and embroider about their time in Paris—neither immune to its reflected glory—concerns the couple's visit to Picasso's studio. Picasso began his seduction of Blackwood by painting her bitten nails, then invited her to see his doves. Interviewed by Michael Kimmelman for the *New York Times* in 1995, Blackwood described the "old letch" doing a "complete lunge" at her on the rooftop while Freud waited below for three hours, as Freud told Geordie Greig, or for half an hour, as he told Martin Gaylord (*Man with a Blue Scarf*). To circumvent the hiccup of low funds and gain access to Blackwood's trust fund, Lucian and Caroline mar-

ried, returned to London, and settled in to day-drinking and carousing with Francis Bacon and chums in Soho pubs. When not in the pub or in the studio, Lucian slept around and gambled, as was his wont. The odd final straw, as Blackwood tells it, was Freud's indifference to an elaborate meal she had prepared. When Freud pushed away his plate, Blackwood left for a hotel and swiftly thereafter for Italy. Maureen was delighted: "It was marvelous. Caroline ran, ran, ran" (Greig); Freud was bereft. Reportedly he tracked his wife down in Italy and begged her to return, which Blackwood refused to do. Francis Bacon, among others, feared Freud, in his misery, might "top" himself. Freud did no such thing. Like his nemesis, the Marchioness of Dufferin and Ava, the painter lived on and on, outlasting his younger second wife by fifteen years.

❉

Fans of Blackwood applaud her good looks; composer Ned Rorem, for example, declared Blackwood "one of the two or three most beautiful women" he'd "ever seen." Detractors remember her as slovenly and unwashed. Sir Ian Fleming once complained to friends that Blackwood needed "a damned good scrub all over." Blackwood herself seemed to believe her eyes were her best physical feature and throughout her life heavily outlined them with kohl for added emphasis. To judge by Walker Evans's photographs of her, Evans agreed with Blackwood's self-assessment. The pro-Blackwood faction appreciates what Geordie Greig summarized as the "lethal accuracy" of Blackwood's conversational observations, her flair for ignoring the "social niceties" and getting "straight to the point." As a young woman, Blackwood's shyness was said to have tongue-tied her. Alcohol solved that problem but, in the opinion of brother Sheridan's widow, Lindy Dufferin, created another: "Caroline could be mean and a terrific bore when she drank." In her memoir *Why Not Say What Happened?*, Caroline's daughter

Ivana details her mother's loyalty to friends, noting Blackwood's daily habit of spending hours on the phone with those friends, sharing news and dispensing advice. Ex-husband Freud acknowledged her pecuniary generosity, telling Geordie Greig that when he asked Blackwood for funds for Francis Bacon, she readily supplied them, no questions asked. (Blackwood would eventually own—and sell—several of Bacon's paintings, including *The Wrestlers*.) Others found Blackwood's "aristocratic sense of entitlement," in the phrase of Robert Lowell's biographer Ian Hamilton, difficult to stomach. Steven Aronson, who published a lengthy interview with Blackwood in a 1993 issue of *Town & Country*, described his subject as "the most entitled titled person I've ever known." Xandra Hardie (herself the former Lady Gowrie) explained Blackwood's attitude thus: she had "her tribe's fearless, arrogant authority."

<p style="text-align:center">۞</p>

With the means to relocate whenever the urge struck, still in her twenties and in the wake of her break with Freud, Blackwood decided to give acting a try. In Hollywood, she learned to drive, bought a Thunderbird, and hooked up with screenwriter Ivan Moffat, a man who would remain in her life for many years to come. In New York, sans Moffat, she briefly attended Stella Adler's Academy of Acting. (Who were her fellow classmates? Which scenes did she perform? How many servings of vodka, tonic on the side, did it take for Blackwood to overcome her "shyness" and mount the stage? The curious remain curious.) In New York, Blackwood met composer and Aaron Copland protégé Israel Citkowitz, slated to become her second husband and the father of two of her three daughters. Early in their relationship, Blackwood continued to divide her time between New York and California, still, nominally, pursuing an acting career. It was during one of those West Coast sojourns that Stephen Spender invited Blackwood to contribute

to *Encounter.* The result, "Portrait of a Beatnik," is a sneer-y and under-researched piece of work—also funny. The Beatnik, Blackwood writes, "marries in the Ocean (her capitalization), only at midnight."

At a brownstone Blackwood purchased in Greenwich Village, she and Citkowitz settled into domesticity and parenthood. At least initially, Blackwood did not live in the squalor that reputedly characterized her later households and got her banned from multiple hotels. About Blackwood in her New York brownstone, painter Cornelia Foss insists: "There was nothing sloppy about her there . . . She had a wonderful eye. The colors that she chose for her rooms, and the infinite care she took with things! That house was a miracle." If so, a miracle with an expiration date. Despite maids and nannies, disorder set in. Blackwood drank, wrote, and left much of the active parenting to Citkowitz. Bored with her in-house companion, she turned elsewhere for romance, embarking on a long-term affair with Robert Silvers, editor of the *New York Review of Books.* When art historian John Richardson visited Blackwood and Citkowitz, he saw "a mess everywhere." Richardson also observed that the once "brilliant, promising composer" had been reduced to "caretaker," subservient to Blackwood's whims. Erstwhile Blackwood friend Barbara Skeleton based two of the characters in her short story "Born Losers" on Blackwood and Citkowitz during their New York residency. Skeleton describes Grace/Blackwood as someone who created "shambles wherever she went; stubs chucked across a room and left to smoulder"; someone who presided over a residential free-for-all of "stained" sheets, "blocked" lavatory, cockroach-infested kitchenware and "trash bins rankly overflowing"; someone who, told of another's "ghastly misfortune," would "double up laughing"; a wife utterly contemptuous of her passive, acquiescent husband, fully aware that she held "all the trumps" in their unequal relationship.

If Blackwood had become the Queen of Chaos, she met her chaotic match in third husband Robert Lowell. Unlike the extraordinarily patient and unflappably sane Elizabeth Hardwick, Blackwood could not

deal with Lowell's manic episodes. His madness exacerbated her drinking and vice versa. After re-meeting Blackwood at a London publishing party, Lowell, still married to Hardwick, moved in to Blackwood's Redcliffe Square townhouse. Initially Hardwick assumed Blackwood represented merely the latest in a long line of her husband's passing fancies— a rare Hardwick miscall. Lowell joined Blackwood in the top flat of the townhouse; Citkowitz, who had followed Blackwood to London to remain close to the children, continued to occupy the middle flat, and the girls and their nannies continued to occupy the flat below Citkowitz. A scant few months into the Blackwood/Lowell relationship, the poet locked himself and Blackwood in their quarters for three days and refused to allow Blackwood to telephone for help. Thereafter Lowell was hospitalized, his first hospitalization in more than three years, according to Kay Redfield Jamison in *Robert Lowell: Setting the River on Fire, a Study of Genius, Mania and Character*. Blackwood bundled up her kids and fled to the Hebrides. It would become a repeating pattern in their lives together: hospitalization and flight. During various of his manic episodes, Lowell dug at the electrical wires in the walls, read *Mein Kampf* aloud, and incessantly telephoned Jacqueline Kennedy; Blackwood ping-ponged between terror and despair. In early 1971, age thirty-nine, Blackwood discovered she was pregnant; Sheridan Lowell, a first son for both, was born in September. In 1972, Blackwood and Lowell divorced their spouses of record (Citkowitz, Hardwick), married each other, and with her and their children repaired to Milgate, Blackwood's country house in Kent. Walker Evans visited in 1973, snapping Polaroids of the family that show a haggard, wary Blackwood and a glum, pensive Lowell. They were, at that moment, still four troubled years from the finish line. In the now famous conclusion to their story, Lowell was returning to Hardwick when he died of a heart attack in the backseat of a New York taxi. Indicative of his constant wavering between the two women, he was clutching Freud's painting of Blackwood, *Girl in Bed*, when he expired. It was Blackwood, in the *Town &*

Country article, who put about for public consumption the detail that hospital attendants had had to break Lowell's arms to separate corpse from prize. The poet may have been returning to Hardwick, but he died married to Blackwood—a connection his widow continued to tout on book jacket bios. In *On the Perimeter*, her 1984 report on the nuclear protest camps at Greenham Common outside Newbury, her bio paragraph includes the tantalizing news that Blackwood was "at work . . . on a memoir of Robert Lowell." Regrettably—for what a read it might have been!—no such book was published. Left to our imagination: how Blackwood would have portrayed herself, the dead, and the still standing Hardwick.

<p style="text-align:center">⚙</p>

Despite the turmoil of their seven years together, when Lowell was sane and Blackwood sober, they wrote and published. Lowell composed, among others, the poems that would form *The Dolphin*, a collection depicting his complicated attraction to Blackwood (the dolphin) and the break-up of his marriage to Hardwick. His decision to include passages from Hardwick's actual letters dismayed and enraged many of his friends (Elizabeth Bishop, Adrienne Rich, W.H. Auden) and deeply wounded Hardwick, but the book netted Lowell the 1974 Pulitzer Prize. During her Lowell era, Blackwood primarily concentrated on fiction and finished two novels: *The Stepdaughter*, awarded the David Higham Prize for the best novel of 1976, and *Great Granny Webster*, shortlisted for the Booker Prize. The couple often wrote in the same room, Lowell, a compulsive reviser, regularly interrupting Blackwood's progress to confer on the aptness of a word, phrase or line. (How Blackwood felt about those interruptions goes unrecorded.)

Blackwood's worldview was never a cheery one. As a person and as a writer, she did not bask in the glow of positivity or ride the tide of hope. The Blackwood Christopher Isherwood socialized with during

her Hollywood adventure was "only capable of thinking negatively," Isherwood confided to his diary. "Confronted by a phenomenon, she asks herself: what is wrong with it?" (For perspective, in Isherwood's diaries, Joan Didion is tagged "Mrs. Misery.") In interviews, Blackwood liked to quote from Lowell's poem "Since 1939": "If we see light at the end of the tunnel, / It's the light of the oncoming train." Readily acknowledging the macabre twist to her humor, she attributed that coloration to origin, explaining to Michael Kimmelman: "Irish people are . . . funny but have this tragic sense" ("Titled Bohemian," *New York Times*). The quality Isherwood described as Blackwood's "negativity" particularly announces itself in her fiction. Many of her short stories are relentlessly nihilistic, some ghoulish, all blunt and brutal in their depictions of humanity. Just when one assumes the worst of a character has been revealed, Blackwood digs deeper, exposing another layer of selfishness, malice, and deceit. Depending on the reader, that pile-on comes across as comic or horrific—a Blackwood Rorschach test.

Characters consistently and repeatedly behave badly in Blackwood's fictional universe. They run out on marriages (*The Stepdaughter*, "Marigold's Christmas"). They run out on dying dogs ("Addy"). They fire Holocaust survivors from jobs ("Who Needs It?"). They thrive as petty tyrants ("Matron," "The Baby Nurse"). They hector and hate ("The Interview"). They reflexively lie ("Taft's Wife"). Quite regularly they hallucinate. A Blackwood specialty is the internal crack-up. The protagonist of "The Answering Machine" refers to herself as a "female customer drinking in (a) pub who was not always in contact with her own brain." The unhinged fixate on ears, "those absurd rubbery appendages clamped to the sides of . . . heads" ("Angelica"). They fixate on fat: "Her eye caught the blue mottled and fatty flesh of thighs swelling obscenely out of transparent panties" ("The Shopping Spree"). The stepmother narrator of *The Stepdaughter* is convinced that the "weight" of her husband's cake-eating progeny is "monumental enough to bring the whole apartment building down." Some of Blackwood's

mentally unbalanced characters are institutionalized (*Great Granny Webster*); others kill themselves ("How You Love Our Lady," *Great Granny Webster*). In every narrative rage percolates. Even in Blackwood's final novel, *Corrigan,* by far the kindest and gentlest of the lot, daughter Nadine feels "disgusted" by her widowed mother's life choices and fiercely resents her mother for "depriving her of her father in death" as she had deprived Nadine of that father "in life." Many are the deceased fathers. Many are the mothers and daughters operating at odds. Continuously in her fiction, Blackwood plays with and off the reader's expectation that some tiny corner of the misery will brighten. It does not.

<div align="center">❀</div>

Perhaps because I started with Blackwood's quirky brand of reportage, I prefer it. In its offshoots, rabbit holes, and emphases Blackwood's non-fiction retains its capacity to surprise, but does so through tonalities more varied. As a memoirist and as a journalist, she gives presumption, vanity, and hypocrisy more leeway, depicting those foibles and failings with a less lacerating pen. For anyone familiar with Blackwood's oeuvre, her witness/reporter stance of wide-eyed wonder at the information and confessions she's collecting adds to the enjoyment. Whereas Blackwood's fiction goes directly for the jugular, her reportage circles its quarry, assembling damning tidbits along the way. As part of her 1987 report on fox hunting, *In the Pink*, she visits a sanctuary for animals in northern England called "Little Heaven," run by Tim Morgan, who derides Blackwood for restricting her subject to fox hunting, demanding that she "cover every aspect of human cruelty to animals." What, for instance, does Blackwood plan "to do about the cows"? Vegan Morgan exhibits "the unhealthy complexion with which those who restrict their diet to the very purest of ingredients are oddly cursed," Blackwood toys before describing a "persistent sobbing coming from a nearby stable,"

its source a lone infant fox a member of Morgan's commune has res-
cued. When Blackwood inquires how Morgan plans to "rehabilitate"
the animal, he says he intends to "let it spend the night in the sta-
ble," then release it into the fields the following day. To Blackwood's
question: "Won't the fox-cub be eaten by the hounds?", Morgan indif-
ferently shrugs, an animal rights' activist "unable to identify with the
plight of any individual animal." In *On the Perimeter*, Blackwood inter-
views the encamped women protesting an American nuclear facility on
British soil and the townspeople who object to the protestors' presence.
She details the verbal abuse the protestors withstand from the base's mil-
itary personnel as well as passersby, the physical hardship of sleeping for
months in plastic "benders" attached to the ground with "clothes-pegs
and washing line," the emotional hardship of leaving behind children
and families in an attempt to ensure those children have a future, given
the threat of nuclear destruction. Then comes the Blackwood swerve:
Did the protestors ever find protesting boring? "Dead boring," a young
protestor named Mary replies. After some delay, Blackwood arranges
to meet the homeowner who lives across the way, a founding mem-
ber of RAGE (Ratepayers Against the Greenham Encampments). Mrs.
Scull informs Blackwood that the "people of Newbury were suffering
horribly from the mob rule of the Greenham women" and invites Black-
wood to see for herself "what they had done to her view." Blackwood
obliges, confiding to the page that Mrs. Scull's view would "never be
much improved . . . while the base remained." Mrs. Scull, on the other
hand, "seemed to be able to blot out the sight of the vast military in-
stallation that was right in front of her windows. She appeared to see
only a lovely and peaceful English common which had been ruined by
the benders of the peace campers."

Blackwood continued to contribute one-off articles to Robert Sil-
vers's *New York Review of Books* until a year before her death. When
Francis Bacon—the early friend who remained a friend—died, she
wrote a fond obituary. Reviewing a trio of ex-husband Lucian Freud's

shows and show catalogs, she gets in a few licks (e.g., "His earlier work . . . had a lyricism and tenderness rarely to be found in his later paintings"; currently the artist only paints "plants and flowers and animals . . . with his old excited wonder"). She reminds those who require reminding of their entwined history ("When I used to sit for him nearly forty years ago . . .") and reminisces about pre-World-War-II Soho, the "legend" in which she played a part. Altogether it is a flattering assessment of the work of the man she left behind. In 1979, Blackwood reported on the gravediggers strike in Liverpool for *NYRB*. It was a story that allowed her to go full-bore Blackwood. Included is commentary on Thatcherite politics, anti-Semitism, and the dismal working conditions of the gravediggers themselves. "Almost always" there was a grave beneath the one being dug, Blackwood reports, then embellishes: The gravediggers' "feet go through (the lower coffin) and they find themselves wading around in foul water which is floating with rotting human remains . . . grinning skulls staring them in the face." Blackwood interviews Liverpool's "leading undertaker," a "brisk and dapper . . . businessman," who gripes about the "unsatisfactory . . . freelance embalmers" he's been forced to hire to deal with the back-up. There's even a scene of comic mix-up. Blackwood's taxi driver mistakenly drops her off not at the factory that serves as a makeshift morgue but at a car factory nearby. When Blackwood quizzes the outside guard—"Exactly how many hundreds of bodies are being stored here?"—he suspects reconnaissance by the competition.

<div align="center">⚙</div>

Given the artistic fame of two of her husbands, Blackwood already commanded a biographical presence. But in biographies of Freud and Lowell, she counts as sidelight, not focus. Perhaps the buzz and renewed interest created by the *Town & Country* and *New York Times* features, perhaps the initial diagnosis of cancer and subsequent surgery, spurred

Blackwood to scout for her own chronicler in 1995. Shana Alexander, Sag Harbor neighbor, suggested Nancy Schoenberger for the job. Blackwood and Schoenberger agreed to meet, but Blackwood's final illness nixed those plans.

Whether Blackwood's presence and cooperation would have turned Schoenberger's *Dangerous Muse: The Life of Lady Caroline Blackwood* into a different book is anyone's guess. "Obsessed" with her subject, Schoenberger revives the Caroline-as-witch innuendos in her opening acknowledgments, links a car accident of her own to Blackwood's "haunting," and announces that the book before us will be an "exorcism as well as a biography." Apparently exorcism took precedence. Schoenberger dutifully covers the Blackwood trajectory but fails to get at her subject's reckless, black (or otherwise) heart. Among the biographer's eager if unconvincing sources is Blackwood's last boy toy, Andrew Harvey, "twenty years younger than Caroline, and gay," but for whom Blackwood's "passionate sexuality was part of her glamour." In his discussions with Schoenberger, among other claims, Harvey, current director of the Institute for Sacred Activism, takes credit for "opening up" Blackwood to "social issues." Somewhere in the ether, witch Caroline is cackling.

In 2010, Blackwood's youngest daughter, Ivana, published *Why Not Say What Happened?,* a memoir that took its title from a poem written by her adoptive father. Ivana Lowell's book is a recovery text that stars two drinkers, one of whom never stopped imbibing. In recounting Blackwood's life prior to her own birth, Lowell employs the "Mum told me later" approach. Whether Lowell inquired or Blackwood shared without prompting is unclear. Lowell dispels the notion of Blackwood's fine decorating sense ("My mother's idea of decorating was to place as many rickety antiques as could fit in a room onto a comparable number of worn antique rugs") and confirms the havoc, their accommodations "always untidy and unruly." We're told that, although Blackwood considered "sex . . . the best feeling ever—absolutely the best,"

she had a "cynical view of men." Blackwood was also "strange about money" and had "wide feet" that made finding comfortable footwear a challenge. We learn precisely what the meal cooked by Blackwood and pushed aside by Lucian Freud consisted of: "tender baby lamb chops with mint sauce, petit pois and potatoes dauphinoise." We're apprised of Blackwood's drinking habits and fondness for house hunting, her last residence on Union Street in Sag Harbor conveniently located a short walk from an upscale bar. Lowell reveals that she could gauge "how many drinks" Blackwood had consumed "by the way she said hello on the telephone" and on that basis decide whether "it was worthwhile to continue with the conversation." Regardless of "what kind of night had passed," however, come morning, Blackwood would "get up early, pour herself a s strong cup of coffee, and sit down with her notebook to write."

In Ivana's telling, when she was a child, her deeply troubled sister Natalya, six years older, capitalized on "any chance" to "harass" and "frighten" her younger sibling, throwing "plates of food" at Ivana and chasing her "around the house with a knife." As a teenager, the Blackwood daughter who "would do anything to get attention," taunted her mother that she'd slept with Lucian Freud, a claim Ivana is unable to confirm or deny: "I never knew whether this was true or whether (Natalya) had just made it up to upset Mum." Others, such as Geordie Greig, accept the claim as truth. "It was a shameful episode," Greig writes in *Breakfast with Lucian*. "She was seventeen; he was fifty-five." A year later Natalya was dead. Drunk, she had passed out while prepping to shoot heroin and toppled into a bathtub full of water.

The big reveal of Lowell's book is the identity of her biological father. Because Blackwood wanted her daughters to "have the same father," Israel Citkowitz assumed that title and role. Privately, Blackwood told Robert Silvers that he was the father of her third daughter; she told Ivan Moffat the same. Despite the first-name clue, both Silvers and Lowell hoped the DNA test would go his way. It did not. Unlike

Deceived with Kindness, Angelica Garnett's outraged account of the hyp-
ocritical adult conspiracy that peddled Clive Bell as her father rather
than Duncan Grant, Lowell's memoir presents her reaction as less angry
than disappointed. Once the truth was finally out, Moffat came round
to visit, entertaining himself—though not his daughter—by enacting
"cruel impersonations" of the dead Blackwood, sharing "vicious stories"
about Blackwood's drinking, and engaging in a critique of Blackwood's
literary shortcomings (e.g., "unconvincing" male protagonists). A bit
of a jerk, Ivan Moffat. Little wonder Lowell felt disinclined to celebrate
the genetic link.

<div align="center">❁</div>

Too ill to return to her Sag Harbor house, Blackwood spent the last
few weeks of her life in a suite procured by Ivana's boyfriend, Bob We-
instein, at the Mayfair Hotel on Sixty-fifth and Park. At that late date,
if Blackwood remained on any hotel blacklist, the co-chair of Mira-
max Films and The Weinstein Company had the power to override
it. In attendance during Blackwood's final days were her two surviv-
ing daughters, Ivana and Evgenia, her son Sheridan (who, according
to Ivana, had recently renounced socialism for communism), and her
son-in-law, Evgenia's husband, the actor Julian Sands. Robert Silvers
visited daily. Ivan Moffat telephoned. Lucian Freud telephoned. Mar-
ianne Faithfull, who had not long before recorded the direly funny
and dirge-like "She's Got a Problem," lyrics by Caroline Blackwood,
dropped in to sing a "Surabaya Caroline" goodbye. Blackwood's long-
time friend Anna Haycraft, who published novels as Alice Thomas Ellis,
flew in from London. Years before, the two had co-edited a cookbook
designed for the woman who "wanted to be free to drink and talk to
her friends without worrying whether the dinner she is about to pro-
duce will be a catastrophe," recipes provided by their famous friends
("Thick, Fat, Genuine Mayonnaise" from Francis Bacon, tomato soup

from Lucian Freud, corned beef "stovies" from Beryl Bainbridge). A devout Catholic, Haycraft finagled sprinkling disbeliever Blackwood with holy water from Lourdes—just to be safe. And then, Ivana reports, eighty-nine-year-old Maureen booked a seat on the Concorde and descended on the Mayfair Hotel draped in a "floor-length mink," a platoon of suitcases bringing up the rear. After establishing herself in the suite down the hall from Blackwood's, Maureen settled in at the bedside of her rebellious, dying daughter. The rest of the family retreated, leaving the two alone to exchange whatever last words each cared to exchange.

Another Ivana Lowell disclosure: when tests revealed that Blackwood's cancer had returned, her New York doctor declared to the room at large: "I am afraid all of Lady Caroline's naughty years of smoking and drinking have finally caught up with her." If that medical practitioner expected the woman to whom he'd just issued a death sentence to express regret over her improvident ways, he was fast corrected. "Yes," snapped Lady Caroline Maureen Hamilton-Temple-Blackwood, eldest child of the 4th Marquess and Marchioness of Dufferin and Ava. "And I *really* enjoyed them!"

MOTHERS INC.

Freud famously could not talk about mothers.

—Jacqueline Rose

I T HAD BEEN a rainy night in Georgia, and there followed a rainy day. Four miles north of Milledgeville proper and directly across from the Super Inn & Suites, the modest, close-to-earth sign that marked the entrance to Flannery O'Connor's Andalusia wasn't easy to spot and required, in response, a hard swerve left across two lanes of oncoming traffic. A narrow dirt road threaded through a quarter mile stand of woods, that last bit of journeying encouraging the visitor to forget the chain motel, four-lane highway, and traffic at one's back, the better to appreciate the revelation ahead: Flannery Territory, preserved. The two-story, red metal-roofed farmhouse the writer called home for the last thirteen years of her abbreviated life, its front steps and yard immortalized in numerous photos, prime among them Andalusia visitor Katherine Anne Porter in hat and pearls, shoe heels sinking in the grassy dirt as she made her departure amid peacocks. The outbuilding cluster that had formed the set of the PBS production of O'Connor's "The Displaced Person," Mrs. McIntyre made flesh by actress Irene Worth. The front porch/rocking chair vista of pasture, pond and trees.

My assumption that most who made it this far nursed an interest in most things Flannery was quickly overturned by the couple pacing near the house's locked back door, starting point for the interior tour. Allman Brothers fans, they were in town for a concert by sons of the

original band members, and their bed and breakfast proprietor had suggested the Andalusia tour as a way of passing time before their evening's main event. While the man of the pair groused and scowled, his female consort took direct action, pounding on the door. It was not the first time she'd pounded and been ignored, she told me, but it was to be the last. The two huffed off to their car.

Hurry gets you nowhere in the South.

Not that I was complaining.

Their high dudgeon exit meant I got a private tour.

Commentators' descriptions of the main house have ranged from "austere" (O'Connor biographer Brad Gooch) to "unpretentious" (*Saturday Review*) to a "very, very lovely, old southern home" (Sister Loretta Costa, family friend). In the back room that doubled as ticket kiosk and gift shop, the wooden floor slanted, a space heater roared, and damp crept in around the patchily sealed window. Although I felt thoroughly at home, when Regina Cline O'Connor and daughter moved house in 1951 to accommodate Flannery's illness, they must have considered their new lodgings a comedown from the family's in-town setup on Greene Street, often referred to as the "Cline mansion" and once the temporary quarters of a Georgia governor. My tour, conducted by a student at Georgia College, Flannery's alma mater, started in the kitchen, pride of place going to the Hotpoint refrigerator Flannery had purchased for her mother after selling television broadcast rights to her short story "The Life You Save May Be Your Own." I was more drawn to what perched atop the appliance: a silver-plated bar set with martini shaker and glasses. Well documented: Flannery's end-of-the-day cocktail at Sally and Robert Fitzgerald's home in Connecticut, but did that tradition continue with Regina on the Andalusia porch, sun setting? My tour guide couldn't swear to it, one way or the other, though she could swear, with confidence, that the curtains in the house were all sewn by Regina. In the evenings, after supper, "Mrs. O'Connor's sewing machine" was always "running in the back of the house," ac-

cording to Mary Barbara Tate. When Regina hung "revolting ruffled curtains" in Flannery's room, her daughter demanded their immediate removal, "lest they ruin my prose." Flannery won that round. Regina's style was markedly frillier than her daughter's—in window treatments and in dress—but, when necessary, as seamstress, she privileged the practical. Also according to Mary Barbara Tate, Regina stitched up a "very handsome . . . dark green coat, without sleeves but with a cape down to the mid-forearm, so that Flannery could use her crutches more easily."

Andalusia visitors such as myself come primarily to gaze upon one sacred space: the first-floor converted parlor that served as both Flannery's bedroom and workroom. The single bed. The books. The crutches. The crucifix. The writing desk shoved smack against the armoire. As in any guided tour, one can't dash off in the interests of getting where she wants to go, though as soon as we exited the dining/reception room, I tried.

"*Before* we enter Flannery's room," my tour guide said, redirecting my attention to the open door at the back of the hallway, beyond which stood Regina's desk and Regina's desk chair, facing the front porch.

"From where Regina sat, she could see *all* comers," my tour guide emphasized. "Anyone showing up wanting to see Flannery had to deal with Regina first."

Thus prompted, I took a moment to appreciate Regina's gatekeeper post and view, desk to porch, my head swiveling to and fro. When again I locked eyes with my twenty-year-old informant, she nodded slowly, meaningfully.

Mothers.

Everybody's got one.

Mary Flannery O'Connor got Regina. Sylvia Plath Hughes got Aurelia.

❀

Regina Lucille Cline, born in 1896 in Milledgeville, grew up in a prominent blended family, the seventh of Peter James Cline's nine children with Margaret Treanor, whom he married after first wife Kate, Margaret's sister and the mother of seven of his children, died. Regina's father made his money in the dry goods business and once served as Milledgeville's mayor. In Brad Gooch's description: "As a young daughter of a first family in town, Regina was often sassy" (*Flannery: A Life of Flannery O'Connor*). A less even-handed biographer would label Regina an entitled brat. As a child, adolescent, and young woman, Regina Cline expected to have her way. After graduating from boarding school in Augusta, she returned to Milledgeville and met her future husband at her brother Herbert's wedding to Edward O'Connor's sister. Both Regina and Edward were on the rebound, Regina's previous suitor withdrawing from the field because his Protestant family objected to her Catholicism. Engaged less than three months after meeting, Edward and Regina wed in the fall of 1922, both twenty-six.

A World War I veteran, Edward tried to make a go of it in real estate and in Savannah established the Dixie Realty Company. The couple lived in a modest apartment until Regina's family saw fit to upgrade their housing to a townhouse on Charlton Street where Mary Flannery, as Regina persisted in calling her daughter throughout her life, was born in 1925. Flannery called her parents Ed and Regina. It is the opinion of Sister Loretta Costa that "Miss Regina knew early on that she and her husband would never have another child," knowledge that contributed to Regina's overprotective behavior toward the single child she did have. What Costa called overprotective, others called high-and-mighty. The littlest O'Connor attended adult mass with her parents. She was driven to and from school, and Regina decided which children Flannery would play with and which she would not. To improve the family's financial situation, Edward took a job as a real estate

appraiser with the Federal Housing Administration, employment that required a move to Atlanta. Regina did not take to living in Atlanta. In short order, she and Flannery returned to Milledgeville, sharing the Cline house with three women relatives. On weekends Edward made the commute to Milledgeville until, in declining health due to lupus, he joined Regina and Flannery at 311 West Greene Street full time. Three years later he was dead. Age fifteen, Flannery lost a father. Age forty-five, Regina became a widow.

Aurelia Frances Schober Plath, the eldest of three children, was born in 1906 in Boston and named for her mother. Her father, Frank Schober, and Aurelia senior were both born in Austria and had married in Boston in 1905. Frank worked as an accountant, his income sufficient to relocate his family to the coastal suburb of Winthrop before trouble came calling in the form of disastrous stock market investments. Thereafter Aurelia senior handled the family's finances. Because of that shift in parental dynamics, Aurelia junior, in her own description, "grew up in a matriarchy." The salutatorian of her high school class, Aurelia the younger longed to attend Wellesley College but settled for a bachelor's degree at less costly Boston University instead. Pursuing a master's degree in English and German, also at Boston University, she took a Middle High German class taught by Otto Plath.

In her introduction to *Letters Home*, the volume of daughter Sylvia's familial correspondence she edited with vigor, Aurelia Plath hints at a pre-Otto romantic attachment to an MIT professor with whom she'd worked on a translation project. Because the two "worked into the early evening . . . we often had dinner together," she writes, describing how she "listened, fascinated" to her tablemate, "fully realizing I was in the presence of a true genius in both the arts and sciences." Whatever the genius felt about Aurelia, the relationship didn't pan out. Otto, twenty-two years older than Aurelia, stepped into the breach, inviting her on a weekend getaway to his colleagues' farm where he confessed to being a husband of fourteen years who'd not seen his wife in thirteen. In

January 1932, Otto obtained a Nevada divorce and, Aurelia at his side, remarried the same day. The newest Plath couple was keen to start a family right away. Sylvia was born in October 1932, brother Warren in 1935. Far less keen to quit her teaching job at Brookline High School to become a fulltime homemaker, Aurelia, as she writes, "yielded to her husband's wish." Thereafter, in Aurelia's introduction—composed "in answer to the avalanche of inquiries" about Sylvia and providing Sylvia's mother the opportunity to disclose the "crucial decisions and ruling forces" in her own life—husband Otto loses even more of his sparkle. His childrearing notions were outdated. As a couple they had no social life. He hogged the purse strings. At home, he assumed an "attitude of 'rightful' dominance." Despite worsening symptoms of diabetes, he refused to see a doctor. A stubbed toe became infected. Gangrene set in, requiring the amputation of his leg. Illness increased his tyrannical tendencies. He died from an embolism in the lung. Aurelia was thirty-four; Sylvia, eight.

When her father died, Flannery retreated to the attic to draw and write; Sylvia made grand pronouncements: "I'll never speak to God again." Flannery did not speak of her father; Sylvia did not write of hers in her 1940s journal, nor did she mention Otto to her best friend at the time. Two heartbroken, daddy-less girls, their wellbeing now reliant on the survival skills and fortitude of single mothers in a working world that did not favor females. Given the unhappy state of her marriage, Aurelia might have felt relief at escaping the bonds of that entanglement if not for the financial strain a partner-less existence imposed. Otto had no pension. The payout to his modest life insurance policy was quickly spent. More than thirty-five years later, Aurelia remained aggrieved and resentful of her circumstance, telling interviewer Linda Heller a variation of what she'd said on record many times before: "Here I was, a widow with two young children to support. I had a man's responsibilities, but I was making a single woman's salary." Aurelia worked first as a substitute teacher, then snagged a full time position at Winthrop Ju-

nior High School. She left that position when Boston University hired her to teach medical secretaries in its College of Practical Arts, after which she sold the Winthrop house to buy where once she'd hoped to matriculate: Wellesley, Massachusetts. To save on expenses, she and her parents merged households. Aurelia senior took care of the housekeeping and cooking; Frank Schober contributed to the income pool by continuing to work as a Brookline Country Club waiter during the week and rejoining his family on weekends.

When Edward succumbed to lupus, Regina's family also stepped up. Brother Bernard Cline arranged for Regina to take bookkeeping instruction so that she could manage the 550-acre dairy farm, the current Andalusia, he had purchased in the early 1930s, thereby providing his sister with an income. Regina took to her new responsibilities with gusto. As farm manager, she handled milk orders and billing, oversaw building improvements, and directed the farm workers, the once "comely Southern belle" now "feisty, formidable widow" proving herself to be a "natural" at the job (Gooch). As joint inheritor with brother Louis of the farm and business, Regina continued to improve the bottom line. She converted Andalusia from a dairy farm to a more profitable beef farm, regularly bid and won at all-male auctions, sold timber rights for $25,000 more than expected and, once she and Flannery moved onsite, drove the property in her stick-shift Chevy, keeping an eye on one and all. As a widow, Aurelia Plath had a harder time making ends meet—a hardship her daughter perceived and internalized. (As a scholarship student at Smith and earlier, Sylvia scrupulously accounted for every expenditure.) Indisputably, the widow O'Connor held the professional advantage, breaking barriers and accumulating dividends. But as a mother, Regina O'Connor knew she lived on borrowed time, acutely aware that the same disease that had killed her husband would kill her daughter and likely kill her soon.

❁

Aurelia, according to her own reporting, went out of her way to pass along her own literary tastes and ambitions to Sylvia and nurture her daughter's interest in writing. "From the time Sylvia was born I recited poetry . . . to her. She grew up in rhythm," she told a *New York Times* reporter in 1979. In the O'Connor family, Edward counted as the artistically-inclined parent. Having achieved her own success, Flannery confided to correspondent Betty Hester: "Whatever I do in the way of writing makes me extra happy in the thought that it is a fulfillment of what (my father) wanted to do himself." In Edward's absence, however, Regina made sure her talented daughter secured a spot on the Peabody High School newspaper staff and found a public platform for her cartoons and prose. As Peabody's art editor, Flannery gained experience and confidence that funneled her toward the editorship of her college's literary magazine, which also featured her sly cartoons. For those determined to regard Regina as a "benighted . . . philistine," *Creating Flannery O'Connor* author Daniel Moran advises a rethink. "She supported Flannery in her habit of art throughout her life, a life which she lived with Regina for all but five of her thirty-nine years."

Much has been made of the polarities in Regina's and Flannery's temperaments, particularly Regina's garrulousness versus Flannery's close-mouthed, watchful silence—not to say sullenness—in the presence of certain company, leaving the public performances to her mother. (Many a Southern daughter has ceded the same.) In a *Southern Quarterly* article, David Davis pegs Regina "a gregarious, overbearing extrovert"; Flannery, "a sarcastic, intellectual introvert." Family friend Cecil Dawkins portrays the dissimilarities more affably, giving props to "great raconteur" Regina, who would regale her audience with "all she had seen and heard that morning in town," Flannery absorbing the details for other use. A social maven had given birth to a child "never . . . sweet or docile," according to Margaret Uhler, another family friend.

Nor did Flannery grow "sweeter" with age. Of the adult O'Connor, poet Alfred Corn observed: "If she had something to say, even though it might not seem all that nice, she said it . . . She was quite sharp...not easily tolerant of people's foolishness." For someone coping with unremitting physical pain, tolerance might not have seemed worth the effort.

Aurelia Plath believed, and fervently argued, that she and her daughter were kindred spirits. Between them existed "a sort of psychic osmosis." They "shared a love of words," "enjoy(ed) long talks about books, music, paintings," discussed how works of art made them "feel," preferred to convey "words of appreciation, admiration, and love" in writing rather than "express these emotions verbally." The "remark" of Sylvia's she "most treasured" and reproduced in her own journal was a comment uttered by Sylvia, age fifteen: " 'When I am a mother I want to bring up my children just as you have us' " (*Letters Home*). As a thirty-year-old mother herself, Sylvia felt differently. To psychiatrist Ruth Beuscher, she expressed a "fear" of "being like" Aurelia: "I don't want Frieda (Sylvia's daughter) to hate me as I hated my mother."

What Georgian Regina O'Connor and Bostonian Aurelia Plath held in common was a certain gendered attitude. Both prized conformity. Both towed the social line. And both—despite Regina's involvement in the rough and tumble business world—thought of themselves as "ladies" and comported themselves accordingly. Aurelia applied that same standard to her prose—with unfortunate results, in the opinion of *Letters Home* reviewer Maureen Howard, who considered Aurelia's prologue "so lady-like as to be maddening." The Regina quote that most bolsters her philistine reputation, supplied to posterity by Flannery's editor, Robert Giroux, also concerns decorum: "Mr. Giroux, can't you get Flannery to write about nice people?"

The writers in the family went their own way. Again from Maureen Howard's review of *Letters Home*: "Sylvia Plath's triumph is that in her best work she freed herself of the refined . . . niceness expected of

her." Confirming that breakout trajectory: the poet herself. In a 1962 radio interview with Peter Orr, Sylvia announced with what sounds very much like defiant pride: "I'm not very genteel." That same year, asked about her "relationship with Milledgeville," Flannery O'Connor replied: "If I cared what they thought about what I write, I'd have dried up a long time ago."

۞

Sylvia passed on her mother's favorite, Wellesley College, to study at Smith—close but not as close. Flannery walked down the street to what was then named Georgia State College for Women but ventured farther afield for graduate school. After earning her MFA at the University of Iowa in 1947, she accepted an artist residency at Yaddo in upper state New York where she became embroiled in Robert Lowell's mad campaign to oust director Elizabeth Ames. Back in the city, she lived briefly at a YWCA and later in a furnished room on West 108th Street. She made friends with Sally and Robert Fitzgerald, who invited her to board with them in Connecticut while she finished *Wise Blood*. Only illness returned her to the South and Milledgeville. After college, in 1955, Sylvia received a Fulbright scholarship to study English at Cambridge and there met and married Ted Hughes. Husband in tow, she returned briefly to her home state to teach at Smith but loathed the classroom grind. Pregnant with her first child, she and Ted returned to England and there remained.

Physically apart from their mothers, the daughters faithfully corresponded. As Sally Fitzgerald confirms, in Connecticut Flannery wrote to her mother and her mother to her "every single day." The earliest of the 600+ letters Flannery mailed to her mother, archived in Emory University's Woodruff Library, were posted from Iowa City. As a graduate student, Flannery also wrote to Regina daily. She missed mayonnaise. Would her mother send her some?

Originals for nearly 700 letters, Sylvia to Aurelia, reside in the Lilly Library, University of Indiana. More easily accessible to the curious public: those included in Aurelia's *Letters Home* (a testament, in Aurelia's words, to Sylvia's "merry, witty" side) and the non-bowdlerized *Letters of Sylvia Plath*, volumes 1 and 2, that restored what Aurelia had seen fit to cut, restorations that included the "barbed emotions, the volatile wit, the interior darkness" that were also part of Sylvia's personality *(Hudson Review)*.

For all that, we outsiders are afforded only a one-sided glimpse. Sylvia reportedly burned her mother's letters, perhaps during the same period when she torched the manuscript of her second novel along with whatever writings her husband had unwisely left on his Devon desk before scooting off to rendezvous with Assia Wevill. Regina's letters to Flannery are also missing in action. Perhaps Regina burnt the lot herself.

Between rare visits to England, Aurelia relied on her expat daughter's reporting of events: Sylvia's publication news as well as Ted's; the grandchildren's growth and progress; the family's settling in at Court Green; the gardening; the beekeeping; the amassed evidence that Sylvia had achieved the trifecta of poet/wife/mother she'd set out to achieve. Regina's curiosity about Flannery's doings could be satisfied by a short stroll down the hall. To Betty Hester, Flannery wrote: "I suppose I divide people into two classes: the Irksome and the Non-Irksome." Safe to assume, for Flannery, her mother toggled between those two categories. Brad Gooch describes Regina as "both a godsend and a challenge" for her daughter. In the documentary *Flannery: The Storied Life of the Writer from Georgia*, Louise Abbot emphasizes Regina's and Flannery's mutual surprise at finding themselves later-life roommates: "Flannery and her mother never expected to live together as adult women."

That being the case, after moving to Andalusia, they developed a routine, breakfasting together and attending early mass at Sacred Heart Catholic Church. Back at the farm, Flannery wrote from nine until noon "everyday," as she told a TV interviewer, "even on Sundays"; Regina took care of farm business. They returned to town for lunch at the Sanford House Tea Room, where fellow patron Dorrie Neligan recalls: "Flannery mostly ate in silence, while Regina visited with everybody she knew." For desert, Flannery favored the establishment's peppermint chiffon pie. After lunch, they took a breather and both "rested." When visitors—the scheduled, welcome kind—arrived, Regina served meringue kisses and coffee on the porch. Flannery mixed her coffee with Coca-Cola. For dinner Regina cooked what Flannery requested; Flannery did the washing up, never stacking cups and plates beforehand because, as she pointed out to Margaret Uhler, stacking "made the bottoms dirty and that made more to wash." The dishwashing also help to soothe what Flannery, for several years, believed to be her rheumatoid arthritis, the original diagnosis of her illness. To Regina's great annoyance, Flannery's growing flock of peafowl decimated Regina's Herbert Hoover roses. Regina was also not fond of the peafowl's "screaming." Her daughter was. Flannery won that standoff too. The peafowl at Andalusia multiplied and flourished.

Almost to the end of her life, Sylvia continued to share poems with Aurelia, her earliest critic, though by then the sharing was a sharing of achievement, not an invitation to critique. Flannery also shared her work with Regina but, on surviving evidence, did so with less investment in the reaction, content that she liked her stories "better than anybody," as she wrote to Robie Macauley, adding: "I read them over and over and laugh and laugh." In letters to others she joked about Regina's preference for "books . . . with a lot of wild animals" and described her mother's slow-crawl through *The Violent Bear It Away*: "She reads about two pages, gets up . . . comes back, reads two more pages, gets up and goes to the barn." Instead of reading her novel, Flannery

reckons, Regina would rather "be in the yard digging." Regardless, Flannery wasn't about to take writing—or market—tips from her mother. When Regina unadvisedly inquired why her daughter didn't use "the talent God gave her" to "write something that people liked instead of the kind of thing" she did write, Regina got this response: "If you have to ask, you'll never know" (O'Connor letter to Cecil Dawkins).

Judging from Sylvia's response, as late as October 1962, Aurelia Plath was also proffering prescriptive advice. Sylvia's reply: "Don't talk to me about the world needing cheerful stuff!.... It is much more help for me . . . to know that people are divorced & go through hell than to hear about happy marriages. Let the *Ladies Home Journal* blither about those" *(The Letters of Sylvia Plath, Volume 2: 1956-1963)*.

<center>🏵</center>

Experiencing new symptoms, Flannery had returned to Georgia from Connecticut in December 1950 to see her doctor of record. On the train, she had become sicker. During her subsequent hospitalization, the true cause of her illness was confirmed. Regina, in consultation with her family, withheld the lupus diagnosis from Flannery, fearing its effect on her daughter. She also hid from Flannery her own anguish. Lupus, as Regina well knew, was not a curable disease. At the time, Sally Fitzgerald agreed with the concealment; later, "following much inner struggle," she told Flannery the truth. As Fitzgerald described the moment to filmmaker Christopher O'Hare, a shaken Flannery thanked her for the disclosure, but asked Sally, in turn, not to tell Regina about the conversation. "If you do," Flannery said, "she will never tell you anything else. I might want to know something else sometime." The disease killed Flannery in August 1964. Regina "privately . . . spoke of not blaming God for her daughter's early death, but of being grateful for their extra years together," Gooch reports. Flannery had lived longer than expected.

It might be said that Sylvia Plath, who survived an overdose of pills in Wellesley, age twenty, as well as a questionable single car accident in Devon the year before she succeeded in gassing herself in her London flat, also lived longer than expected. Whereas Regina O'Connor's concerns for her daughter's health remained confined to the physical realm, after Sylvia emerged from the basement crawl space, miraculously still breathing, Aurelia Plath's worry focused on her daughter's mental state. Reflecting that long-churning anxiety, Aurelia rushed into print an obituary in her local newspaper that listed Sylvia's cause of death as "virus pneumonia." She also called "Sylvia's friends and neighbors and former colleagues at Smith to assure them that her daughter had died from pneumonia and complications following a severe cold" (Edward Butscher, *Sylvia Plath: Method and Madness*). Aurelia was not alone in the subterfuge. Initially, Ted Hughes also allowed his children to "assume" that their mother "had succumbed to pneumonia" (Jonathan Bate, *Ted Hughes: The Unauthorized Life*).

No mother expects to outlive her child. Regina was sixty-eight when she lost her daughter; Aurelia, nearing fifty-seven when Sylvia killed herself, both mothers the mothers of writers whose fame death amplified. Living on: unflattering mother portraits in poetry and prose—the Mrs. Mays, the Mrs. Greenwoods. In his segment of *Flannery: The Storied Life of the Writer from Georgia*, Flannery's editor, Robert Giroux, contends: "Regina never realized she was in the stories." Although by no means an "interleckchul," in Flannery's mock spelling of the word, Regina, Southerner that she was, could certainly sniff out a slight—in person or in print. The idea that any character bearing a resemblance to her passed unnoticed is more than a stretch; it's a conclusion that borders on the wacky. Whatever she thought of the cross-pollination, along with whatever she said to the author as a result, remained a private affair. In public, Regina took the queenly approach of never complain/never explain regarding her daughter's writ-

ing. If Aurelia Plath had followed a similar strategy, she might have spared herself further grief.

As sole executor of Flannery's will and estate, Regina was the family member who signed off on her daughter's posthumous publications, including *Everything That Rises Must Converge* and *The Complete Stories*. Because Sylvia died intestate, her literary estate passed to her estranged husband, who, with the help of his formidable, formidable sister, Olwyn Hughes, oversaw—and, in the case of *Ariel*, infamously edited—Sylvia's remaining works. To publish anything of her daughter's, Aurelia had to bargain with the Hugheses.

Seemingly, Regina had no quarrel with the publication of Flannery's fiction and occasional prose, collected in *Mystery and Manners*, but sparred with editor Sally Fitzgerald over the contents of *The Habit of Being: Letters of Flannery O'Connor*. As Daniel Moran writes in *Creating Flannery O'Connor*: "Regina had her own ideas about the propriety of publishing her daughter's letters or those of anyone else." Earlier, when Maryat Lee asked permission to quote from Flannery's letters in an article for the *Flannery O'Connor Bulletin,* Regina replied:

> Maryat, about the letters, I can't help but feel Flannery wrote those letters just to you and I wonder if she would like them published . . . I appreciate what you said in your letter and it would be nice for people to know another side of her, but people are funny and those who believe that there is no other side, you simply can't change them.

"Lee's skirmish with Regina," Moran continues, "prefigured the longer battle" Regina waged with Sally Fitzgerald over "hundreds" of Flannery's letters. Compromises were eventually reached regarding the contents of *Habit of Being,* but not without a flow of complaints, Fitzgerald to Giroux, regarding Regina's intransigence and infuriating opinions regarding what could stay and what should go.

Following the 1965 publication of *Ariel*, Aurelia Plath described her life as one of "torment" and "humiliation" due to "critics . . . psychoanalyzing her relationship with Sylvia" (Bate). Worse was to come. "Out of respect for Aurelia's feelings," Diane Middlebrook reports in *The Husband*, initially there had been no plans to publish an American edition of *The Bell Jar*. (Originally published under a pseudonym, the novel was re-released in Sylvia's name in 1966.) Rumors of a pirated American edition "in the works" had caused the Hughes siblings to reconsider. Olwyn took on the task of persuading Aurelia "to see the financial advantage that would accrue to the children if Aurelia abandoned her squeamishness" (Middlebrook).

Sylvia, Aurelia would later claim, never wanted the novel published in her native land, but published it was, proving to be, again in Middlebrook's phrase, a "vastly greater embarrassment" for Aurelia than *Ariel*. Unsympathetic character Mrs. Greenwood resembles Aurelia Plath, just as the novel's protagonist, Esther Greenwood, resembles the author. On the eve of the novel's publication in England under pen-name Victoria Lucas, Sylvia rather cavalierly dismissed the publisher's qualms regarding characterization: "My mother is based on my mother, but what do I say to defame her? She is a dutiful, hard-working woman whose beastly daughter is ungrateful to her." Then Plath got down to brass tacks: "Even if she were a 'suing' mother, which she is of course not, I don't see what she could sue here" (*The Letters of Sylvia Plath, Volume 2: 1956-1963*).

Following tense negotiations with Ted Hughes (who expressed serial misgivings), Aurelia forged ahead with the project she was convinced would counteract the damage done to her motherly reputation by *The Bell Jar*. *Letters Home*, her contribution to the Plath omnibus, did not evoke the response she craved. Self-justifying and immensely flawed were among the milder criticisms leveled against Aurelia's selectively narrow presentation of her supremely complicated daughter at the time of the book's publication and in the years thereafter. In *Red*

Comet: The Short Life and Blazing Art of Sylvia Plath (2020), Heather Clark adds image to the verdict: "Aurelia suggests . . . that Sylvia inherited . . . literary precociousness, and perhaps even . . . literary talent, from her . . . But Sylvia was the voyager; Aurelia could only wave from the shore with a mix of envy and pride."

In 1956, Flannery sent this tongue-in-cheek note to her agent:

> My mother and I were amused . . . to read in . . . *Perspectives* that I lived in an unlikely sounding place called Milledgeville where my mother raised hogs and I raised peacocks. My mother can't stand pigs and has never allowed one on the place—but now she is raising them it seems in French, German and Italian.

Regina's "amusement" with the press would not survive her encounter with Josephine Hendin, author of *The World of Flannery O'Connor*, billed as the first close study of the "autobiographical elements" in O'Connor's work. After spending a day with "indeterminately old" Regina, she of the "hard blue eyes" and "self-consciously patrician family," Hendin remarks on the "monotonous" nature of the O'Connor farm and the Southern brand of politeness "that engulfs every other emotion, that permits no contact on any but the most superficial levels." As parting shot, Hendin serves up this rebuke: "Mrs. O'Connor will tell you no more about O'Connor than you will learn from the *Union-Recorder*." If Regina succeeded in revealing no more than she cared to during her meet-up with Hendin, the result caused her to pull in her skirts and decline the dubious pleasure of further conversations about her daughter with inquiring strangers, no matter their credentials.

In contrast, until the end of her life, Aurelia labored to "correct the terrible misconceptions" about her relationship with Sylvia, as she described her burden and mission to Plath scholar Leonard Sanazaro. She was not the "ogre" Sylvia portrayed and the literary world took her

to be; furthermore, it was she who had suggested Sylvia base her novel on a "child-parent conflict" *(New York Times)*. Writing to Judith Kroll, author of *Chapters in a Mythology: The Poetry of Sylvia Plath*, Aurelia played the martyr card: "(Sylvia) has posthumous fame—at what price to her children, to those of us who loved her so dearly . . . There is no escape for us." In the margins of Aurelia's copy of Kroll's published book, now housed in the Sylvia Plath Collection at Smith College, Aurelia scribbled rebuttal after rebuttal. It was Sylvia who "refused to grant" the necessary separation between mother and daughter. Aurelia had "encouraged every act of independence!" She, not Sylvia, was the one who had "worked to be free and . . . live (her own) life" apart from "the complexities & crises" of Sylvia's. Ever the injured party, when Aurelia moved into a retirement home in Newton, Massachusetts, she blamed *The Bell Jar* for the "trouble" she had "making friends" (Clark).

Aurelia outlived her daughter by thirty-one years, dying of complications from Alzheimer's disease in 1994, age eighty-seven. Her *New York Times* obituary was respectful, brief, mentioned the course she had developed for medical secretaries at Boston University, her *Letters Home* publication and collaboration with playwright Rose Leiman Goldemberg on a play based on those letters. Regina outlived her daughter by almost thirty years, dying at age ninety-nine, in 1995. In death, Regina received kudos such as Aurelia Plath might have coveted. Sally Fitzgerald, Regina's one-time sparring partner, wrote the eulogy, lauding the business acumen, charm, and strength of "Miss Regina," urging that the deceased "be celebrated for herself" rather than for her literary connection. Confined to a wheelchair in her later years, Regina had returned to the Greene Street house and there continued "to receive old friends, always perfectly coiffed and touched with rouge for visitors," Fitzgerald assured any concerned that Regina, in her final days, had lost zest for gabbing or primping. In her will, Regina arranged for the upkeep of Andalusia and its continuance as a shrine to her daughter. She lies next to Flannery, East Side, Section A, Lot 39, in Milledgeville's

Memorial Hill Cemetery. An ocean and then some separates Aurelia's final resting place from Sylvia's in Heptonstall, Yorkshire, domain of Aurelia's former son-in-law. In a *Paris Review* interview the year after Aurelia's death, Ted Hughes lobbed another stone in Aurelia's direction, suggesting she had swiped the manuscript of Plath's third, unfinished novel during a visit to Court Green to see her grandchildren after Sylvia's death.

Both mothers had wanted to be mothers, but to be the mother of a famous writer requires another level of skill and resilience. Flannery worried in advance how her death would affect Regina but "would have been so proud of the way Regina just took hold and carried on," believes Sister Loretta Costa. In her own tortured way, Aurelia Plath also carried on.

"I once had the feeling I would dig my mother's grave with my writing," Flannery wrote in a 1956 letter to John Lynch. "But I later discovered this was vanity on my part. (Mothers) are hardier than we think."

ENCOUNTER WITH A TEXT/CONTEXT

A BODEGA/BODEGA BAY visitor encounters no shortage of attractions. Rolling hills, picturesque harbors, sand, sea, starfish, barking seals and, for those of us who prefer our coastal towns misty, creep-in/creep-out fog. The schoolhouse-now-private-residence Hitchcock made famous can be peered at close range; the nearby St. Teresa of Avila church, photographed by Ansel Adams a decade before its cameo in *The Birds*, can be entered at will and without faith. Available to both gawkers and consumers: hat shops, bait shops, surf shops, kite shops, platefuls of today's fresh catch served in restaurants wide and narrow, boats to rent, high/low hiking trails that thread through (pick your pleasure) spare or jagged terrain, and, this day, an estate sale in progress along Shoreline Highway—my first estate sale opportunity since the pandemic made communal browsing less joy than risk.

What is it about certain old books? The heft? The wide, wide margins? The no-stint-on-quality paper? The 1951 ninth reprint of Grace Margaret Morton's *The Arts of Costume and Personal Appearance* offered the above seductions, plus the allure of situational ironies: we, its potential buyers, were an unfashionable, near slovenly bunch, garbed to the person in an accessory Morton could not have foreseen: the face mask.

Author Morton, clothing authority and academic, taught at the University of Nebraska for more than twenty years, a home economics professor and chair of the textiles and clothing division. Her ascending, triple-threat career was cut short by sudden death in 1943, a scant few

months after the original *Arts of Costume and Personal Appearance* was published. Prior to its publication, throughout the 1920s and thereafter, Morton's fashion advice and historical reports appeared in the *Journal of Home Economics* (e.g., "Psychology of Dress") and Extension newsletters (e.g., "Appreciating Grandmother's Handiwork"). She also lectured outside the classroom, in one instance speaking on the "Art in Dress" to the Omaha branch of the American Association of University Women in January 1924. Those articles and lectures, on campus and off, presumably amounted to short takes on material she expanded to fill the 400 pages of *The Arts of Costume and Personal Appearance*. The result is not a book that delays its intentions. On page one of her preface, Morton offers up the "eager hope" that the contents that follow will help raise the bar in women's fashion and establish a "higher standard of taste among people everywhere." Among the book's target audience(s): "students of home economics" who'd go on to teach the subject; "advisers in retail stores"; and the more comprehensive category of "all those concerned with selecting, making, selling and wearing apparel."

From the start, certain crusade fundamentals crosshatch the fabric of Morton's prose: the staunch belief that "taste" *can* be acquired; that women—despite restrictive "economies" and "irregularities" of face and figure—*can* improve their public presentation; that to achieve professional success and personal fulfillment, women *must* fit the mould ("The world still wants its women to conform to certain standards of beauty"). That said, no reward will be forthcoming without considerable and continuous effort. And what of it? Morton is nothing if not a proselytizing disciple of the try hard/try harder school. To *fail* in effort not only dishonors the self, it inflicts injury on Beauty in its most abstract configuration, a dual disrespect Morton refuses to countenance.

Its inspirational ambitions notwithstanding, *The Arts of Costume and Personal Appearance* was issued as a textbook and fulfills the requirements of that niche. There are illustrations; there are summaries; there are glossaries; there are charts; there are Further Reading suggestions.

Like every textbook worth its salt, there are subheads ("Expressiveness of Lines, Spaces and Shapes," "Chroma or Intensity," "The Silhouette," "Personal Attractiveness and Marriageability," "Sway-backs and Prominent Posteriors"). In addition to covering subjective topics the likes of "Understanding and Dressing to Temperament," Morton provides in depth, technical discussions of color and texture. To bolster her arguments, she cites painters (Botticelli, Ingres, Whistler, Titian, Cezanne, Gauguin, Van Gogh, Arthur Dow), of-the-era writers (Clare Booth, Fannie Hurst, Dorothy Thompson), costumed movie stars (Vivien Leigh as Lady Hamilton), fashion designers (Coco Chanel, "Madame Valentina," the "young," "intelligent," "resourceful" Edith Head), scientists, social psychologists, and in one instance First Lady Eleanor Roosevelt, praised for her "unflagging energy." The author provides daily and weekly plans for "cultivating self-made good looks" and a checklist of "equipment" necessary to pull off the job. "Wardrobe building" suggestions are supplied for a range of events/activities ("spectator sports," "homemaking and chauffeuring," "formal teas") attended/undertaken by students, businesswomen, homemakers, empty nesters, the young, the "mature," the "thin" with "bony necks" and "prominent shoulder blades," the "near-stout," and the fully "stout," who must under no circumstance give in to the desire to wear "spike-heeled shoes," a blunder that will make their "feet look too slender to support a heavy body."

Published during wartime, *The Arts of Costume and Personal Appearance* acknowledges the "great economic crisis," "era of emergency," and ongoing "limitations and curtailments of materials to which civilians are accustomed." Morton shares the decision to omit colored illustrations "to keep the price of the book at a reasonable level," adding: "The author of a volume of this kind in which there are no color plates has a real problem in attempting to tell the things she wants to tell about color." A single show of petulance. Morton strongly believes that "personal appearance still plays a part in morale" and that "the enduring principles set down in this volume will carry over into the new world

ahead." For those resistant to the morale argument, Morton has another
up her sleeve:

> In these troubled times there are many who sorely need
> a sense of security and feeling of significance. May it not
> well be that the achieving of an idealized version of one's
> self through the best possible personal appearance may
> help to free the spirit and bring a sense of poise and ade-
> quacy without which no human can be really happy?

A fan of the royal we, on occasion Morton's language sweeps to-
ward the flowery. In a discussion of rhythm as "the mainspring of fine
costume":

> In its simplest form we can see rhythm in the ripple of
> waves . . . in the sequence of attitudes of a great dancer
> . . . In spiral arrangements, as of a seashell . . . We feel it
> in the horizontal movement of trimming on wide-skirted
> evening gowns; or in the undulating lines of a picture hat,
> as it dips in relation to the head and shoulders.

In a discussion of line:

> We enjoy horizontal line movement because it suggests
> the repose and quiet calm of the horizon, or sleeping an-
> imals, or flat, quiet, resting waters. We respond to verti-
> cal shapes . . . because they revive in us the feeling of sta-
> bility and grandeur, of tall cliffs . . . We thrill to upward
> swirls and flowing drapery because it suggests vigorous
> plant growth or the fascination of rising flame.

There are also thrills to be gleaned from striking combinations of
color: "Too much harmony, too much sweetness and ease pall upon

us. We look for the unexpected, and in the mastery of some dissonant element we get a thrill of conquest."

Such flights of rapture, however, are rare. By and large Morton delivers crisp, direct description ("low, flabby busts") in straightforward diction ("Clothes should be chosen for the places we go . . . not for the places we would like to go"). With similar bluntness, she tells us: "Many women's hat problems are due to oversized heads . . . often caused by having too much hair, which should be thinned." The "average woman's taste in the choice of allover patterns is far from good"; "few women have the strength of personality . . . to wear large scale, bold prints"; and "although American women are conceded to have the best figures in the world" (who concedes this is unclear), "in many ways we fall far short of the standard." There is no ambiguity as to the "contemporary ideal" figure, defined by Morton as:

> Oval head and face, arms slender . . . shoulders and hips the same width, waistline well curved, thighs the same width as the hips . . . graceful, proportioned calves, slender ankles, and feet which, when standing, come together.

The "most enviable height"? Five feet five. Regarding the "flat-chested boyish figure of the 1920's with its debutante slouch and air of disillusionment"? Good riddance.

Confident in her mission, Morton's tone, which aims at encouragement, now and again descends to scold and reprimand: "All too few people today seem to have the particular brand of intelligence or skill to achieve results which may be said to embody style." "Those who claim that clothes bore them have surely failed to understand feminine psychology." And, for Morton, this obviously exasperating state of affairs: "Some young women of real ability fail to realize the value of a good appearance. Sometimes they are absorbed in intellectual pursuits and regard themselves superior to so-called feminine frivolities."

When criticizing a specific public someone, Morton characterizes rather than names: "a certain Swedish skater of stocky chest and arms"; "the short figure and bowed legs of one of Hollywood's beloved stars" (identified elsewhere as Bette Davis by less discreet Edith Head). Morton has no qualms about using "peasant" as pejorative and problem category ("Square, wide, peasant-like feet require shoes with broad, square toes and low heels") and does little to disguise her objection to "aggressive" females. For a color exercise, she tosses students a double-whammy challenge: come up with a "school dress" for a girl handicapped not only with the dread "aggressive nature" but also bodily "plump." Although accomplished women are lauded throughout the text, the author sticks to the premise that professional advancement can be achieved—and sustained—by the retiring and the demure. "Many a handsome face has been enhanced or marred by the mental attitude or the general philosophy behind it," she writes in a section that promotes the importance of a "pleasant facial expression." Approvingly she repeats *Vogue* editor Caroline Duer's distinction between wrinkles "of the skin" and "of the soul," the latter, in Morton's elaboration on theme, created by "holding grudges" or "being envious and uncharitable." For those unsure of how far they've fallen on the wrinkle index: "A study of one's face in good light without make-up may reveal selfish, pouting wrinkles or lines of anxiety or melancholy or fear." *If* "deep lines have developed between your eyes, try the use of 'frowners' at night. They can be had at any drugstore and have many times broken up this habit entirely." How to dispatch the afflictions of anxiety, melancholy, and fear Morton leaves to other texts and experts.

Morton's frowners advice appears as number eight in a list of nine "exercises" at the conclusion of chapter two. A great many of her exercises, chapters one through thirteen, make me extremely glad not to have occupied a seat in Morton's classroom or been at the mercy of her grading pen. A substantial number resemble *Buzzfeed*-style self-evaluation quizzes:

• Do you dress to win the approval of the opposite sex? Your own sex? As compensation? As self-expression? As escape?

• Analyze yourself to see if you can determine wherein you do or do not possess qualities of style.

• List your assets and liabilities to consider in working out your own personal problems (of proportion).

• Record ... your voice ... Is it harsh, strident, monotonous, or uncultivated?

Other assignments demand more time and talent:

• Plan and execute in water color or tempura paint a series of experiments demonstrating . . .

• Make a collection of costume accessories such as shoes, bags, gloves, belts, jewelry, etc., in which structure has significance and decoration is restrained, emphasizes structure and is well suited to its function.

• Explain the difference between stylish, stylized, taste, smartness, chic, being "in style," "having style," elegance, being elegantly dressed, dressy, cute . . . the spectacular, the banal, the dramatic. Illustrate those terms with examples.

The final example above bookends a chapter titled "The Meaning of Style," a probe into what style isn't ("making up one's face in public places") and is ("the choice of some tellingly effective ornament, not at once noticed, but, when noticed, not easily forgotten"). For the confused—or tremulous—another daunting "rule" to ponder: "Style is personality." Above all, the acquisition and maintenance of style requires "self-discipline," starting with the "self-discipline . . . to see that

one is well scrubbed and brushed and polished and exercised, well-girdled, with carriage erect, no matter how persistent one's inclination to relaxation or indolence." To be very, very clear: there shalt be no slacking off—not today, not tomorrow, not *ever*.

Bombarded by dos and don'ts, I find I need a break and take it within view of where the very stylish Tippi Hedren/Melanie Daniels boated across Bodega Bay with her cage of lovebirds, attired in a pale green sheath dress with matching jacket, fur coat, silk scarf, suede gloves, heels, purse, and necklace of gold, courtesy of Morton favorite Edith Head. Reportedly, Head made six copies of the outfit to accommodate various stages of bird attack. The 1952 short story "The Birds," penned by Daphne du Maurier—no fashion slouch herself in those Cornwall sweater and slacks sets—features protagonist Nat Hocken, who had suffered a "wartime disability," works part-time on a nearby farm, and can't comprehend why the persecuting birds have come to acquire the "instinct to destroy mankind with all the deft precision of machines." Hitchcock had reprinted Du Maurier's story in one of his *Alfred Hitchcock Presents* anthologies, but what reanimated his interest in the subject matter was a 1961 article published in the *Santa Cruz Sentinel* headlined: "Seabird Invasion Hits Coastal Homes," a report referenced in the film. For his 1963 production, Hitchcock kept Du Maurier's title, the coastal setting, the bird attacks, the pecked-to-death corpses, the escalating frenzy of attacker and prey, inept bureaucratic responses, house confinement, and of course the spookiness. Otherwise he glammed it up with socialite character Daniels, love interest/lawyer Mitch Brenner (Rod Taylor), open roads, and open waters. Du Maurier's tale starts claustrophobic and mostly stays that way, concluding with the working class Hocken family huddled in a dark, boarded-up house that may—or may not—withstand the next avian attack. In Hitchcock's film, the four primary characters make their getaway in Melanie's snazzy Aston-Martin.

No used book comes into one's hands without a shadow presence. The previous owner had paid three dollars and fifty cents more in 1951 (or thereafter) than the dollar I'd paid for Morton's book in 2021. During the course of her ownership, Helen Fiondella had married—if the clue of the added name Swindt in different ink can be trusted. Did Helen Fiondella Swindt agree with Grace Margaret Morton's assertion that "very few *normal* (my italics) young women do not look forward to marriage"? One wonders. With the lightest of pencil strokes, Helen checks the "Good Skin" section and underlines an entire paragraph on "good carriage" with instructions to "point . . . feet straight ahead . . . not at an angle" and thus prevent "waddling." She also underlines a lengthy paragraph on how to achieve a "sitting posture" that is "hygienic" and "also presents a good appearance and indicates good breeding" in which feet also figure, one foot to be placed "a little in advance of the other." Helen joins me again on page 48 for Morton's "Design Essentials" discussion and checks the sentence: "All of art is concerned with the organization of certain fundamental elements, called by moderns the 'plastic elements' . . . line, form and space, dark-light, color, and texture." Helen also endorses Morton's opinion that "no other element is so important to good costume" as line. Helen and her pencil return to number Morton's "stages in developing color appreciation" on page 131. On pages 137-138, Morton discusses the science of color, light, spectrums and artificial illumination, but Helen holds back her pencil until Morton offers the caveat: "Although these facts give us no direct help in the problem of combining colors, they do put value and meaning into whatever work we do with color." And then Helen and her pencil desert me for 150 pages, returning briefly, briefly to star Morton's conclusions on what constitutes "a masculine nature." Thereafter Helen 1) finds nothing more of note in Morton's textbook, 2) succumbs to the slouch of disillusionment, 3) stops reading by chance or by choice.

For whatever reason Helen exited Morton's text, I miss reading over her shoulder. I miss my mother too, who, in 1943, the year of Morton's first edition, was a four-year wife and first-time mother of an infant son, "Stretching the Clothing Dollar" by sewing not only the start-with-these-basics scarves and blouses Morton recommends, but dresses, coats, suits, and hats, an accomplished seamstress since her teens. Were she still alive, I could call and get her take on Morton's take regarding "reefer-type" coats and "fluttering chiffon." We could reminisce about the admiring citizeness who waylaid my twenty-year-old self on the Boulevard Saint-Michel to ask whether I'd sell, for a handsome price, half of my ensemble: a denim skirt fashioned from a pair of bell-bottom jeans. I could remind my mother that a chic Parisian had instantly recognized the craft and ingenuity of her one-of-a-kind creation—ingenuity that, war-tested, my mother continued to keep in play, even when times turned less hard than once they'd been.

ALSO BY KAT MEADS

PROSE

2:12 a.m.—Essays
Birds, Dogs, Catspaw
Born Southern and Restless
Dear DeeDee
For You, Madam Lenin
In This Season of Rage and Melancholy Such Irrevocable Acts as These
The Invented Life of Kitty Duncan
Little Pockets of Alarm
Miss Jane: The Lost Years
Not Waving
Senestre on Vacation (writing as Z.K. Burrus)
Sleep
Stress in America: 9 Mini-Tales
Watering
Wayward Women
when the dust finally settles

POETRY

Filming the Everyday
Ladies First
Miss Jane Repurposes
Night Bones
The Queendom
Quizzing the Dead

ANTHOLOGY

(Co-editor with Cris Mazza, Gina Frangello and Stacy Bierlein)
Men Undressed: Women Writers on the Male Sexual Experience

CPSIA information can be obtained
at www.ICGtesting.com
Printed in the USA
BVHW040033010423
661524BV00003B/3

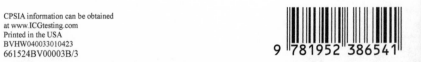